THE ENTIRE CITY PROJECT

THE ENTIRE CITY PROJECT
ROYAL ONTARIO MUSEUM

MICHAEL AWAD

Royal Ontario Museum
100 Queen's Park
Toronto, Ontario
M5S 2C6
www.rom.on.ca

Distributed in Canada by
University of Toronto Press
5201 Dufferin Street
Toronto, Ontario
M3H 5T8
Toll-free tel. 1-800-565-9523

Library and Archives Canada Cataloguing in Publication

Awad, Michael, 1966-
[Photographs. Selections]
 The entire city project : Royal Ontario Museum / Michael Awad.

 Catalogue of an exhibition held at the Royal Ontario Museum beginning
 on May 2014.
Contents: Foreword—Michael Awad : in the city / by Sarah Milroy --
 The entire city project—The most important studio ever taught at
 the University of Toronto's School of Architecture [and the origins
 of my visual art practice] / by Michael Awad—Royal Ontario
 Museum—Curriculum vitae.
ISBN 978-0-88854-499-5 (bound)

 1. Awad, Michael, 1966- —Exhibitions. 2. Photography, Artistic—
Exhibitions. 3. Royal Ontario Museum—Pictorial works—Exhibitions.
4. Museum buildings—Ontario—Toronto—Pictorial works—Exhibitions.
I. Milroy, Sarah. Michael Awad. II. Royal Ontario Museum, issuing
body, host institution III. Title. IV. Title: Royal Ontario Museum.

TR647.A98 2014 779.092 C2014-901638-7

Designer: Tara Winterhalt
Editor: Dimitra Chronopolous
Managing Editor: Sheeza Sarfraz
ROM Press Assistant: Alice Tallman
Nicholas Metivier Gallery Director: Sarah Massie

The Royal Ontario Museum is an agency of the Government of Ontario.

The exhibition *The Entire City Project: Royal Ontario Museum* has been financially assisted by the Ontario Cultural Attractions Fund of the Government of Ontario through the Ministry of Tourism, Culture and Sport, administered by the Ontario Cultural Attractions Fund Corporation.

Printed and bound in Canada.

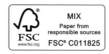

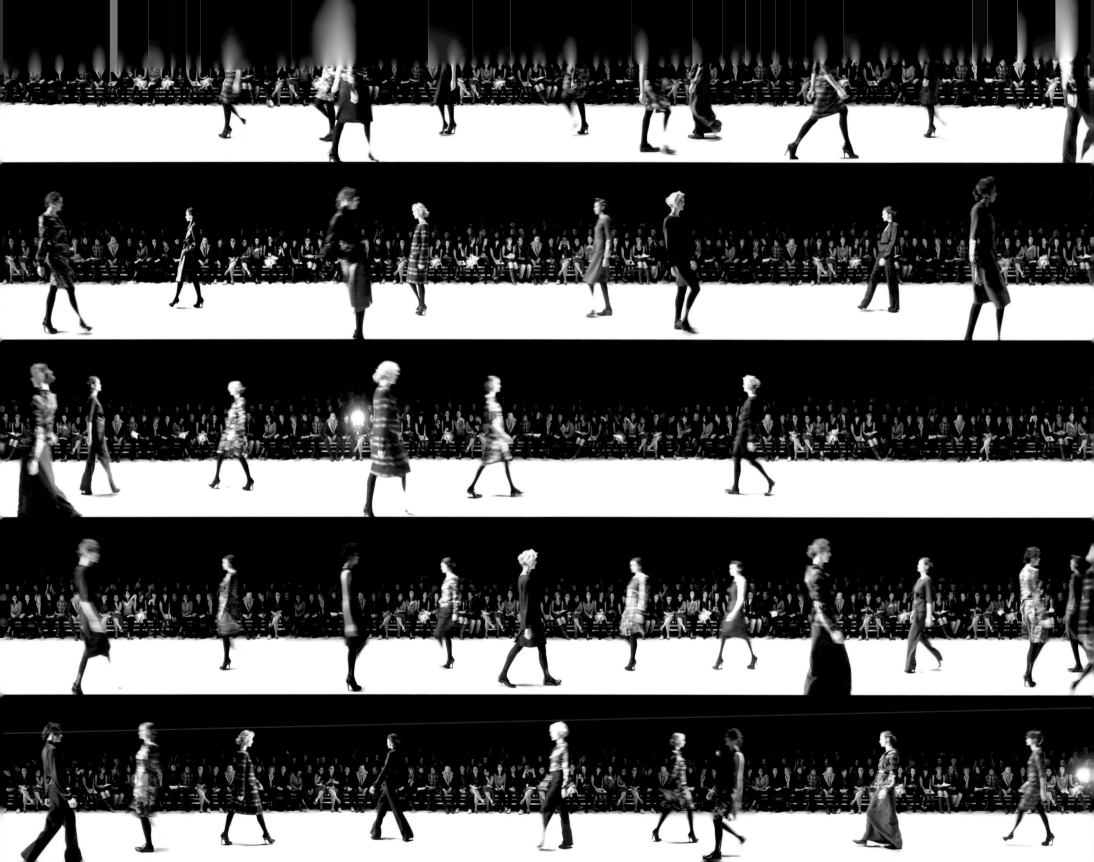

CONTENTS

FOREWORD

The Entire City Project: Royal Ontario Museum reveals the ROM in a way that it has never been seen before. Toronto-based, award-winning artist Michael Awad has captured the essence of the Museum in its vastness, from treasures that reside in our vaults to Museum secrets hidden in plain sight. Awad presents them here for the first time in a series of photographs that leave virtually no facet of the Museum unexamined. The images in this catalogue capture a hundred years of collecting—a photographic time capsule that celebrates the Museum's encyclopaedic collections. Displayed in Awad's unique signature style of continuous horizontal bands of imagery, the compositions blend together into a single uninterrupted composition.

A constant presence at the ROM for twelve months, Awad moved silently through the building with his equipment, capturing all the various layers from the pubic galleries, to the collection storage areas, laboratories, workshops, mechanical rooms, and staff offices. With more than 100 ROM images, each spread is a cross-section of the wonders in our custody. Featured within is the Museum's vastness—current exhibitions, nine floors of curatorial offices, long corridors with precious specimens behind their doors, busy labs, a photography studio in the second basement, rare meteorites deep within the third basement, and much more.

Featured at the ROM as part of the Museum's year-long Centennial celebrations, Awad's work opens the ROM in new and unexpected ways and creates an encompassing vision of a modern museum—an academic facility for collections research, an educational centre for students, a community gathering spot and a workplace for a diversely skilled group of employees and volunteers. The completion of Awad's ROM project marks an important milestone in The Entire City Project, as it is the first time a major public institution is captured in its entirety.

It is thanks to the generous support of the Province of Ontario and the Ontario Ministry of Tourism and Culture that this publication is possible.

Janet Carding
Director and CEO

ACKNOWLEDGE

I would like to express great appreciation and thanks to Janet Carding and Dan Rahimi for their support of this project; to Francisco Alvarez for starting the ball rolling on this several years ago; to Britt Welter-Nolan, Arlene Gehmacher, Ann Webb, and Tamara Onyschuk for carrying the ball to the finish line; to James Nixon for his project management and arranging access to every corner of the ROM; to Diana Lu and James for guiding me through the Museum; to Sarah Milroy, Sarah Massie, and Laura Berazadi for their contributions to this book; to Sheeza Sarfaz and Tara Winterhalt for creating this book; and to David Rokeby and Nicholas Metivier for their contributions to my artistic practice.

Michael Awad

MICHAEL AWAD

IN THE CITY

BY SARAH MILROY

To find Michael Awad's house in the Little Italy neighbourhood of downtown Toronto, you have to search out a pathway between two buildings in the middle of a block—a little crack in the urban mosaic—and then follow it as it tunnels inward, switching back and forth between easements before giving onto a small courtyard edged by buildings. On the day I visit, I discover a half-built igloo there, covered in a dusting of fresh snow, the product of an experiment in architecture that Awad attempted during one of the city's winter cold snaps. (He made the building blocks, he says, by freezing water in bins.) The east side of the courtyard is dominated by his large half-built garage and studio, the facade cloaked in plastic tarps and plywood. The old reclaimed garage to the south, which Awad now uses as his studio—the place where he builds the custom cameras and mounts that he uses in his artmaking—is destined, he says, to be remade into a guest house. The whole site has been under construction for fourteen years, he adds cheerily; before that, it took two years to get the permissions even to begin. There appears to be no end in sight to the modifications under consideration. It occurs to me that's exactly the way he likes it.

The main structure, on the north side of the courtyard, currently serves as Awad's living space, and it too is a work in progress. The kitchen has a kettle and a fridge but no stove, although he is designing a kitchen that he says involves a "new appliance standard" too big to patent. ("I will have redefined kitchenness," he says to me, with a quiet smile.) A sleeping loft is suspended above the living room on a steel wall mount and can be moved horizontally, should he want to reconfigure the building at some later date. "Problem solving, coming up with creative engineering solutions to support design ideas," he says—that is what he loves to do.

This is not altogether surprising; his parentage suggests a brilliant hybrid of left- and right-brain propensities. His mother is a Russian-born engineer who (among her other endeavours) designed the seismic preparedness at the Pickering nuclear power plant. His father, who was born in Cairo, is one of Canada's leading thinkers about schizophrenia, having created one of the longest-abiding predictive diagnostic tests. Awad says their Etobicoke home was always full of art, including a haunting oil painting of the corner of Yonge Street at Queen Street by a little known Canadian landscape painter named F.W. Schilbach, and a horizontal painting-collage by Awad's father depicting a row of endearingly scruffy downtown storefronts, a long and skinny composition that prefigures Awad's own photographic streetscapes.

At one end of his living space, three massive banks of computers form giant parentheses on facing desks—the work stations from which he generates his photographic art, and from which he still conducts his parallel architectural

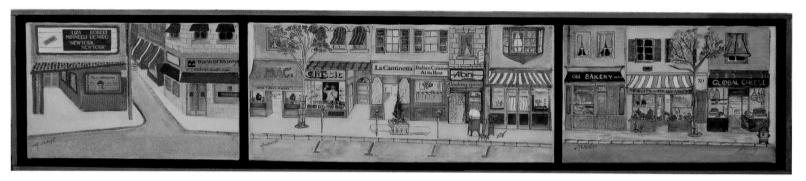

LEFT
Street Scene
George Awad, 1977
10 × 50 inches

OPPOSITE (LEFT)
5th July 1942: A crowded
beach of New York's
Coney Island at noon on a
Saturday.
Weegee (Arthur Fellig)
International Center of
Photography/Getty Images

OPPOSITE (RIGHT)
Subway Portrait
1938–1941
Gelatin silver print
Walker Evans
Size: Image (irregular):
6.5 x 9.5 inches,
Sheet: 7.75 x 9.87 inches
The J. Paul Getty Museum,
Los Angeles
© Walker Evans Archive,
The Metropolitan Museum
of Art

practice. A former denizen of Shim-Sutcliffe Architects and KPMB Architects, Awad began his career in the company of some of Toronto's most distinguished practitioners. (This, following an undergraduate degree that began in math and physics but ended in architecture.) As a high-school student, urban architecture had been a kind of muse, and he passed much of his spare time taking pictures of Toronto's abandoned industrial buildings. Today, he still enthuses about the silos at the foot of Bathurst Street, the Goodyear tire plant in Mimico, and the old Canron steel foundry on Toronto's outer harbour, with its two blast furnaces. ("They looked like alien motherships," he recalls.) Later, as an apprenticing architect, he was often sent out to document projects under construction, a practice that re-engaged his connection with the camera. "Photography brought me to architecture," he told me, and then architecture brought him back to photography.

How to make a record of urban space, in all its endless detail and constant flux? And how to address the limitations of still photography to account for it? These questions provoked Awad's creative response, leading him, in 1995, to modify an old aerial surveillance camera—a clunky Cold War relic that he still owns and which he repurposed to shoot sideways at street level. Walking or cycling or driving in a car, he found he could capture the streetscape, and the passing people in it, in one long continuous image. "Basically," he says, "I hybridized a cinematic camera to act like a still camera," indulging a curiosity that anticipated the Google Earth phenomenon a decade before its emergence in consumer culture. He decided to call this body of work The Entire City Project.

His first pictures in this mode captured only two minutes of experienced time, resulting in images of, for example, King Street from Portland Street to Bathurst Avenue, with the city recorded in long, thin two-block sequences that he displayed as wall-mounted light boxes. Once he made the switch to digital capture in 2002, however, he was able to extend that duration, shooting, for example, Queen Street from the Humber River to the Don River, which took a full hour—as he puts it, "a very slow drive from one end of the city to the other." At this point, he started presenting the photographs as prints, with the ribbon-like images stacked sequentially from top to bottom. Like the earlier works, they offered a new kind of visual experience—a still image of elapsed time, and an intriguing challenge to the notion of the decisive moment.

At the heart of Awad's compulsion is the urge to achieve completeness. The Entire City Project is an exercise in frustrated yearning, calling to mind other works in the photographic medium that strain toward a kind of comprehensiveness-ad-absurdum. In the studio, we mull over a few of the precedents that come to mind, like the artist's book *Every Building on the Sunset Strip* (1966), by California conceptual artist Ed Ruscha, or Eugène Atget's fastidious records of turn-of-the-century Parisian streets and storefronts, documents of a city in the throes of massive urban reconfiguration—both artists creating photographic memorials to vernacular architecture under siege.

Increasingly, Awad's work came to highlight not just the city's architecture, but its human inhabitants as well. Talking about this shift, we look together at Weegee's *Crowd at Coney Island, Temperature 89 degrees... They came early and stayed late* (1940), a picture in which a vast and tightly packed multitude extends as far as the eye can see, an impossible plethora of humanity. "I wonder what it would be like to see that picture blown up," he says to me, pondering the appeal of all that human specificity captured forever. I show him Walker Evans's subway photographs of 1938 to 1941, some six hundred pictures that Evans took on the sly with a concealed camera tucked into his coat sleeve, his response to the compression and anonymity of 20th-century American urban life. Like Awad's, these are pictures that were taken in a manner that elided traditional viewfinding. You take the picture, and only later do you discover what you have.

Awad's pictures began with a connection to the technology of surveillance, and they continue to generate thoughts about the crowd—its vitality, its

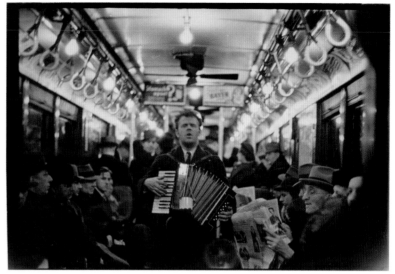

variety, but also its vulnerability and its potential to harbour threat. On the wall beside us as we talk is a near-mural-sized photograph of the Boxing Day crowds at Toronto's Eaton Centre. Swarms of shoppers are laden down with parcels, jamming the escalators. "I was there taking pictures on the day of the Boxing Day shootings," he recalls, remembering the events of 2005. Further iterations in the crowds series have captured more congenial moments in city life, including the Caribana festival, various Toronto running and cycling marathons, and the expectant crowd awaiting the Santa Claus parade. These photographs are documents of our thronging that express the frenzy of urban life and the collective spectacles into which we are conscripted.

Many of the artists we talked about have been recent discoveries for Awad, with the exception of Bernd and Hilla Becher, the much-revered progenitors of the Düsseldorf school of photography, whose work emerged in the 1960s. The couple are noted for their extended architectural typologies of residential and industrial architecture—gridded records of water towers, oil refineries, apartment blocks, barns, homes, factories. "I admire the discipline of it," he says of their work. "Each category has its own framing strategy, its own lighting, its own distinct proportion. The methodology becomes as important as the subject." In the end, their work becomes a kind of encyclopedia of built form, never complete but intriguing in its subtle variety. The differences stand out, oddly conspicuous counterpoints to conformity that express the quirky human signature, prompting us to look more diligently at the things we think we know.

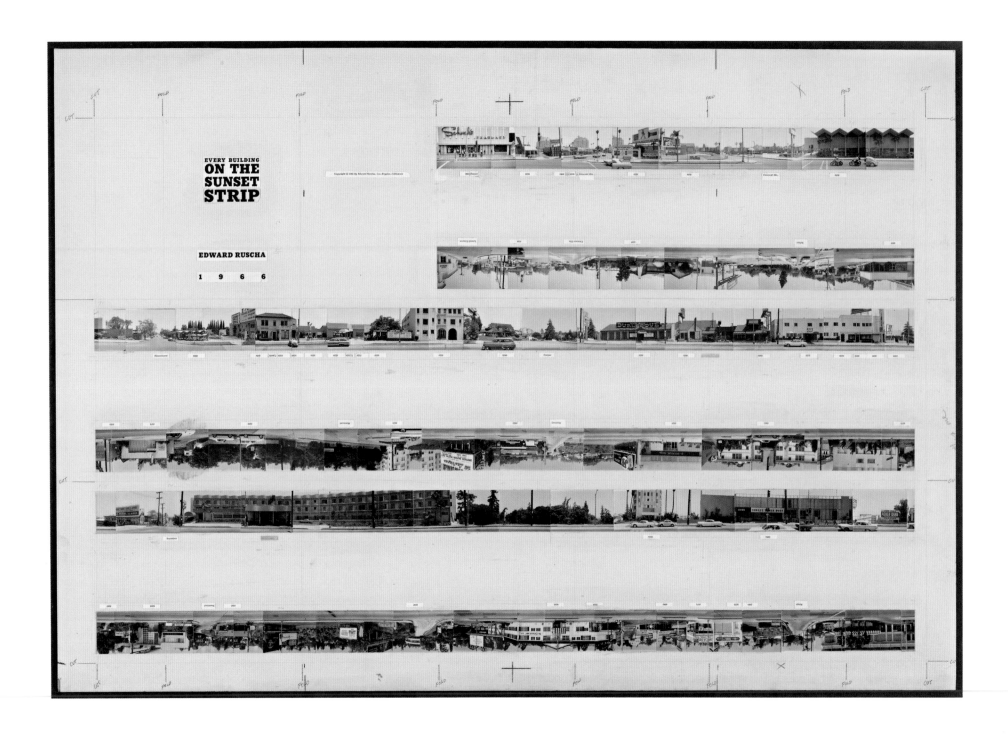

The commission to photograph the ROM has allowed Awad to extend his preoccupation with cataloguing into new realms. "It's the first time I've ever been able to come so close to actually completing something," he says with a laugh. "It's almost achievable!" But, of course, not quite. The assignment has involved documenting all the interior and exterior spaces of the ROM, including all the slings and arrows of Libeskind's Crystal, all of the new and old galleries, the public gathering places, as well as the back-of-house, in which Awad finds "a kind of nobility"—the curatorial offices, the storage areas, and the basement machine rooms with the air conditioning pumps, furnaces, and pipes that visitors normally never get to see. Yet space constraints in some areas of the museum make the passage of the track-mounted camera impossible. Operational and security concerns come into play, and the sacredness of some objects means that there are curatorial proscriptions against their reproduction. As always, completion hovers beyond the far horizon, never to be attained.

The ROM has held a place in Awad's imagination since childhood. The infamous bug room, glimpsed on a school field trip, left an indelible mark, he says: "I can still remember the crate with the cow in it, and the four hoofs sticking up out of the top," the animal being stripped of its flesh within. "But my biggest impression was just of the building itself," he remembers, in particular the Byzantine dome over the old Queen's Park entrance, a space of wonder. The Libeskind overhaul, he says, has created a kind of complexity in the flow. "There is no one walk-through now," he says. "The narrative has been perforated, and there are all these divergent points of access." In many of his photographs of these spaces, he captures that sense of labyrinthine confusion.

Coming back to the ROM as an adult, the collection has been a revelation to him—just the exciting and maddening notion of its depth and breadth. How to catalogue it? How to account for the experience of being in it? In this encyclopedic museum of world cultures, curatorial endeavour can lead to some eccentric outcomes, he says, mentioning one of his favourite oddments at the ROM: a small scale model of the Acropolis that is sequestered in a kind of cubbyhole. "It's a small model of arguably the most massive cultural artifact imaginable," he says. "It's such a strange contradiction." Natural history displays can also generate some peculiar twists on reality, he says, like the avian gallery in which a group of taxidermied birds can be seen wheeling together through a large open space—"a kind of UN flock, all blended in together."

The human flock, too, can take on some distinctive behaviours, and watching the crowds, he has made some discoveries. "The kids go right to one thing and they stay with it. Often they will just look at one or maybe two things. The adults are more systematic," he says, wanting to make sure they have covered everything. Creating the ROM portrait has also brought him into close contact with the museum's staff, of which he is in awe. "There is one curator there who has spent his whole life studying two hundred years of European ceramic art," he says. "It's extraordinary to think of that focus and commitment, that depth of knowledge. People here can just get so extraordinarily deeply into one thing."

Curious, too, is the transition he has observed from storage to display. He flips on his phone to show me a recent crop of his research pictures: a group of stuffed owls in glass cases gathered in a loading area, awaiting transport for loan to another museum. "You are so used to seeing these things beautifully lit, against backdrops suggesting where they live," he says, "but take them out of that and they are suddenly just cargo." The rocks in the geology labs, too, seemed touchingly mundane to him in their deshabille, given their dazzling spotlit splendour in the ROM's front-of-house minerals galleries. For him, that transformation is something to marvel at. He reminisces about the traditional exhibition displays of his youth, when design concepts were less obtrusive and our experience of objects in the museum was less mediated by interpretive schemes. Today, he still searches out such moments at the ROM. The sculpture gallery devoted to Greek antiquities is a favourite, he says, with the glittering coins around the perimeter and a number of small marble busts and torsos in the centre, open to the air and light. "You can move freely between them," he says. "It's just you and the object, and you can have that one-to-one relationship."

I ask him if, in the end, he thinks this exercise will demystify the ROM. "I don't think so, he says. "In fact, I really hope not." Pausing, he adds: "What I'm aiming for is the overwhelming feeling of how complicated it is. Just because you see something visually—whether it's a museum or a city—it doesn't mean that you understand it." There is always going to be more information.

THE ENTIRE CITY PROJECT

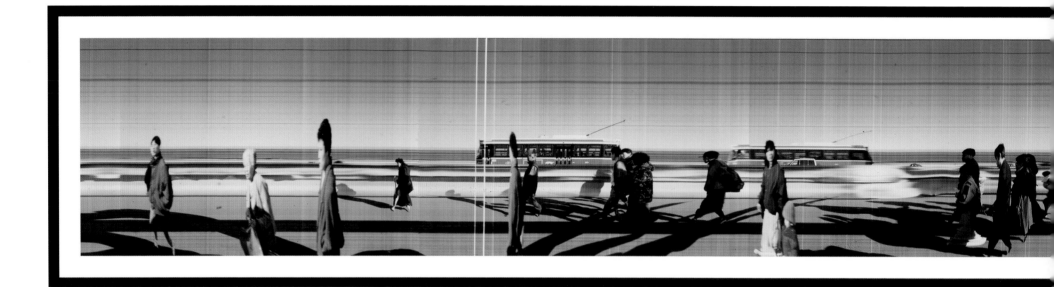

Chinatown, Toronto, 2012
chromogenic print
12 x 96 inches
edition of 8

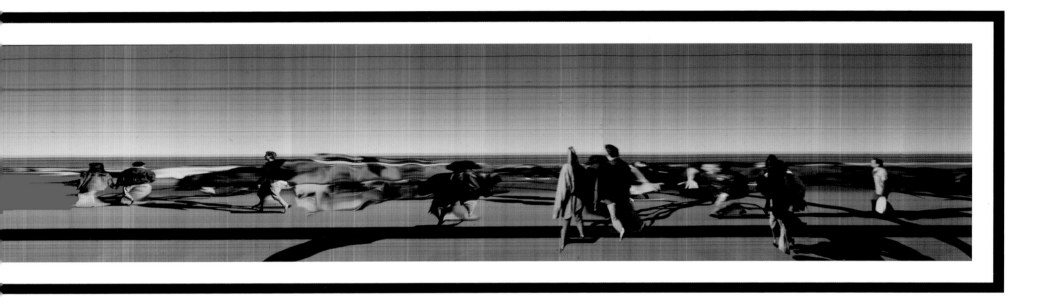

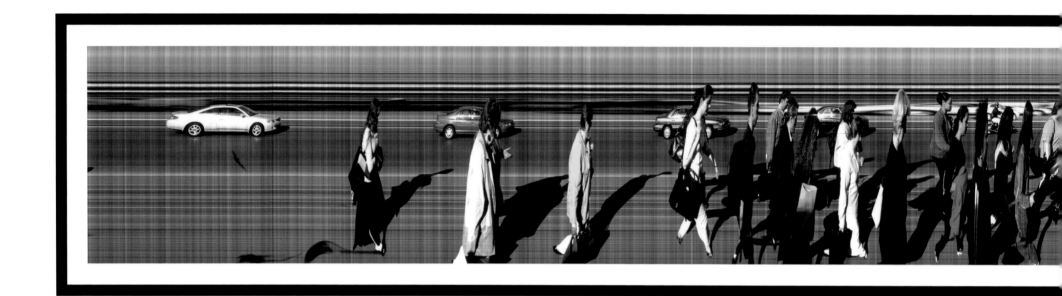

Bay Street Rush Hour, Toronto, 2004
chromogenic print
12 × 96 inches
edition of 8

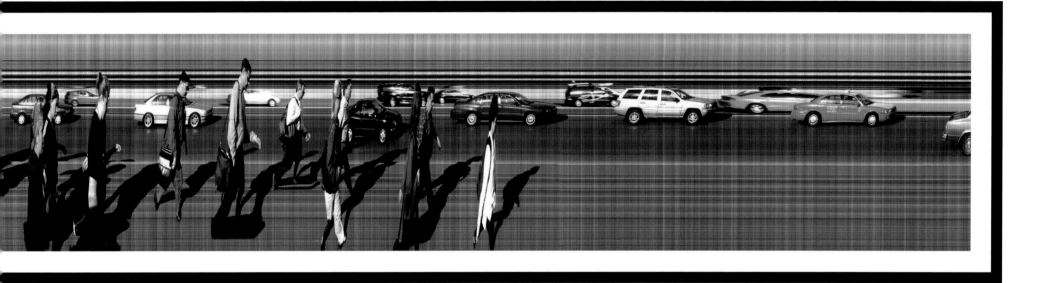

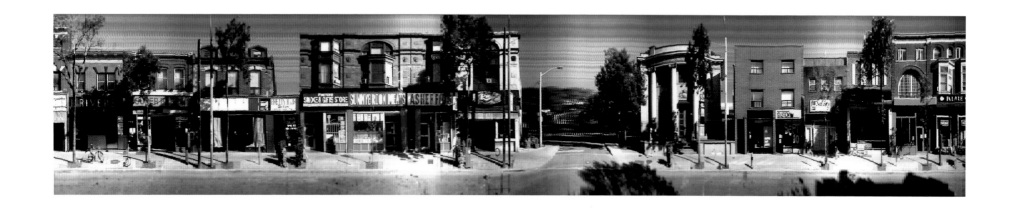

detail | *Queen Street, Toronto,* 2005
chromogenic print
48 × 96 inches
edition of 6

24

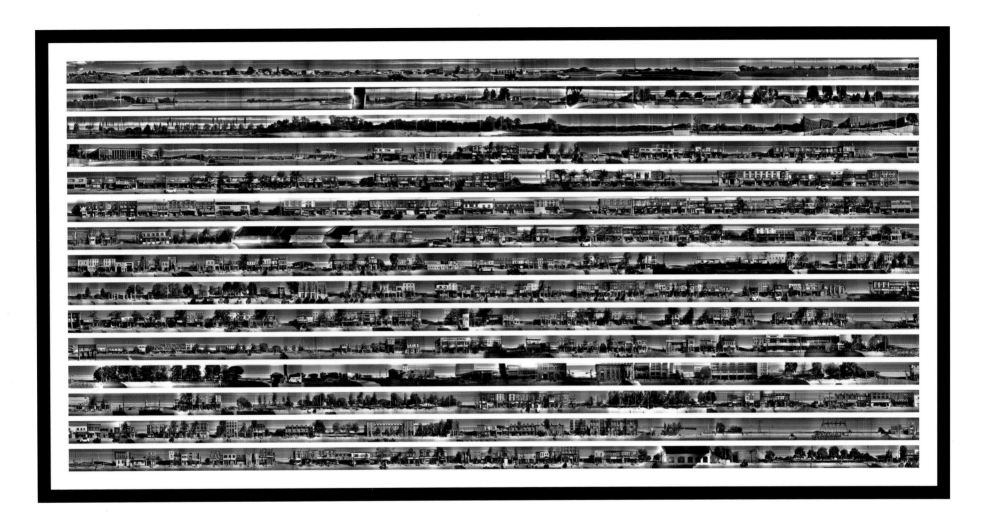

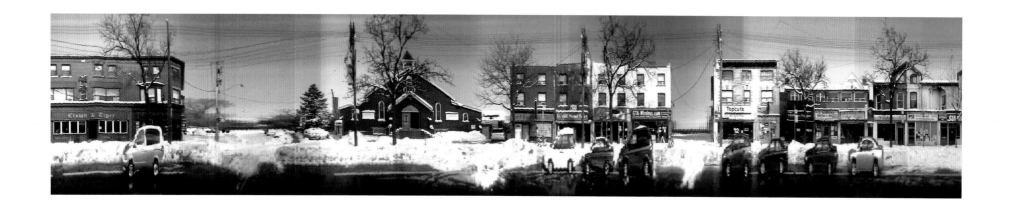

detail | *College Street, Toronto,* 2008
chromogenic print
48 × 72 inches
edition of 8

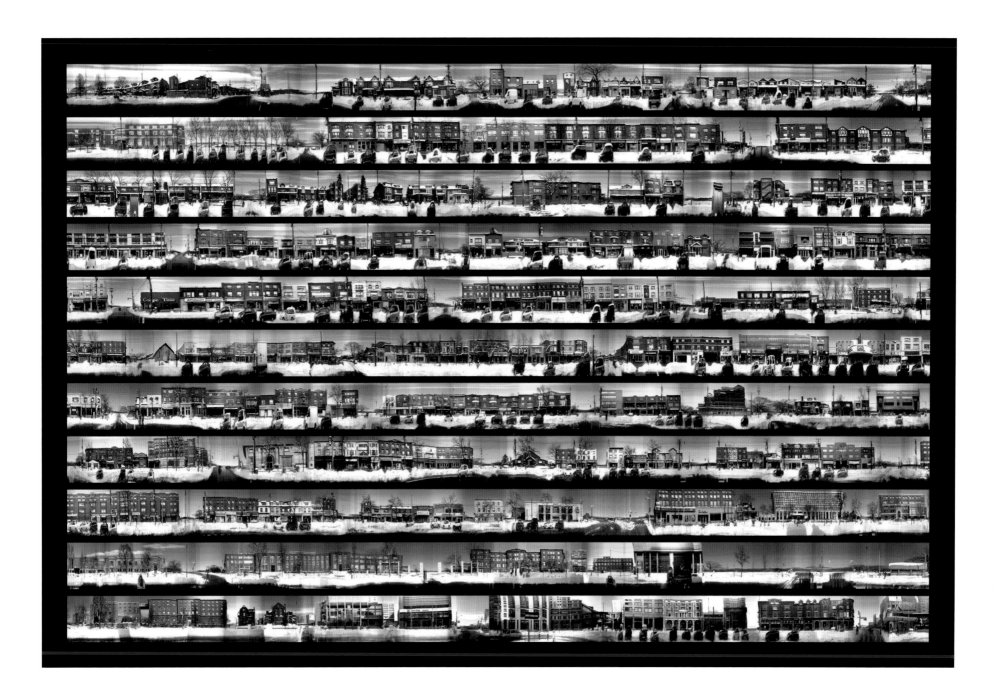

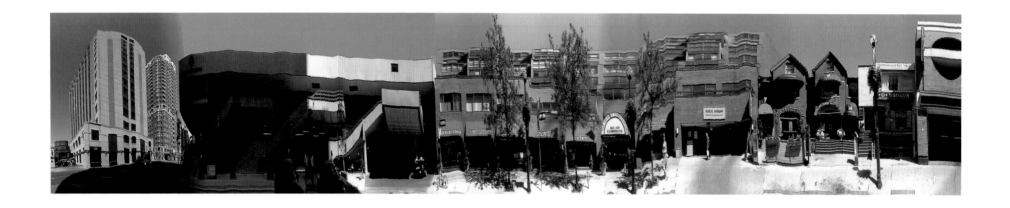

detail | *The Village of Yorkville, Toronto,* 2010
chromogenic print
44 × 48 inches
edition of 9

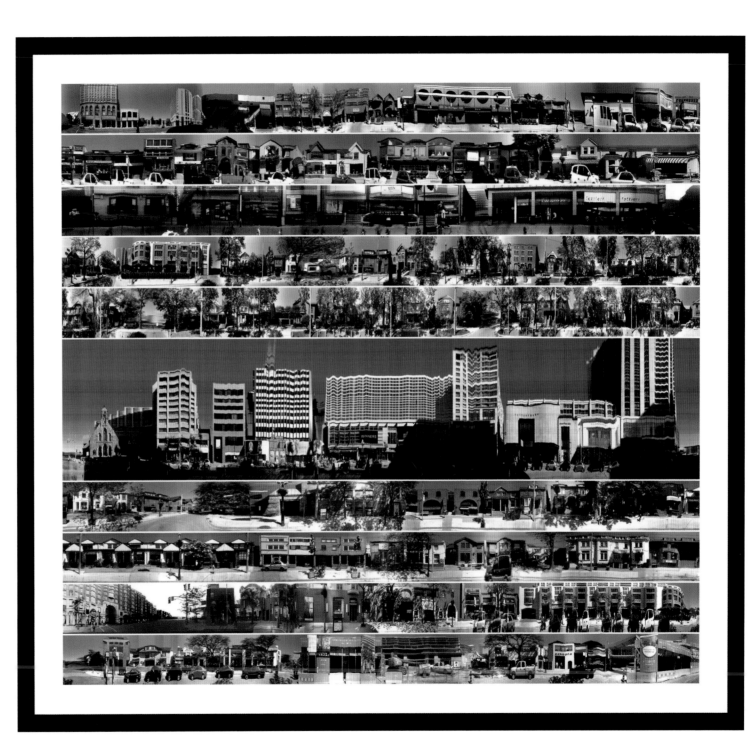

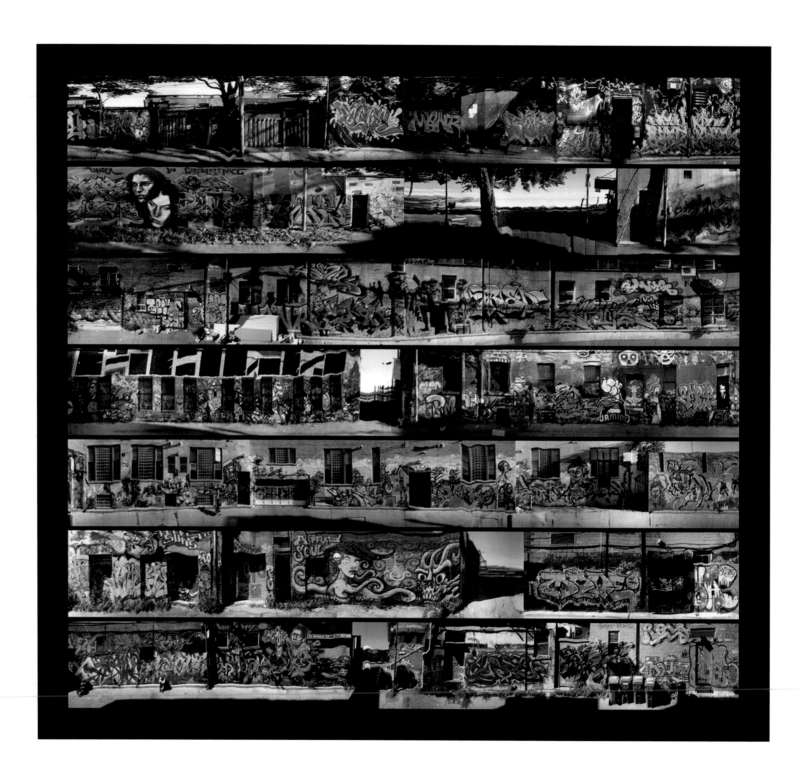

Laneway Graffiti, Toronto, 2012
chromogenic print
44 × 48 inches
edition of 9

30

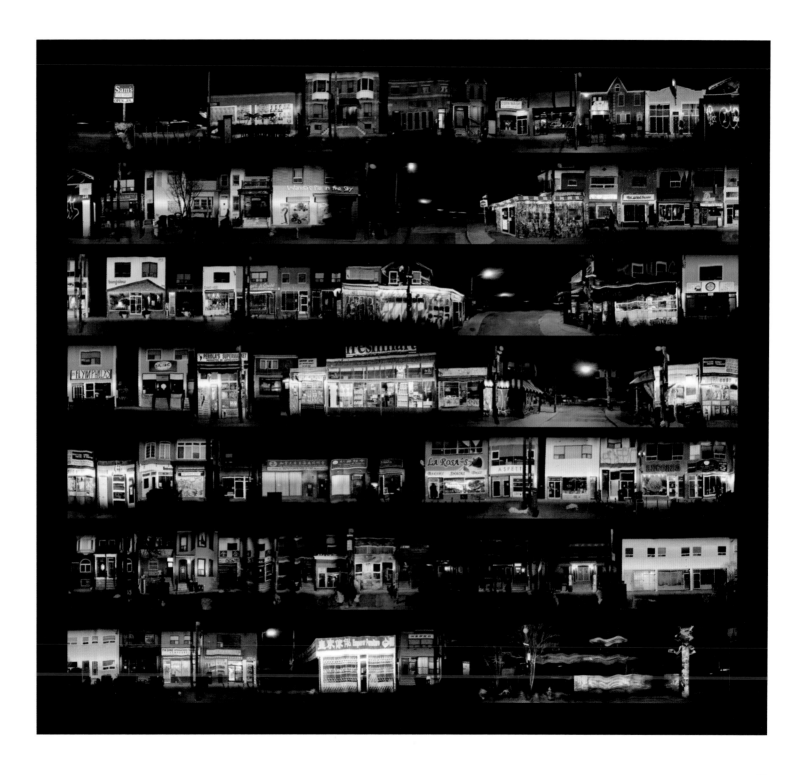

Kensington Market at Night,
 Toronto, 2014
chromogenic print
44 × 48 inches
edition of 9

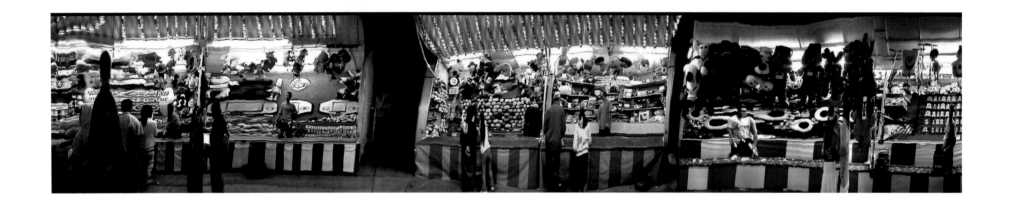

detail | *The Canadian National Exhibition at Night, Toronto,* 2005
chromogenic print
48 × 96 inches
edition of 6

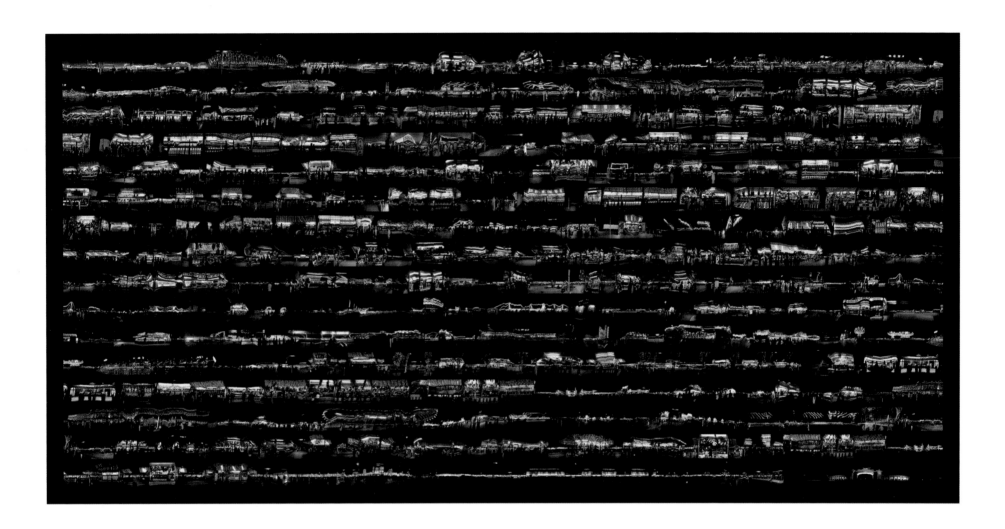

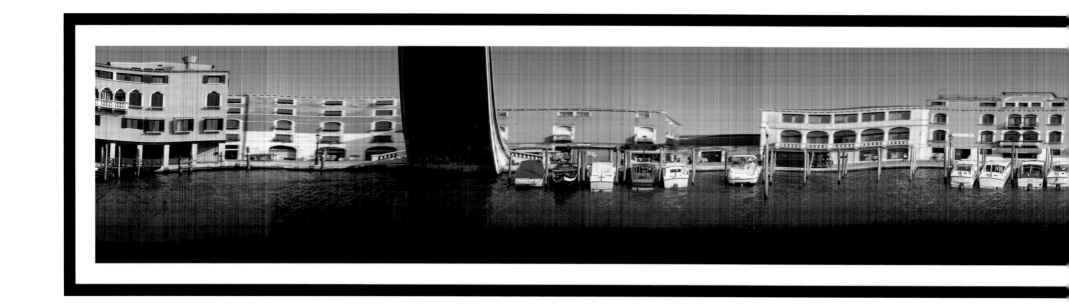

Grand Canal, Venice, 2005
chromogenic print
12 × 96 inches
edition of 8

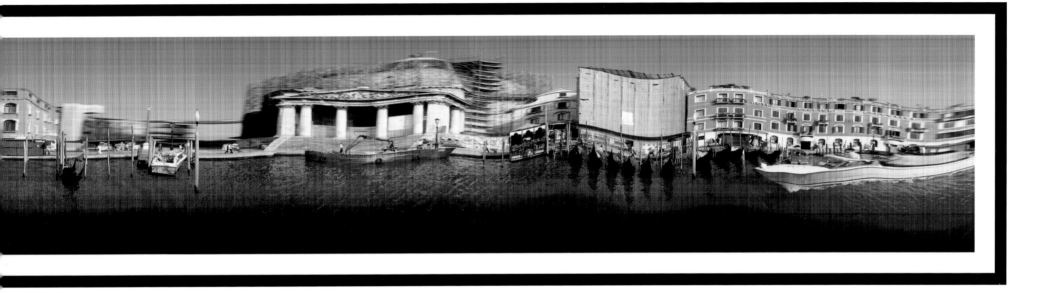

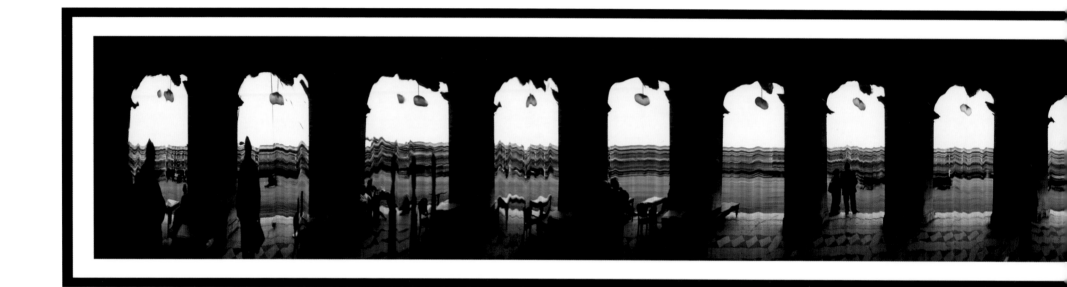

Arcade of Piazza San Marco, Venice, 2008
chromogenic print
12 × 96 inches
edition of 8

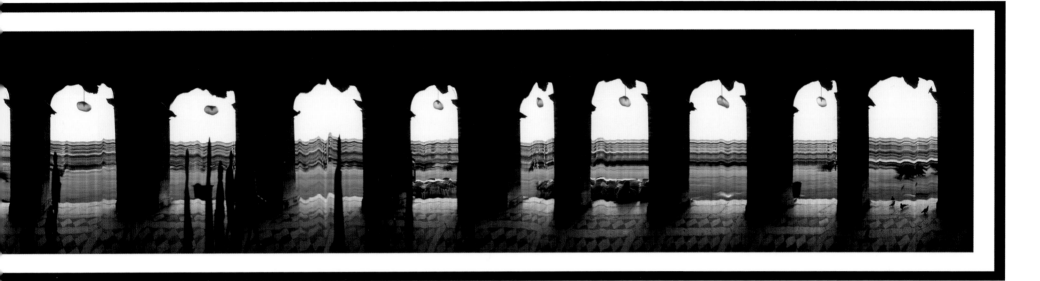

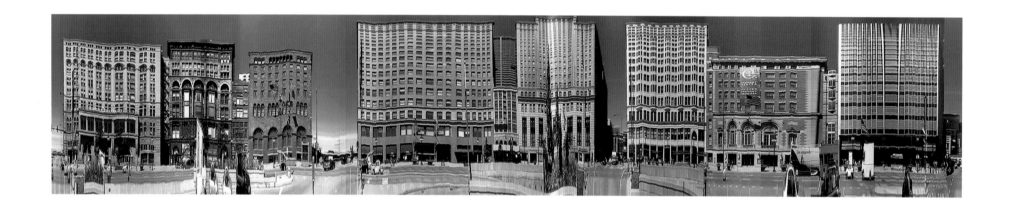

detail | *Michigan Avenue, Chicago*, 2007
chromogenic print
48 × 72 inches
edition of 8

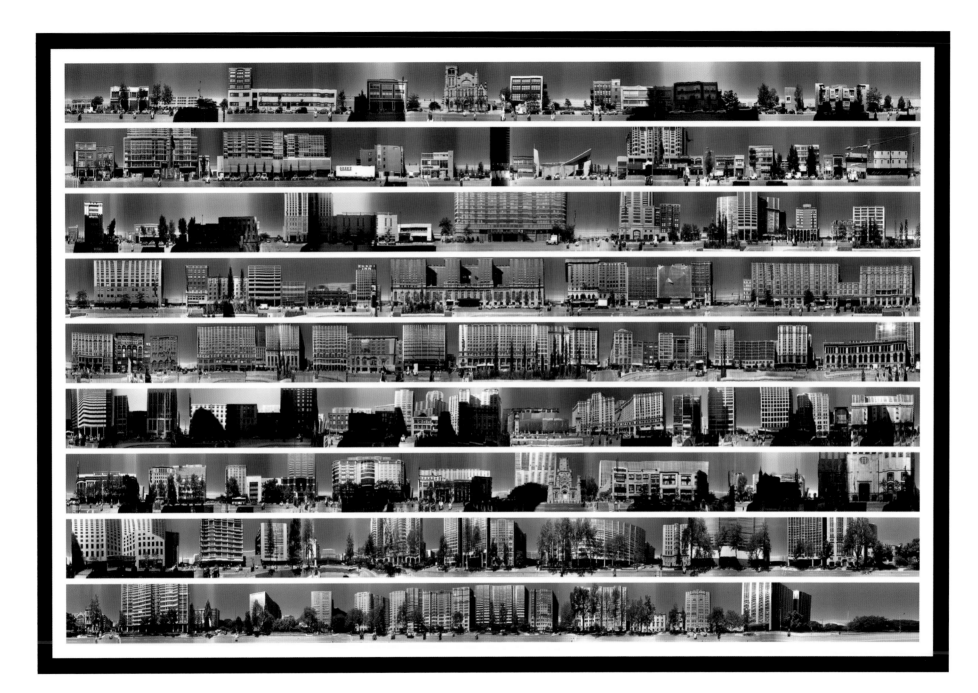

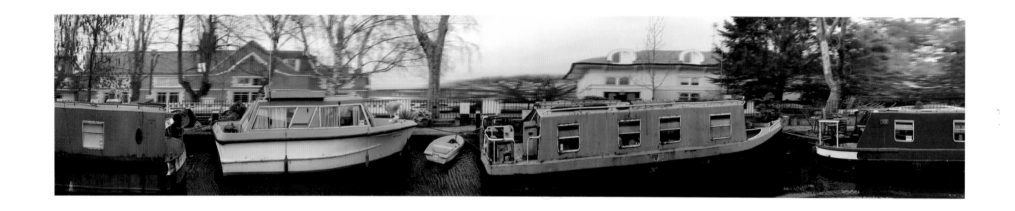

detail | *Regent's Canal, London,* UK, 2014
chromogenic print
48 × 72 inches
edition of 8

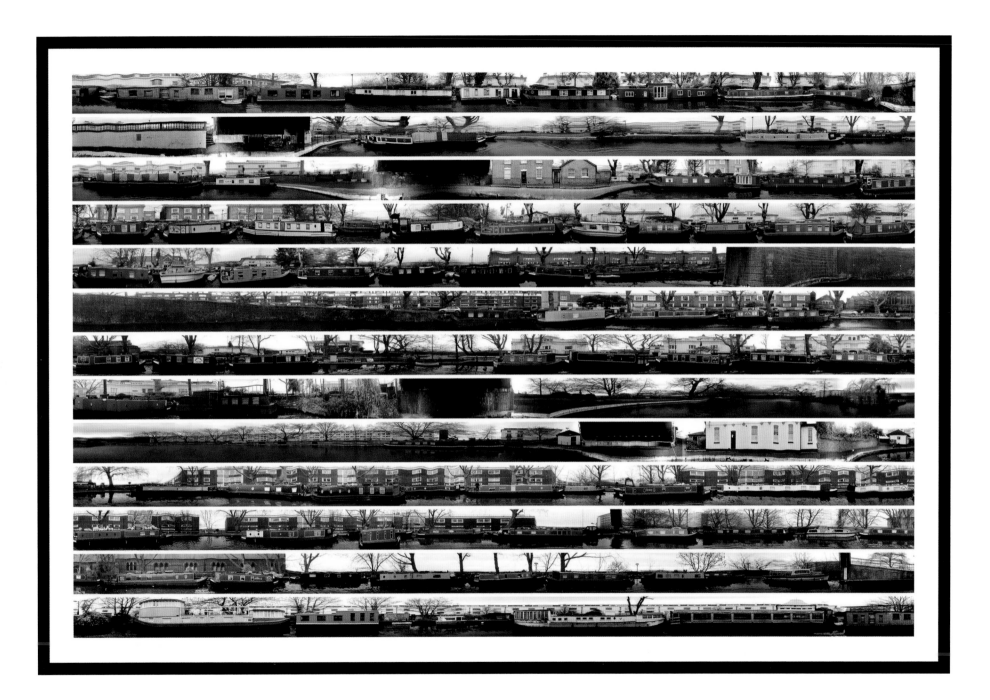

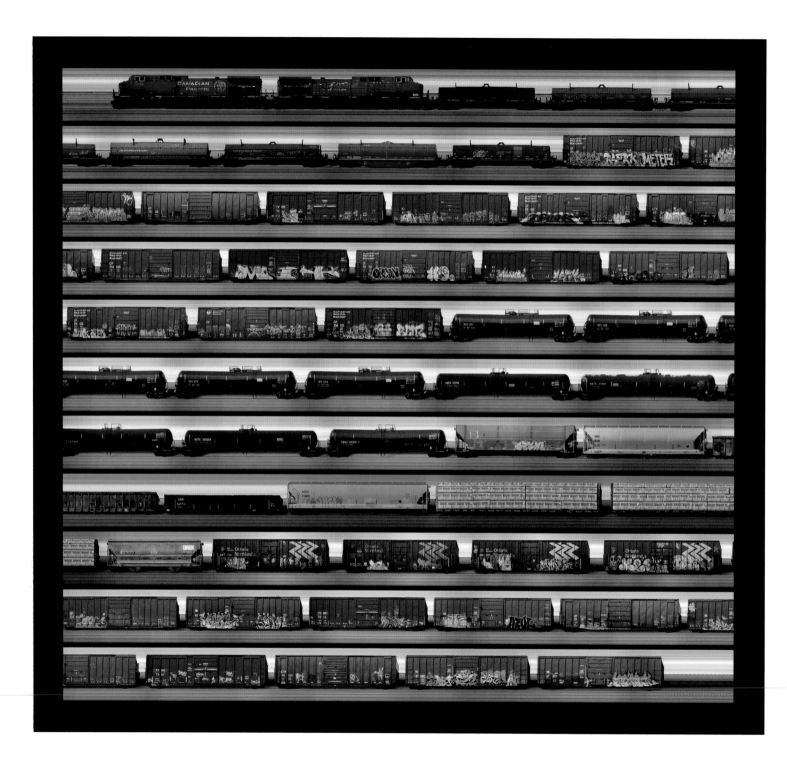

CPR Crossing #26244 (1),
 Toronto, 2012
chromogenic print
44 × 48 inches
edition of 9

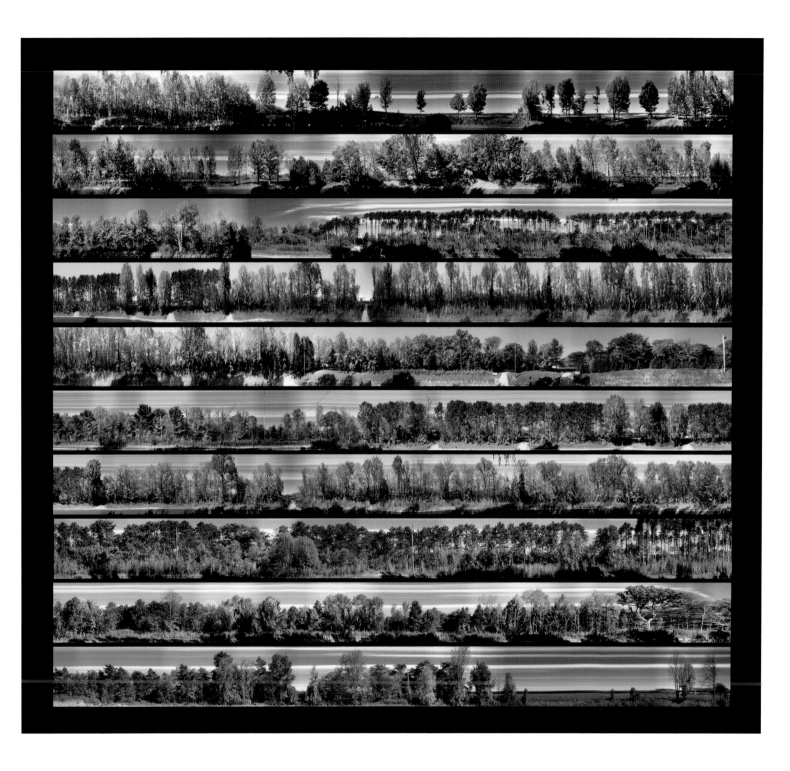

Rural Road 19, 2012
chromogenic print
44 × 48 inches
edition of 9

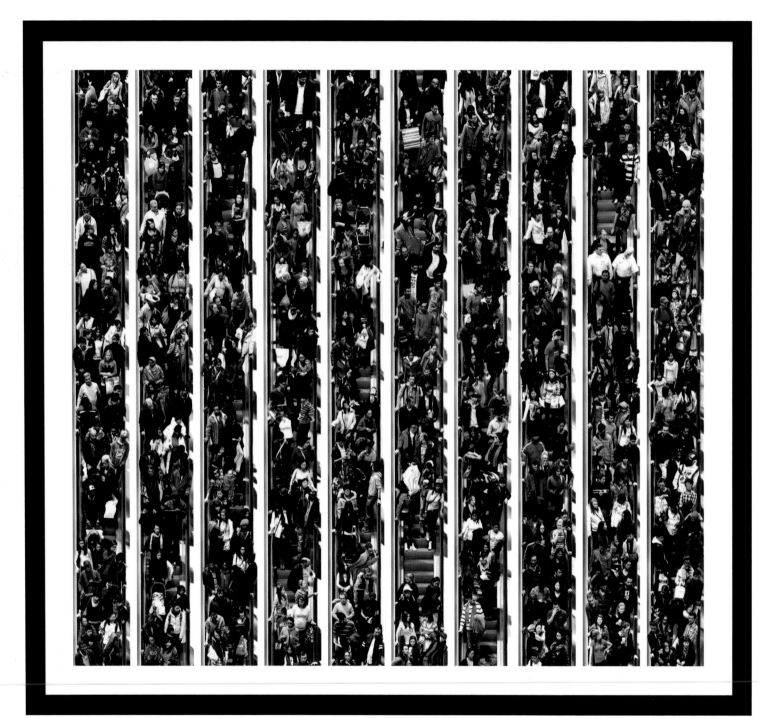

Escalator (down), Toronto, 2012
chromogenic print
44 × 48 inches
edition of 9

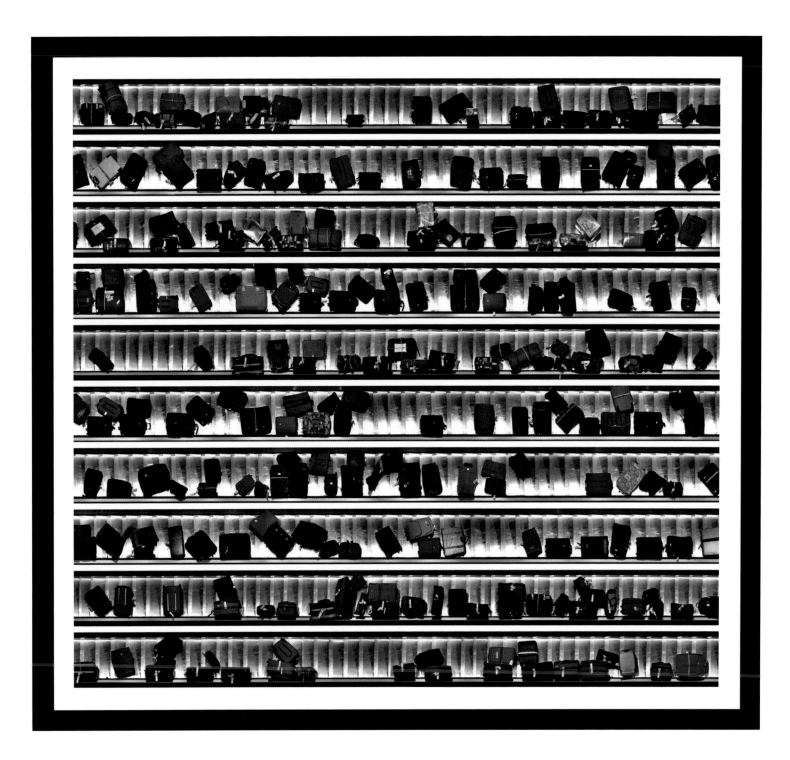

Luggage Claim, Toronto Pearson International Airport, 2006
chromogenic print
48 × 96 inches
edition of 6

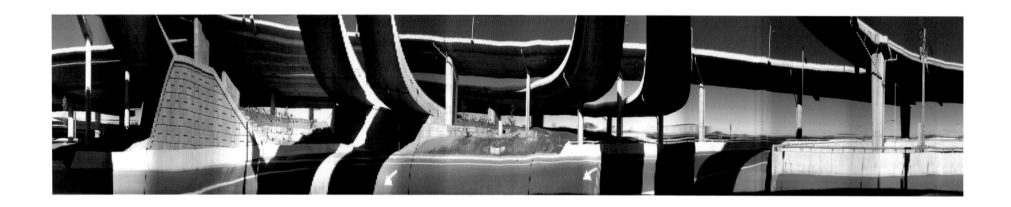

detail | *Highway Network, Toronto Pearson International Airport*, 2005
chromogenic print
48 × 96 inches
edition of 6

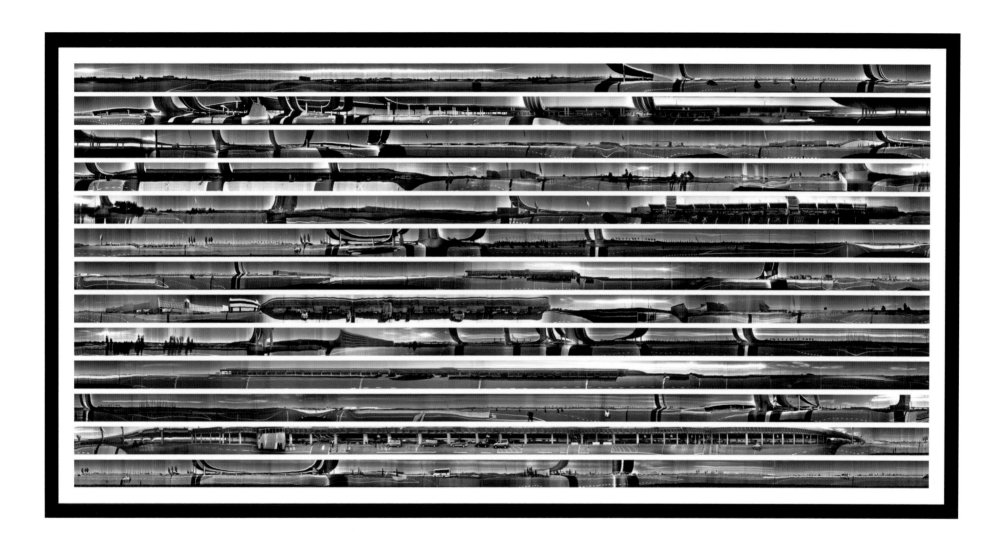

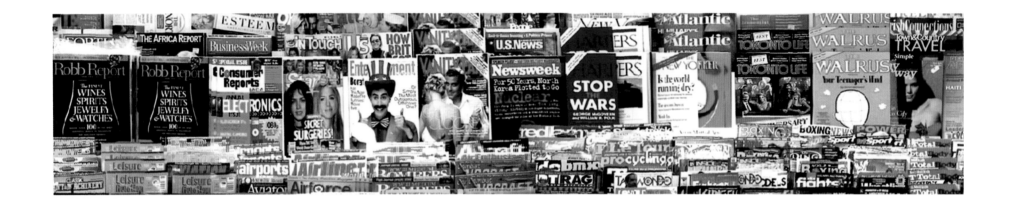

detail | *3000 Titles, Magazine Rack, Toronto, October,* 2006
chromogenic print
48 × 72 inches
edition of 8

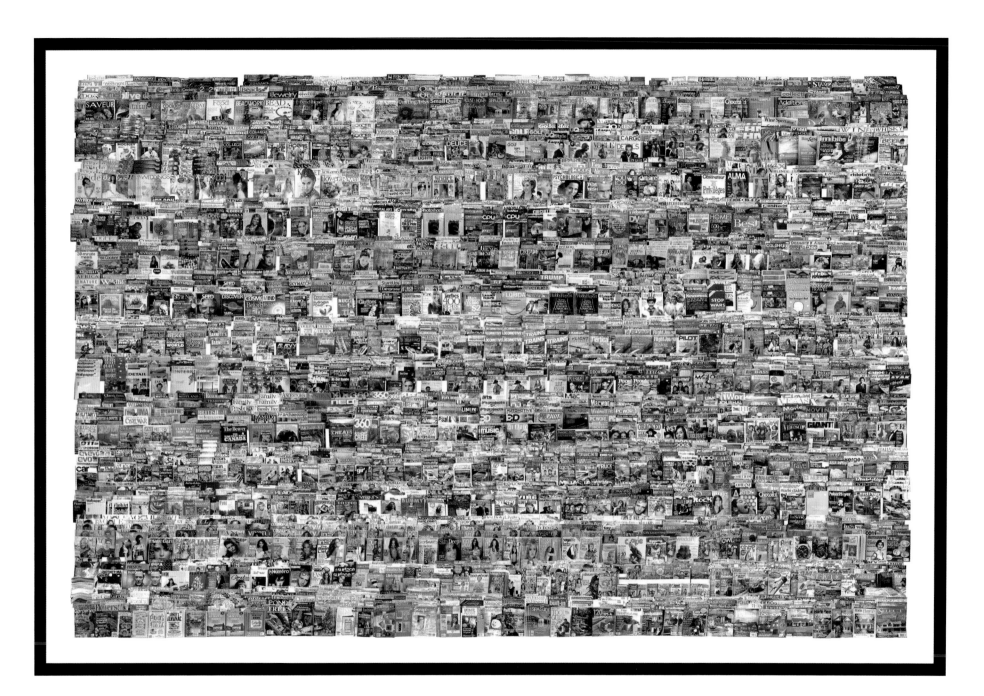

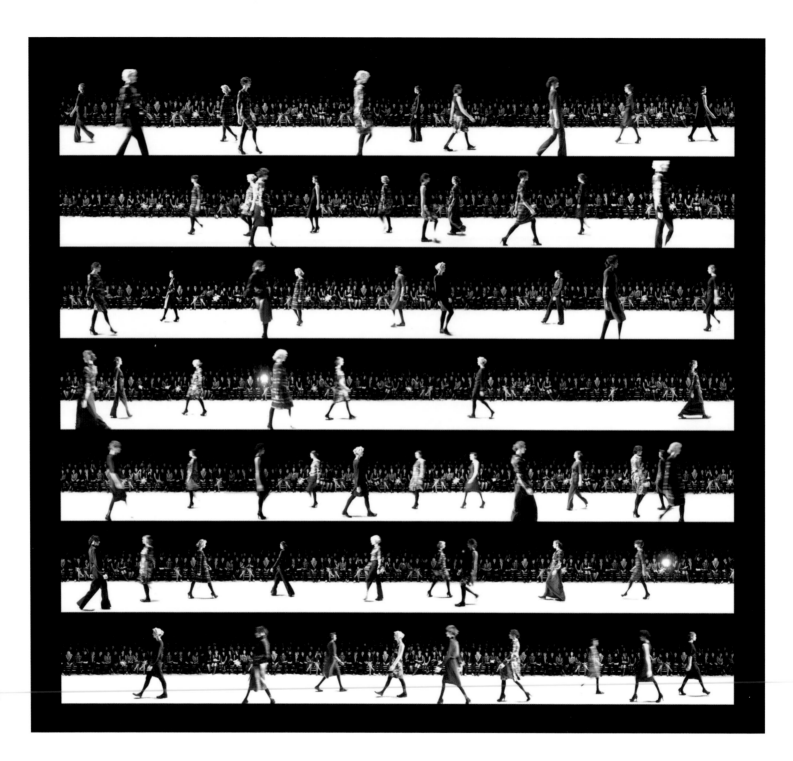

Comrags, Fall Collection, Toronto, 2011
chromogenic print
44 × 48 inches
edition of 9

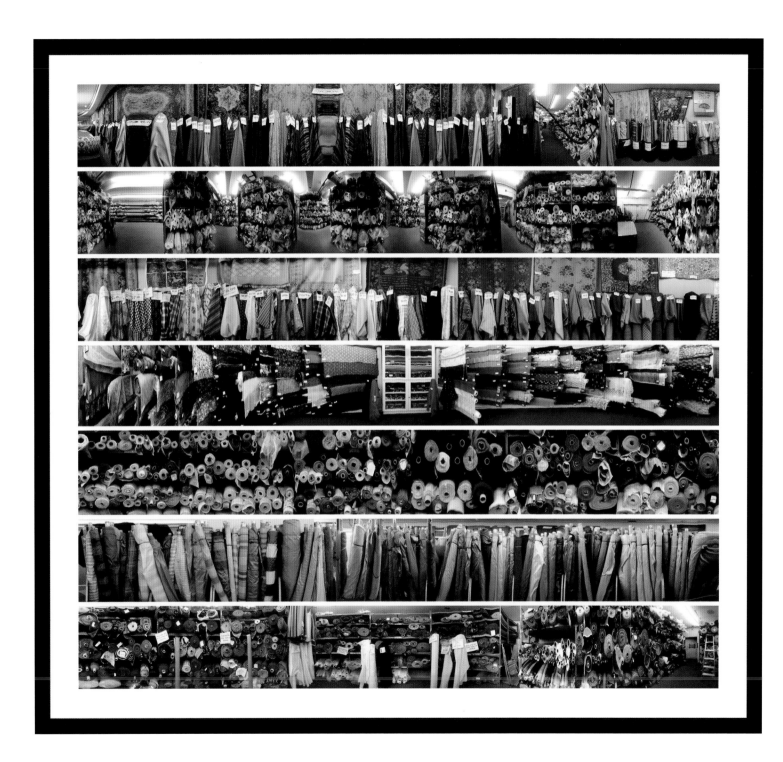

Designer Fabric Outlet, Toronto, 2014
chromogenic print
44 × 48 inches
edition of 9

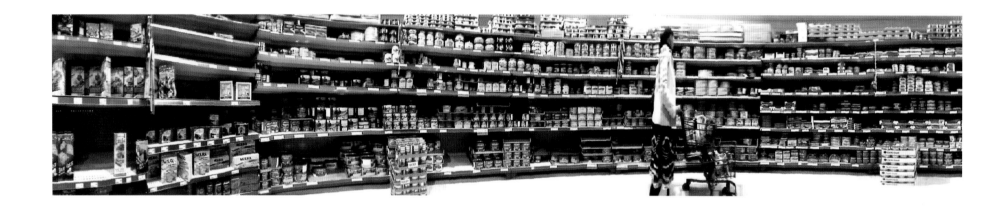

detail | *Supermarket, Toronto*, 2005
chromogenic print
48 × 96 inches
edition of 6

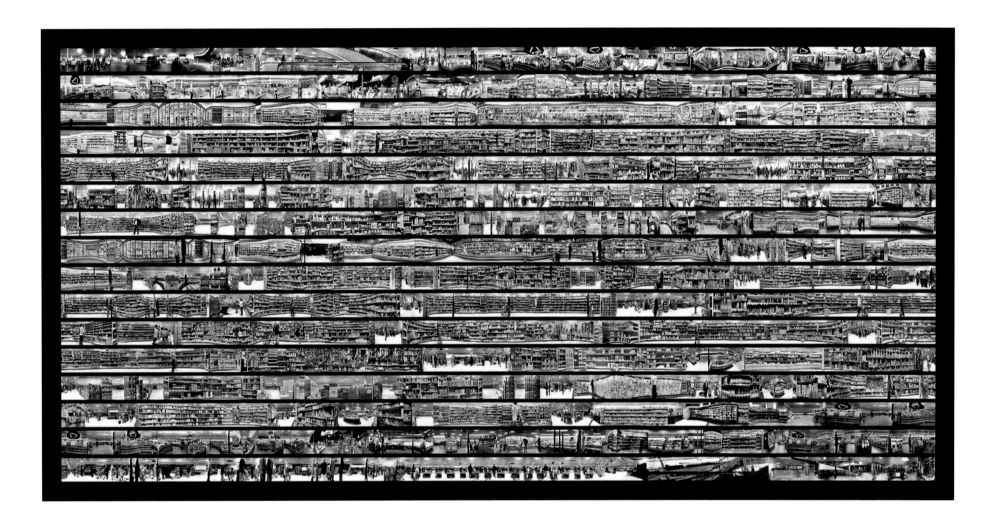

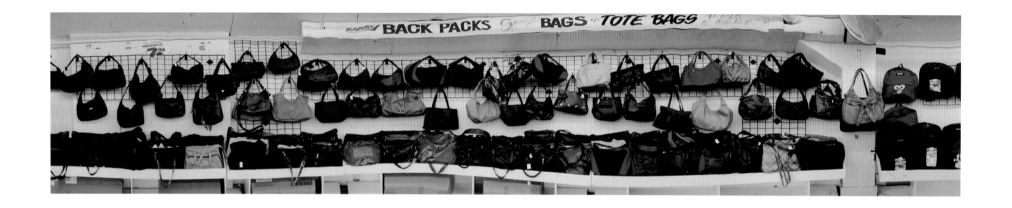

detail | *Honest Ed's Warehouse, Toronto,* 2014
chromogenic print
48 × 72 inches
edition of 8

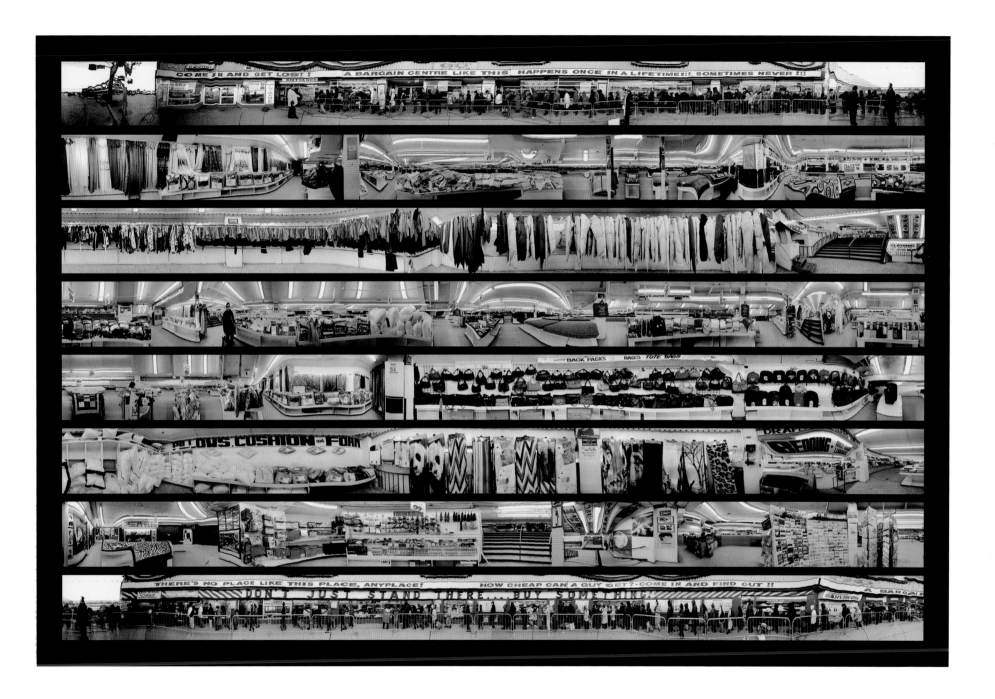

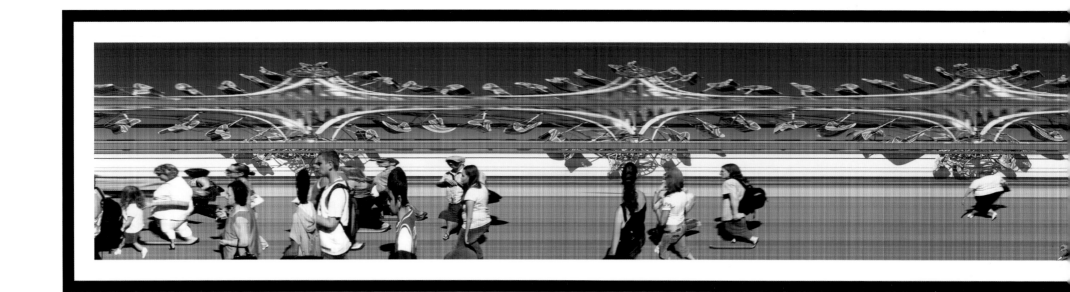

The Zipper, The Canadian National Exhibition, Toronto, 2006
chromogenic print
12 × 96 inches
edition of 8

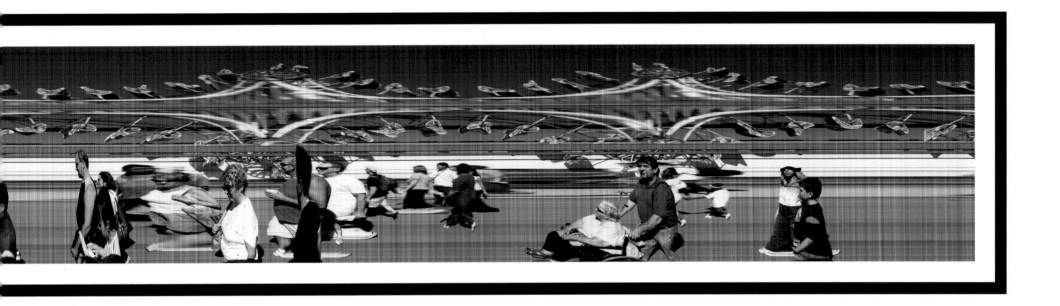

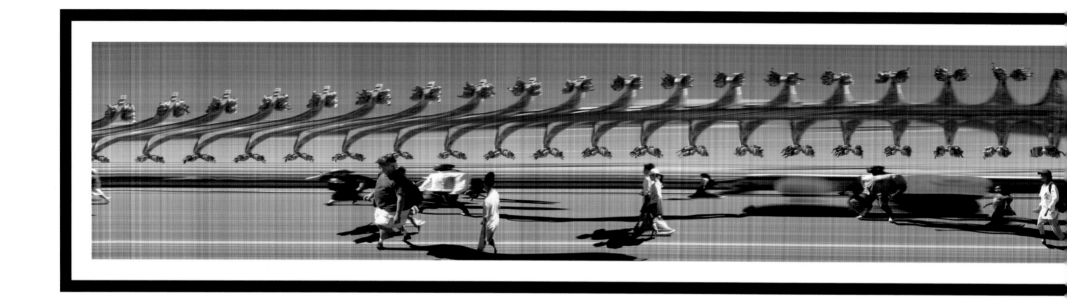

Powerflip, The Canadian National Exhibition, Toronto, 2006
chromogenic print
12 × 96 inches
edition of 8

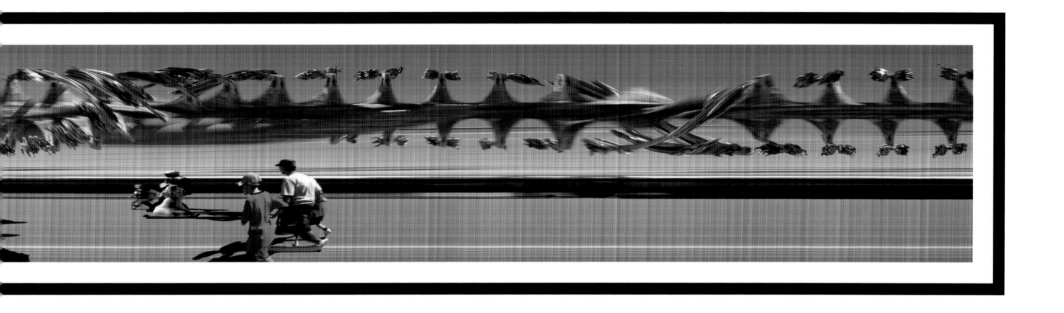

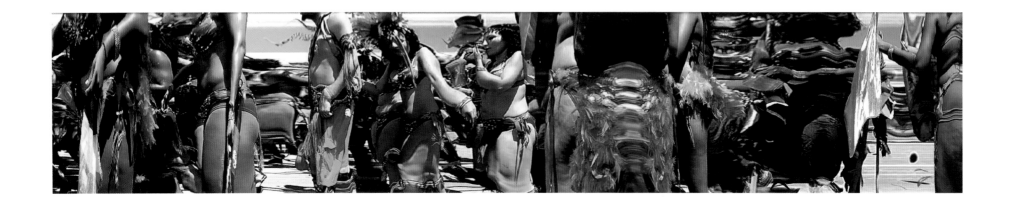

detail | *Caribbean Parade, Toronto,* 2013
chromogenic print
48 × 72 inches
edition of 8

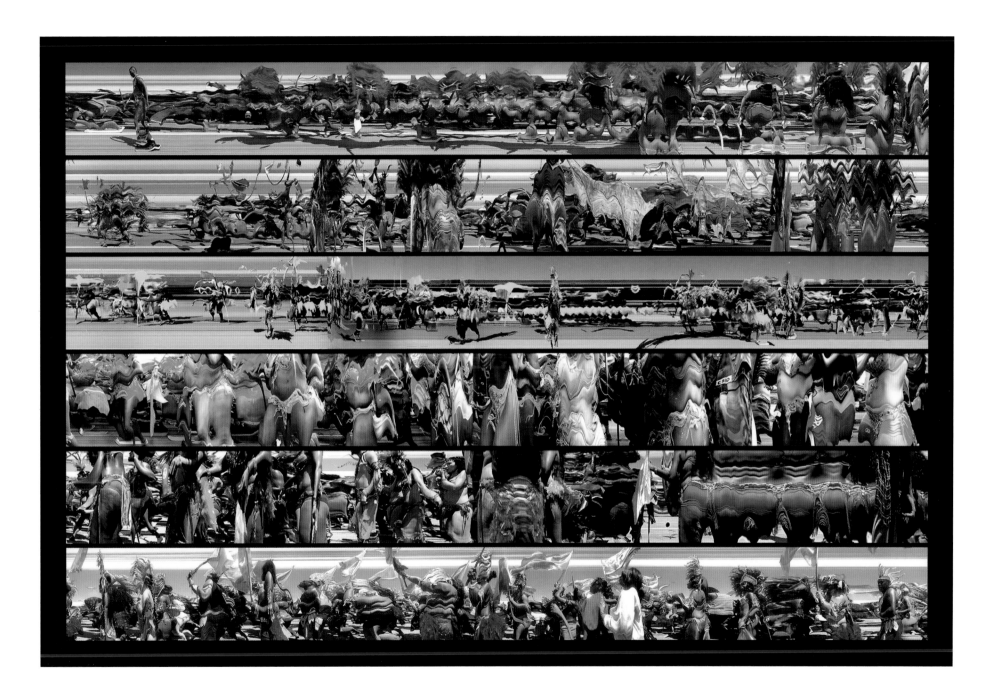

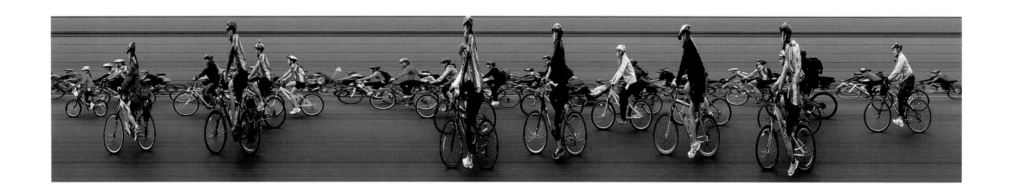

detail | *Bike-A-Thon, Toronto,* 2014
chromogenic print
44 × 48 inches
edition of 9

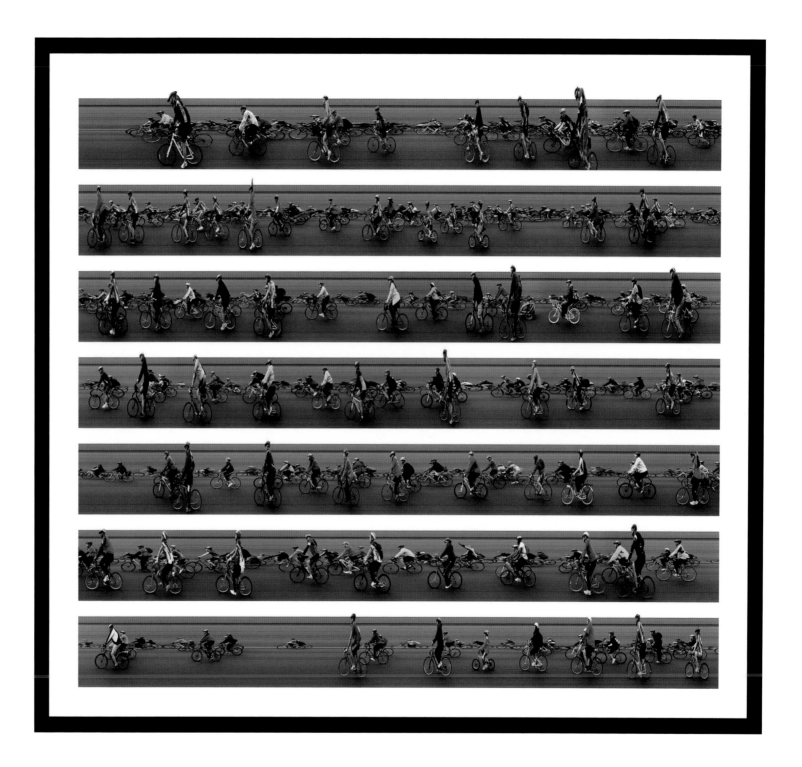

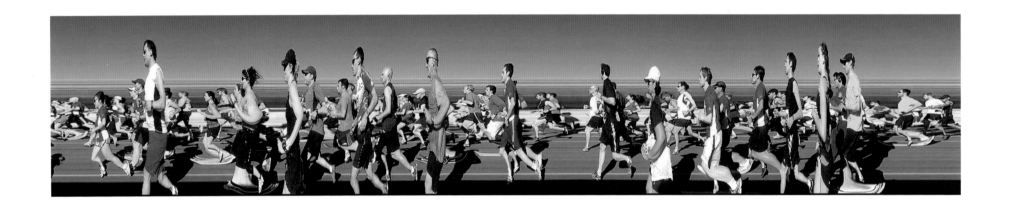

detail | *Toronto Marathon,* 2014
chromogenic print
48 × 72 inches
edition of 8

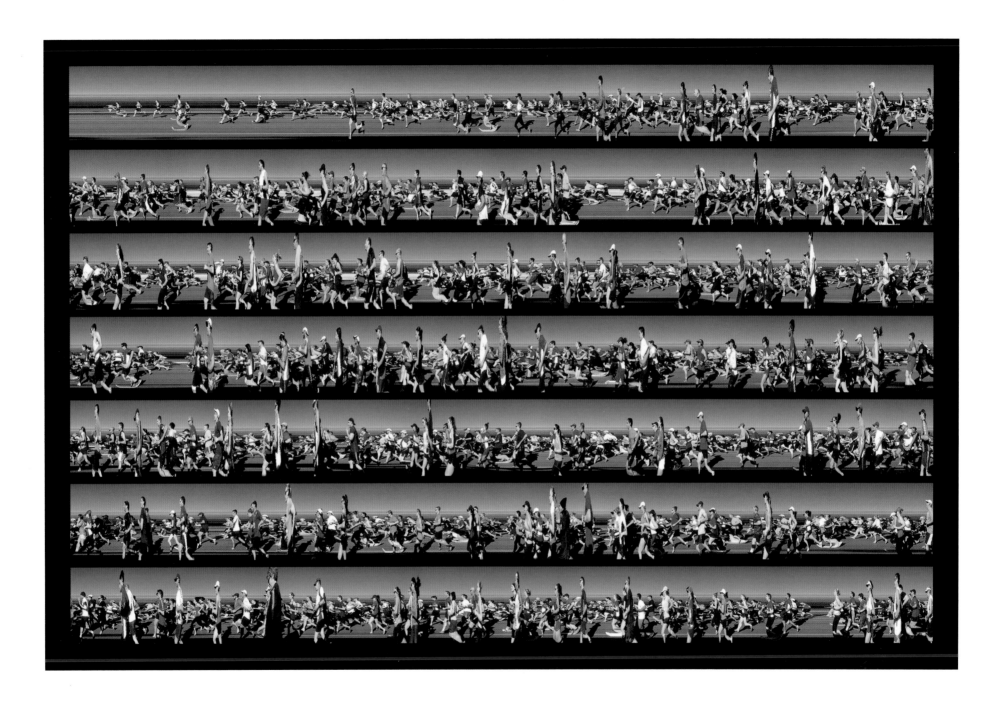

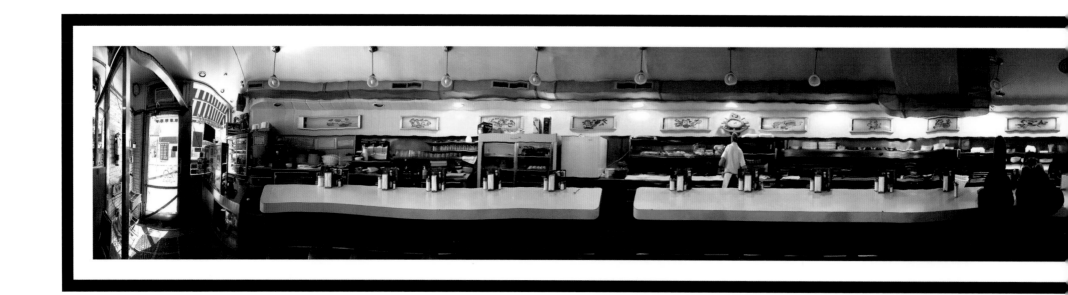

Mars Diner, Toronto, 2014
chromogenic print
12 × 96 inches
edition of 8

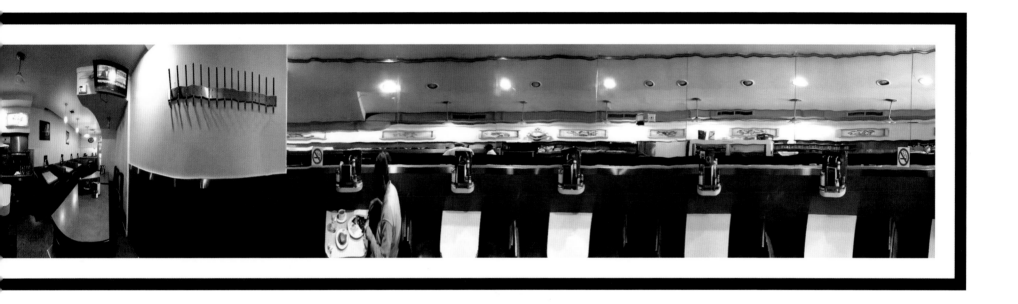

THE MOST IMPORTANT STUDIO EVER TAUGHT AT THE UNIVERSITY OF TORONTO'S SCHOOL OF ARCHITECTURE [AND THE ORIGINS OF MY VISUAL ART PRACTICE]

BY MICHAEL AWAD

I **studied architecture** from 1987 to 1992 at the University of Toronto. In 1990 I enrolled in an experimental design studio taught by professors Brian Boigon and Sanford Kwinter. More than 20 years later, I can trace important elements of my artistic and professional practices back to the events of that studio.

Training to become an architect was, and still is, based largely on simulation. A student is typically given a building site and a building program, with parameters that can be real or hypothetical—for example, a live / work house for a lawyer-and-musician couple with extended families on a site in a downtown residential neighbourhood. The professor acts as a mentor and / or client. A typical design process starts with an analysis of the site and the program, followed by conceptual design and design development, and ends with a final design proposal. Students are guided through a design process which closely approximates that used in professional offices. My education was divided into 10 such simulations, or design studios: studios 1 to 5 were mainly to build skills, studios 6 to 8 involved specialized buildings, and studios 9 and 10 formed a self-directed research thesis.

The vast majority of design studios at that time were conventional, but in the spring of 1990 one studio stood apart. Offered by Brain Boigon and Sanford Kwinter, Five Appliances in the Alphabetical City was an alternative architectural studio in which the site was a classroom, the client was the group of 16 students, and the program was "to establish a theoretical architecture in which thought too is seen as a diagrammatical act; assembling, deploying, relating, and dividing."

The specific expectations were threefold. First, we were to build a representational "city." Second, each student was required to create urban "appliances" which performed urban tasks. Finally, appliances were to be brought into the city to perform their tasks. The site was a classroom located in the studio on the 4th floor: a corner room, measuring roughly 25 feet square, with two walls of windows and high ceilings. The room was locked, all the participants had a key, and the studio was accessible 24 / 7.

There was one simple rule of city-building: Once an element was built, it was available to anyone else to modify, build upon, dismantle, or ignore. Each action was to be described in writing in a logbook, which would become the city's historical record. Each element was expected to have its own rationale and to contribute to the city in a particular way.

The first few objects built were removed from the room or completely dismantled by others and left on the floor as piles of parts. This continued for a couple of weeks. Even though much effort was spent creating city objects, there was little evidence of any tangible progress. The situation was

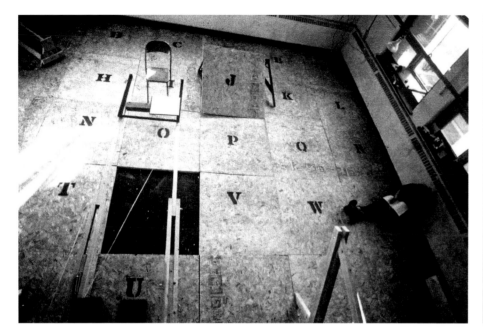

A) The Alphabetical City, 1990

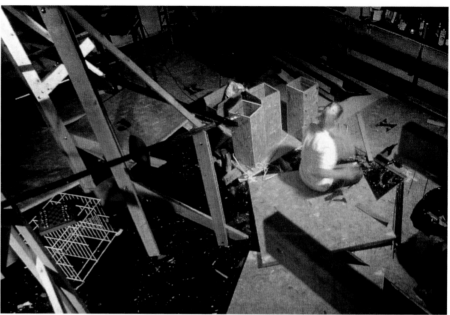

B) The Alphabetical City, 1990

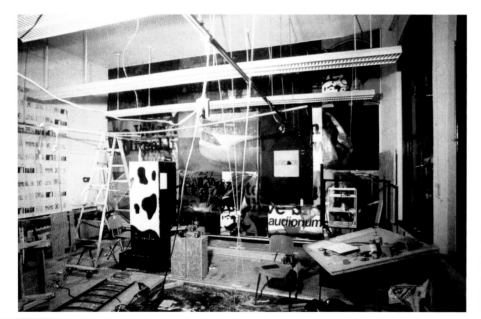

C) The Alphabetical City, 1990

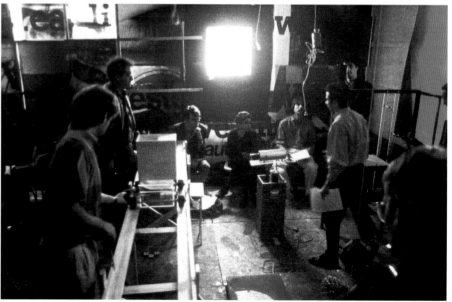

D) The Alphabetical City, Final Review 1990

becoming adversarial. Each designer had different ideas of how the city should be organized. Everyone wanted to claim authorship of the main principles of city organization, but the competitive atmosphere was obliterating the city as quickly as it was being built. After several weeks of city-building there was little to see and students were expressing serious concerns about the studio. That was when the experimental nature of the studio became clear.

Out of frustration or necessity—or both—alliances emerged. Relationships and groups formed among the students. Agreements were made, some visible and others secretive, to leave each other's elements alone or to act together against other elements. As suspicion and mistrust grew, the city began taking shape, the classroom filling with objects and infrastructure. The personally combative environment devolved into warring camps.

Change was constant and dramatic. A table and chair were brought in to represent a gathering place. They were reconfigured as an abstract, vertical, twisted sculpture which represented urban weather. A large black box with an upturned spotlight was installed to represent the justice system. Within a few days, as a sign of resistance, it was re-painted white with black cow spots. Walls of advertising were built over all the windows. These billboards soon attracted graffiti, and holes were cut to restore sunlight to the room. A wooden floor with text was created as both physical and poetic infrastructure. It was reconfigured into many unrelated objects, such as work surfaces and vertical partitions. Private spaces were created and then dismantled. Objects originally build to

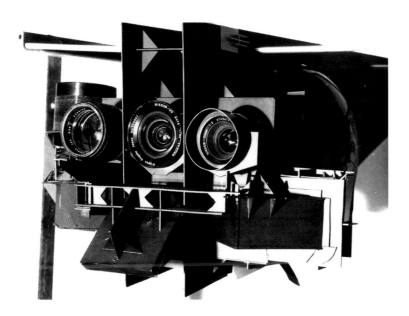

E) The Lens Helmet Appliance,
Alphabetical City, 1990

sit on the floor were suspended upside down from the ceiling. Several objects disappeared completely, only to be found later in other parts of the school or outside. There was at least one secret romance, and one sexual conversion.

As the room continued to fill, animosity between groups of participants grew. So too did the scope and impact of our activities. Oversized power tools, homemade electrical components, and questionable DIY wiring were all used. Electrical breakers were continuously tripped, causing studio-wide blackouts which disrupted other students. There was a flood that caused damage to the studio floor and almost daily acts of vandalism. The school's administration began hearing complaints of dubious and disruptive activities by the Alphabetical City studio from other instructors and students.

Then, there was an act of arson. The student responsible was suspended. The dean of the school threatened to end the studio, but was convinced otherwise by Boigon and Kwinter.

A studio meeting was hastily called. The professors expressed serious doubt about the final outcome of the project and implored everyone to act responsibly, but not respectfully. They clearly did not want to undermine the subversive ecosystem of the studio.

Then Boigon and Kwinter quietly enlisted several students, who were showing leadership within the city, to act as monitors. They requested advance reports of potential conflicts so that steps could be taken to prevent further administrative scrutiny. This was a turning point: the professors had been co-opted by their own experiment.

In the final review, with several professors in attendance, the entire room was activated. Image projectors spun like robotic spotlights out of control. A small railway train carried a load of poetry back and forth on a closed-loop track. The hot water radiator system was hacked: hoses were connected and outflowing water was coloured with pigment and pumped outside to run down the side of the building, resulting in a large green stain on the façade of the school of architecture. When the justice machine was turned on there was a flash of light and smoke. Apparently, someone had re-wired it to fail in a very public manner.

My "appliance" was a vision device worn over the head. The apparatus was a motorcycle helmet modified by the addition of six lens. Each lens produced a different image of the world, looking left and right, up and down, close and far. All six images were projected onto a screen inside the helmet in real time. The helmet acted as a visual collector to intensify the urban landscape. It visually eliminated empty interstitial space. The goal was to transform the sensory overload of multiple vantage points into an intelligible experience.

I wore the helmet in public only once. It made walking through the city a challenge since some of the imagery was upside down and backwards. It drew expressions of confusion, and alarm, from passersby. The experience was disorienting and dangerous. Only one professor was brave enough to try on the helmet during the final review. Kwinter, after taking only three steps, demanded that "someone get this thing off my head!!!"

Although the experience inside the helmet was very confusing, the concept of moving through the city and observing urban life from every direction resonated with the review committee. Subsequently, this idea became The Entire City Project and the central concept of my artistic practice. The project now employs a wide array of photographic techniques and equipment: film and digital, custom-built cameras, and custom imaging software. Unlike Google's streetview, which was started many years later, The Entire City Project is a cultural reflection on urban life. It is dedicated to capturing all aspects of Toronto's daily life—all its special events, all its public and private spaces, all its residences.

Most schools of architecture still rely heavily on the outdated model of the master–student relationship. The Alphabetical City was dysfunctional, a bit dangerous, but truly innovative, because it did not simulate a sanitized design process. Instead, it flung a group of strong-willed students with big ideas into a highly charged environment. Boigon and Kwinter employed the same techniques as military basic training. Stress and hardship were applied to break the individual's independent spirit, and their confidence was then rebuilt as a member of a team. Groups self-organized around strong individuals, but personal initiative was still expected and celebrated. In a competitive environment, within a very limited space, the only way to express your personal creativity was to first build relationships. Even though the studio had strong theoretical underpinnings, it was the most tangible of any design studio taught at the school. Individual failures eventually lead to collective success.

I consider the final assessment of my work to be one of the pinnacles of a 12-year student career. The Alphabetical City studio generated the conceptual foundation of my visual art practice and established research methodologies I used in three provocative thesis projects under professors John Shnier, Thomas Schumacher, and Rolophe el-Koury. Additionally, and most importantly, the Boigon / Kwinter studio defined professional methodologies, which I employ to this day.

In the end, the 16 participants felt they had not simply learned, but survived. Some were much closer, others deeply divided, but everyone was enriched by the experience. Six weeks after the students dismantled the

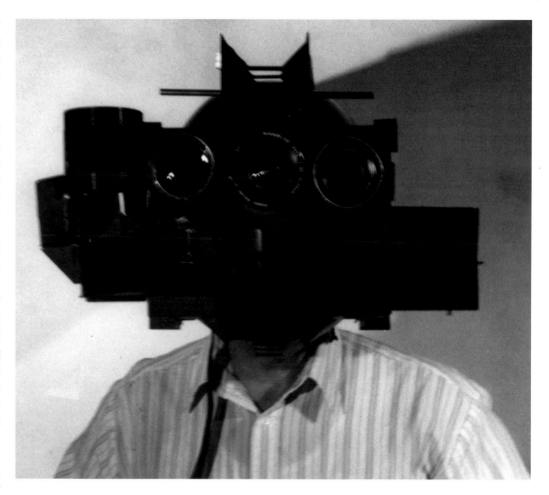

F) The Lens Helmet Appliance, Alphabetical City, 1990

Alphabetical City, the university dismantled the host classroom. All physical traces of the experiment were discarded. To this day no other design studio has taken such academic risk, or had such personal impact on its students. Boigon and Kwinter should be applauded for their pedagogical experimentation and praised for taking such risks with their own academic careers. By colliding ego, creativity, and competition, the studio became a microcosm of the real design world. In retrospect, I wonder if the intent was to design a city, or to stage an experiment in sociology.

The Alphabetical City studio generated the fundamental principles of my art. To this day, I continue to experiment with lenses, cameras, capture techniques, and all sorts of vision apparatus in my ongoing practice to capture this city in its entirety.

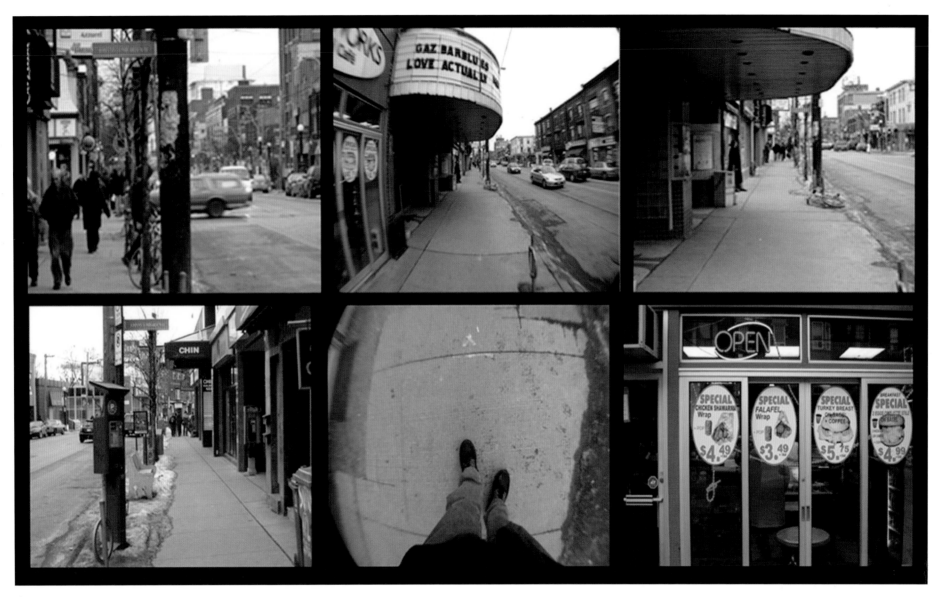

G) The Lens Helmet
Video stills
Appliance, view from inside,
1990

ROYAL ONTARIO MUSEUM

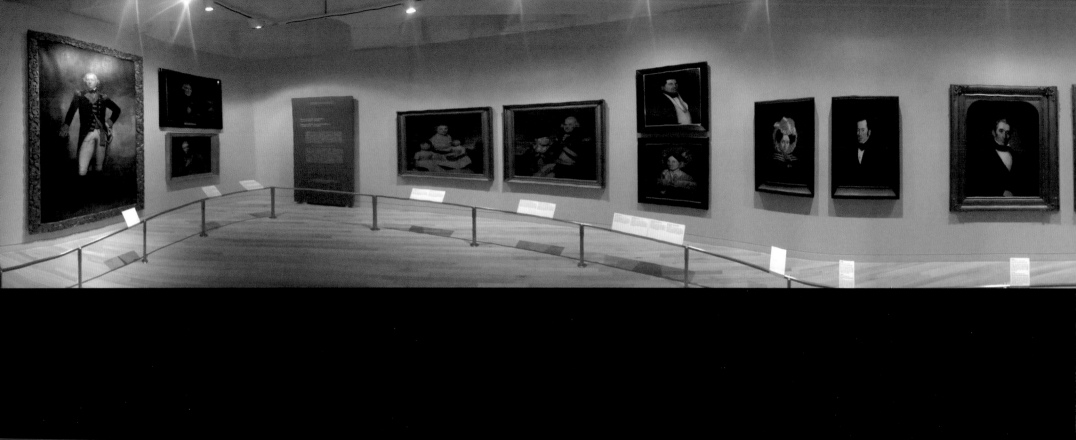

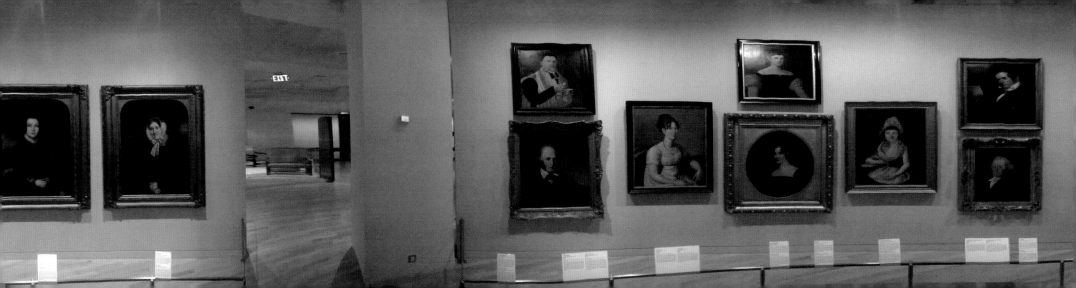

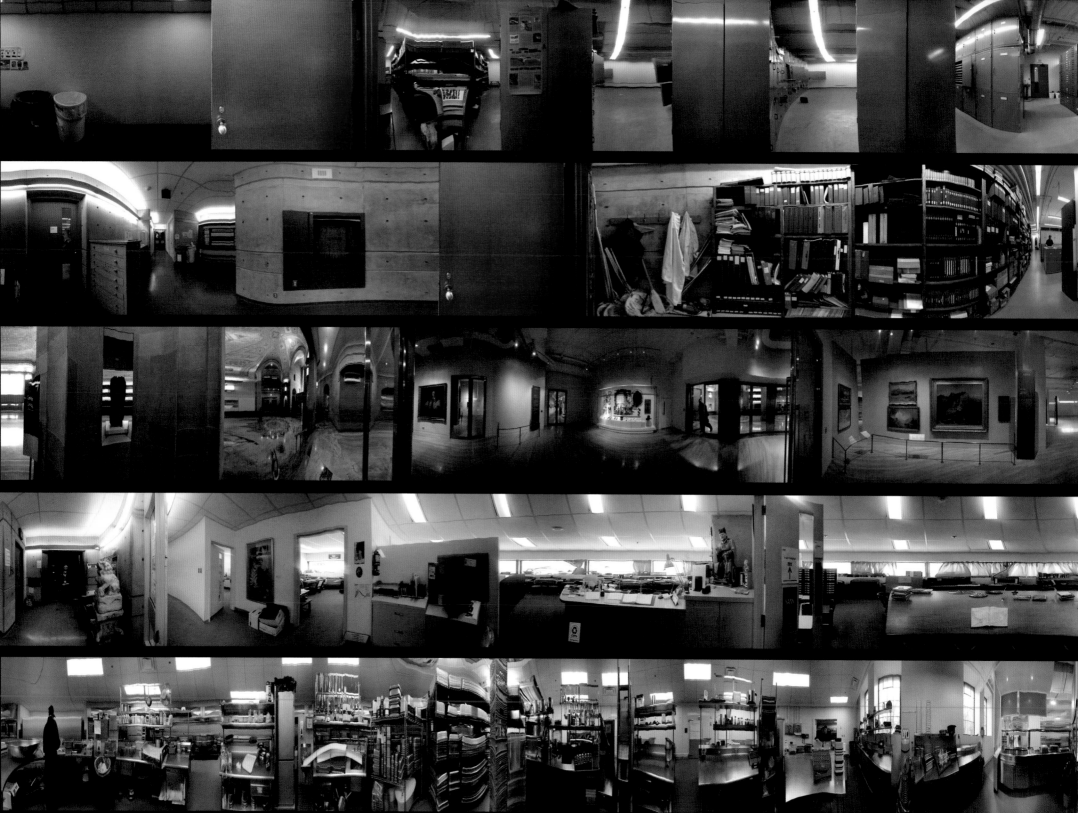

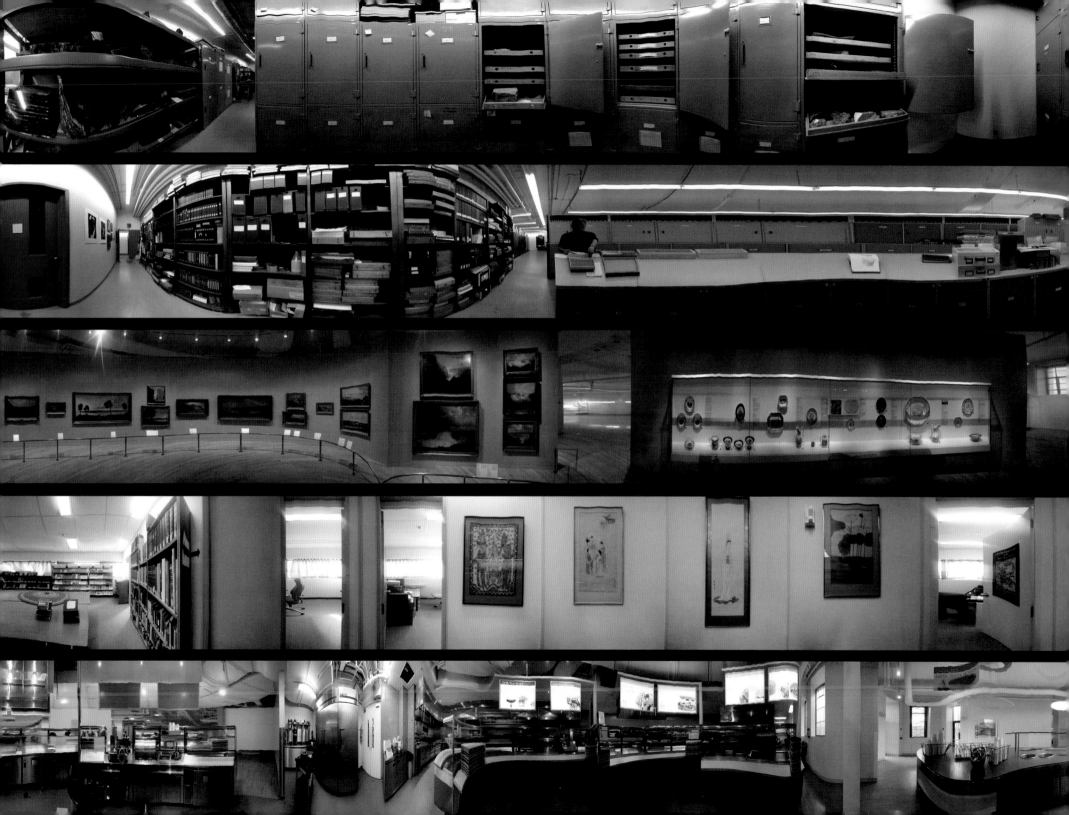

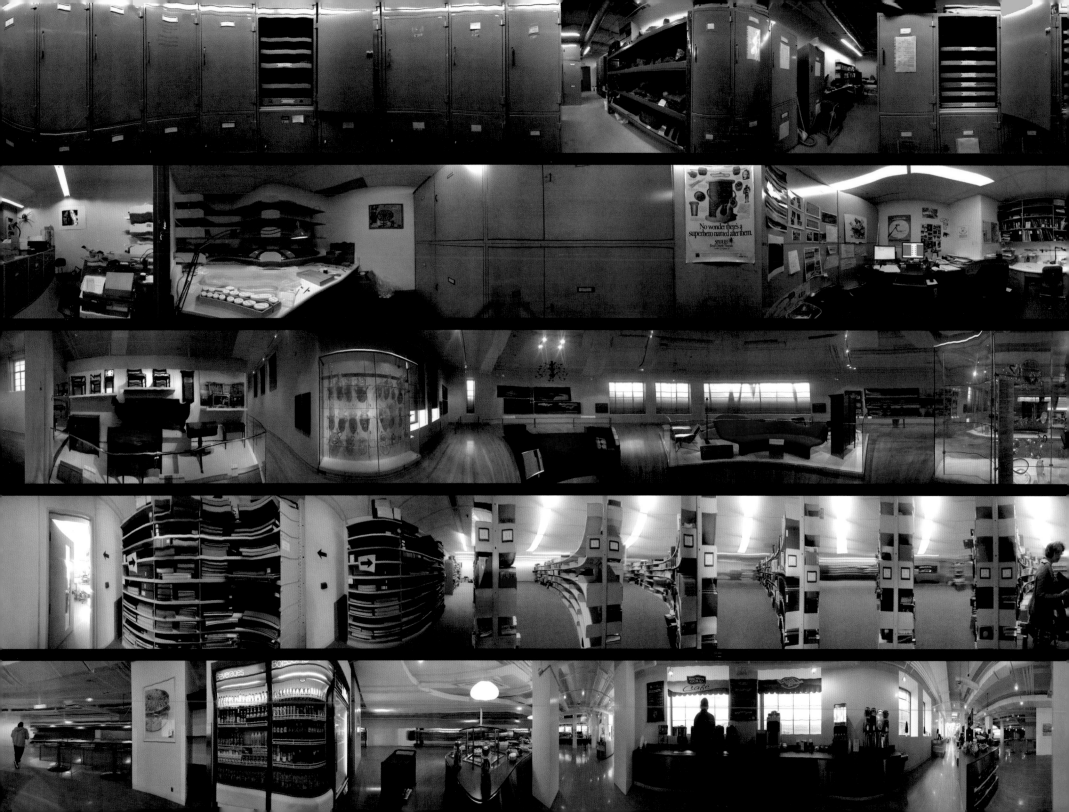

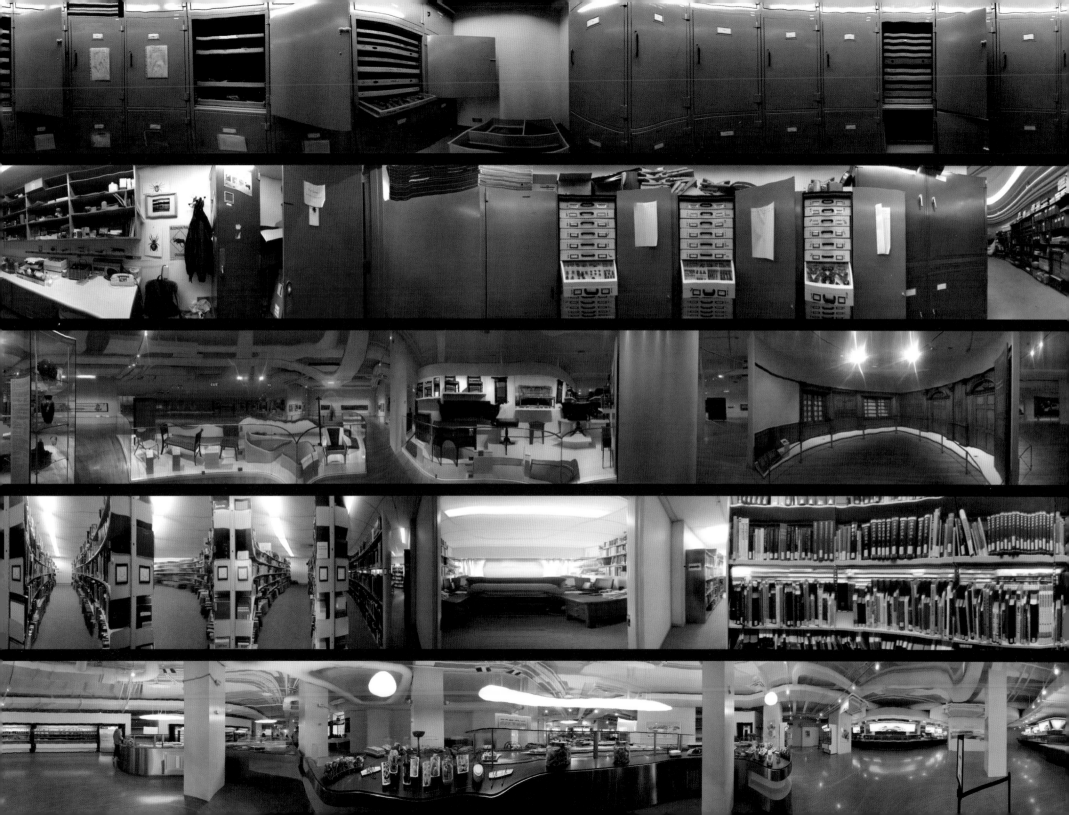

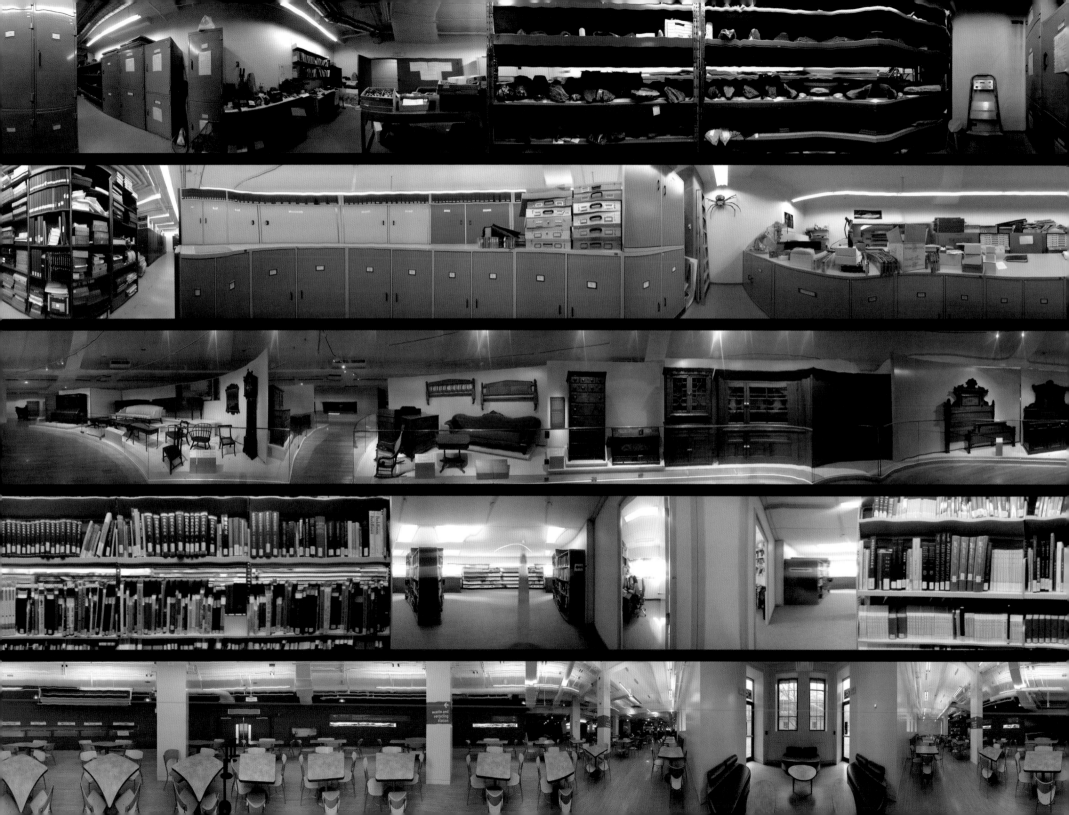

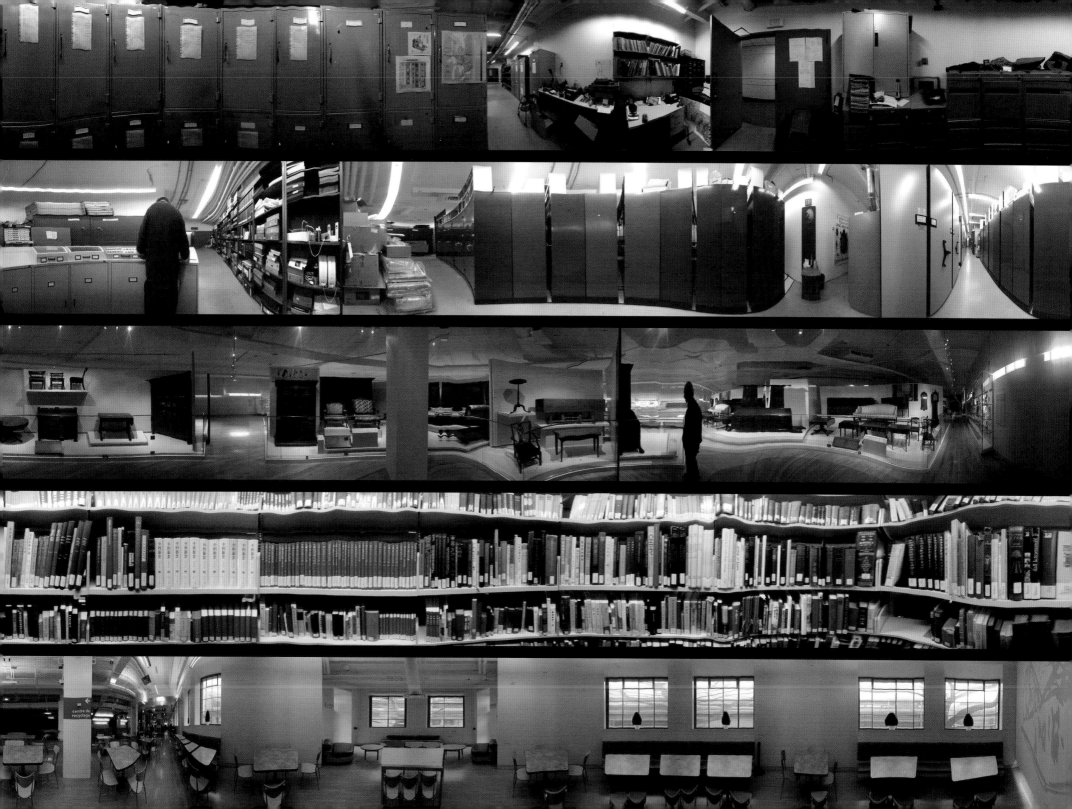

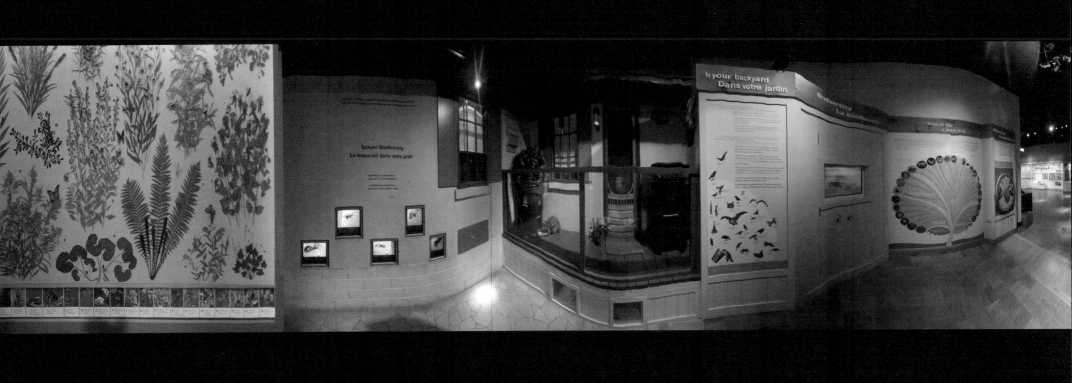

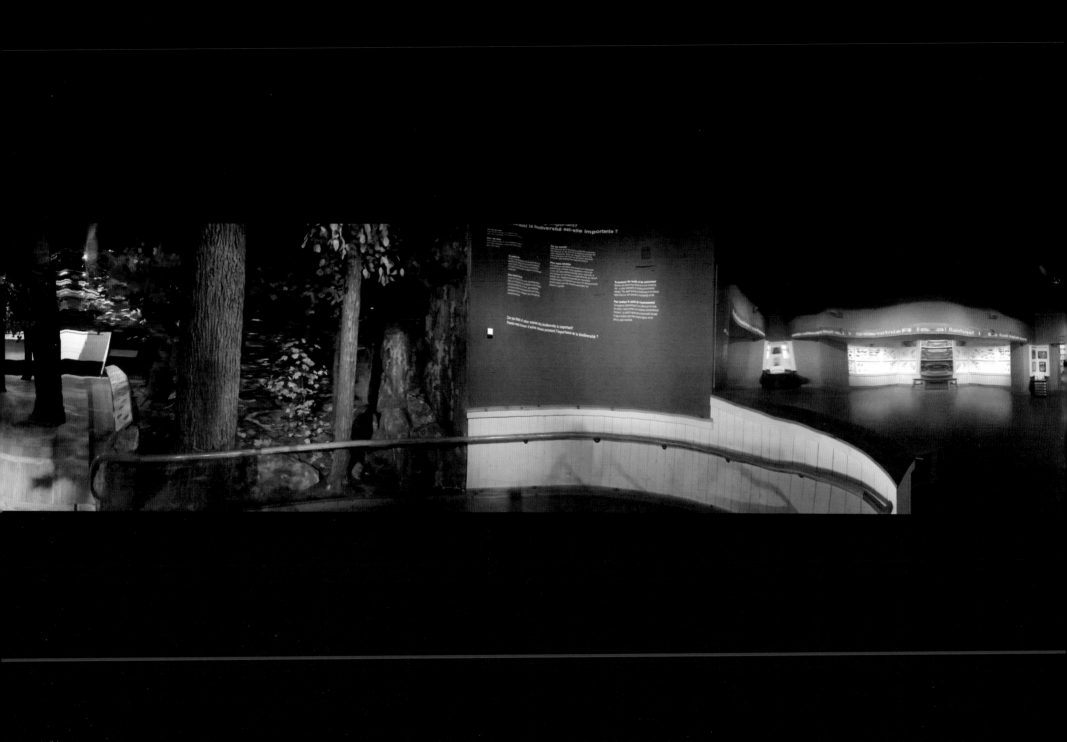

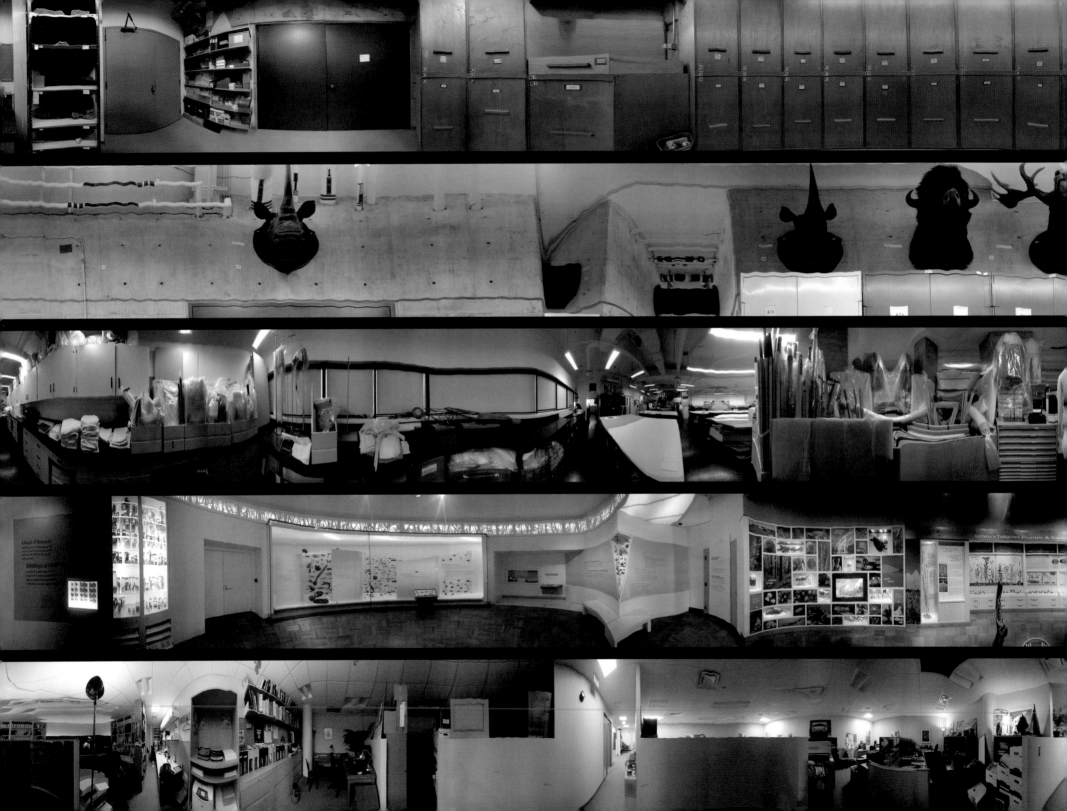

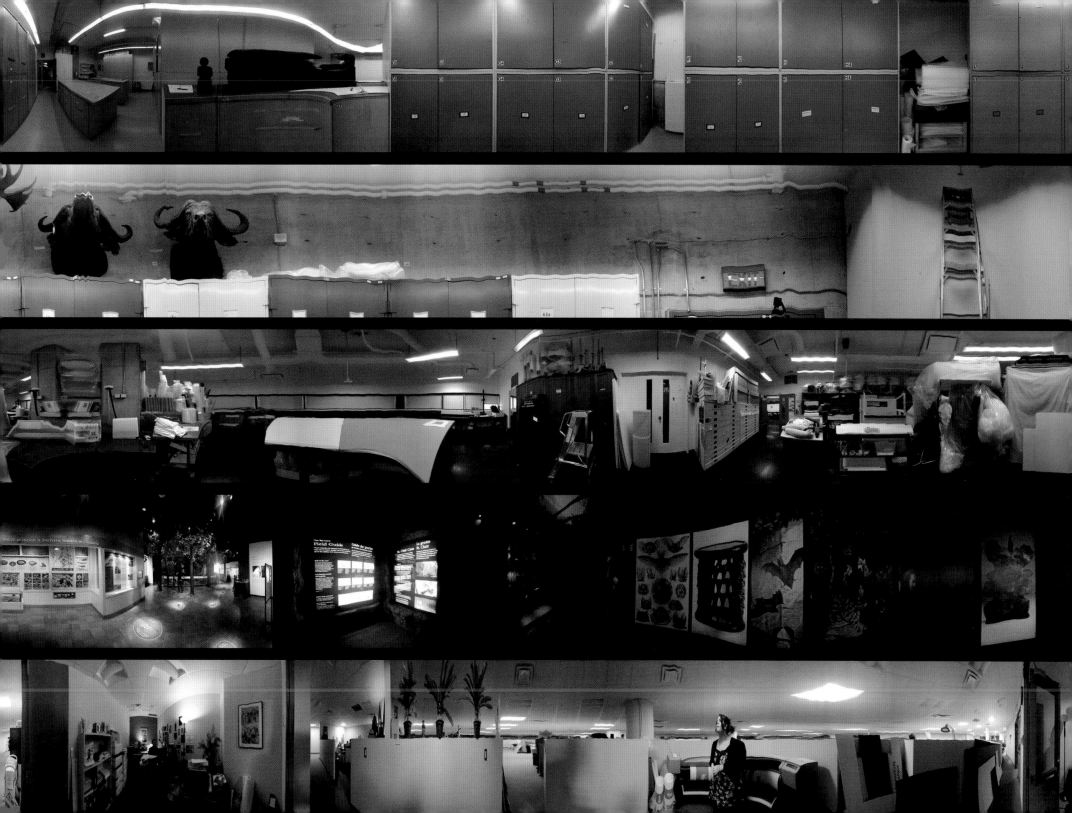

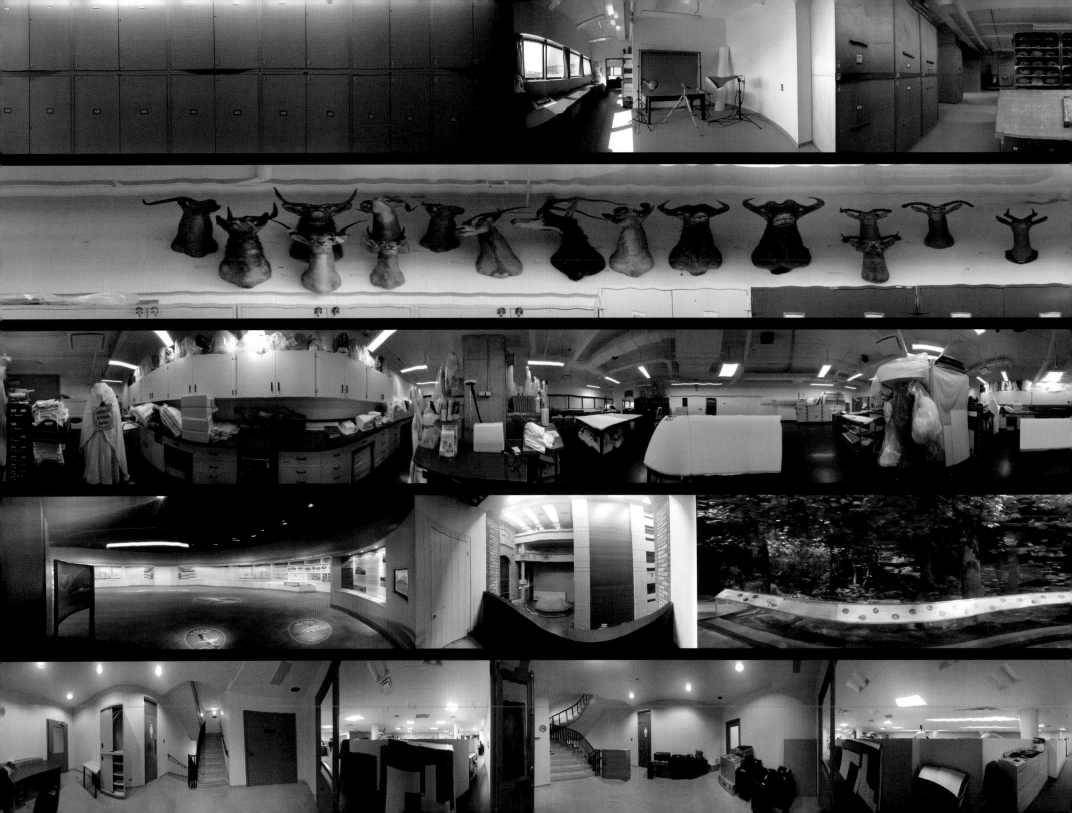

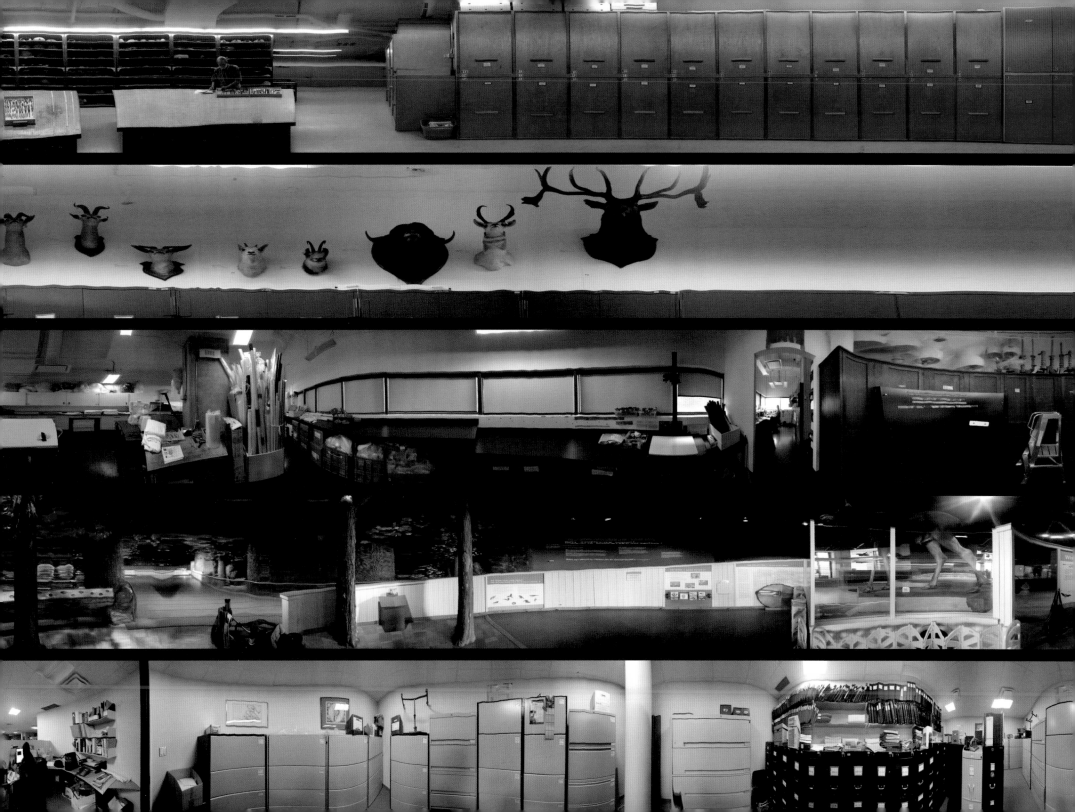

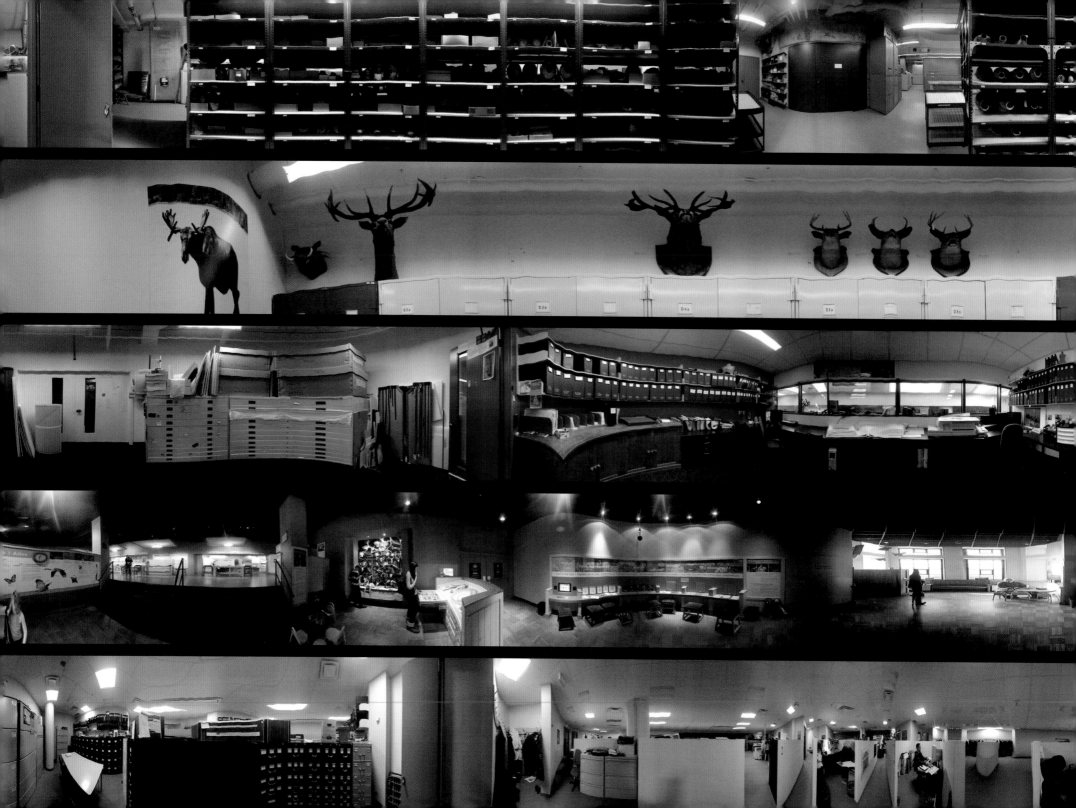

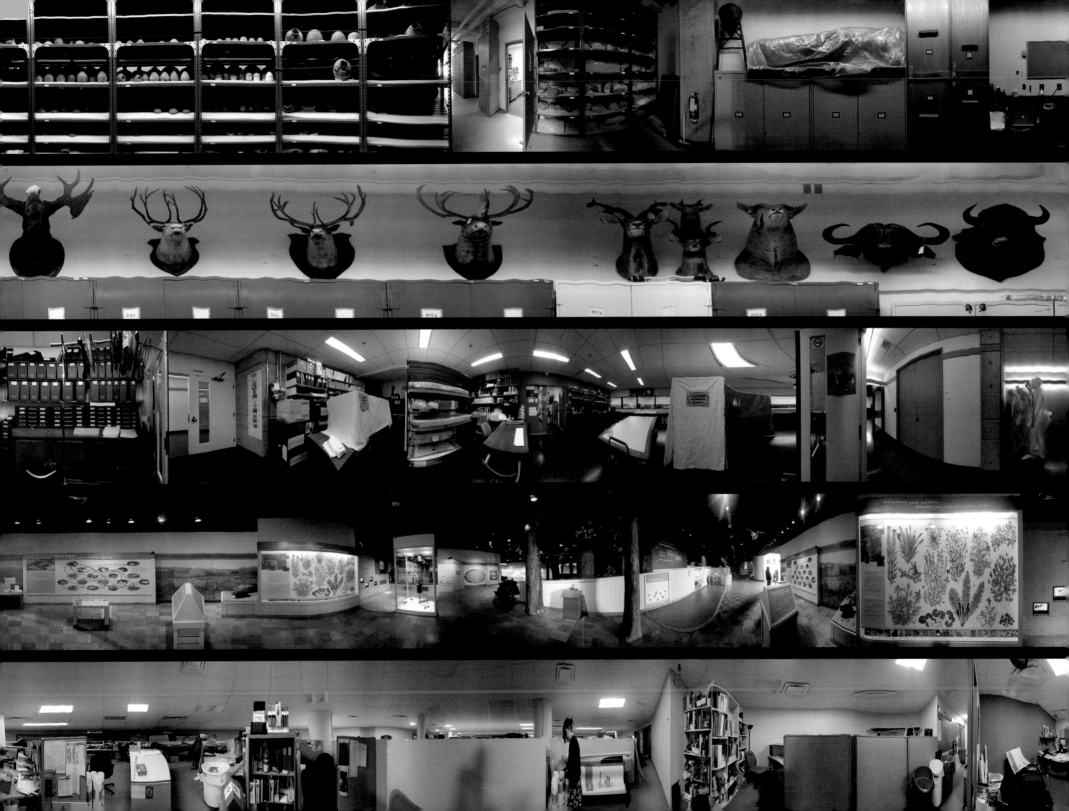

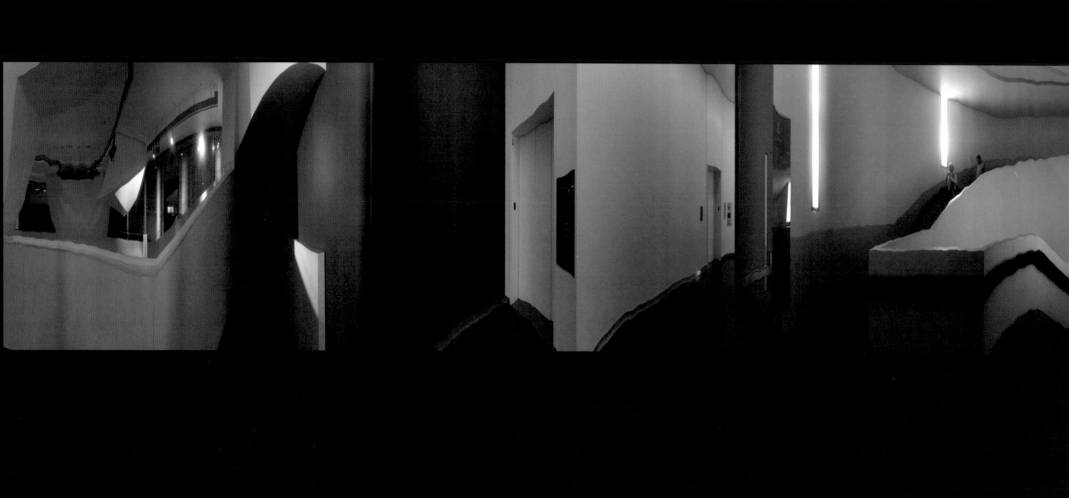

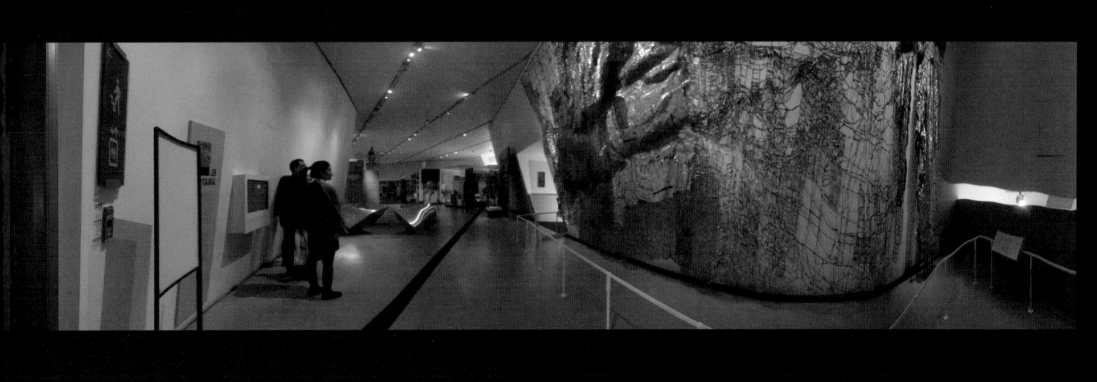

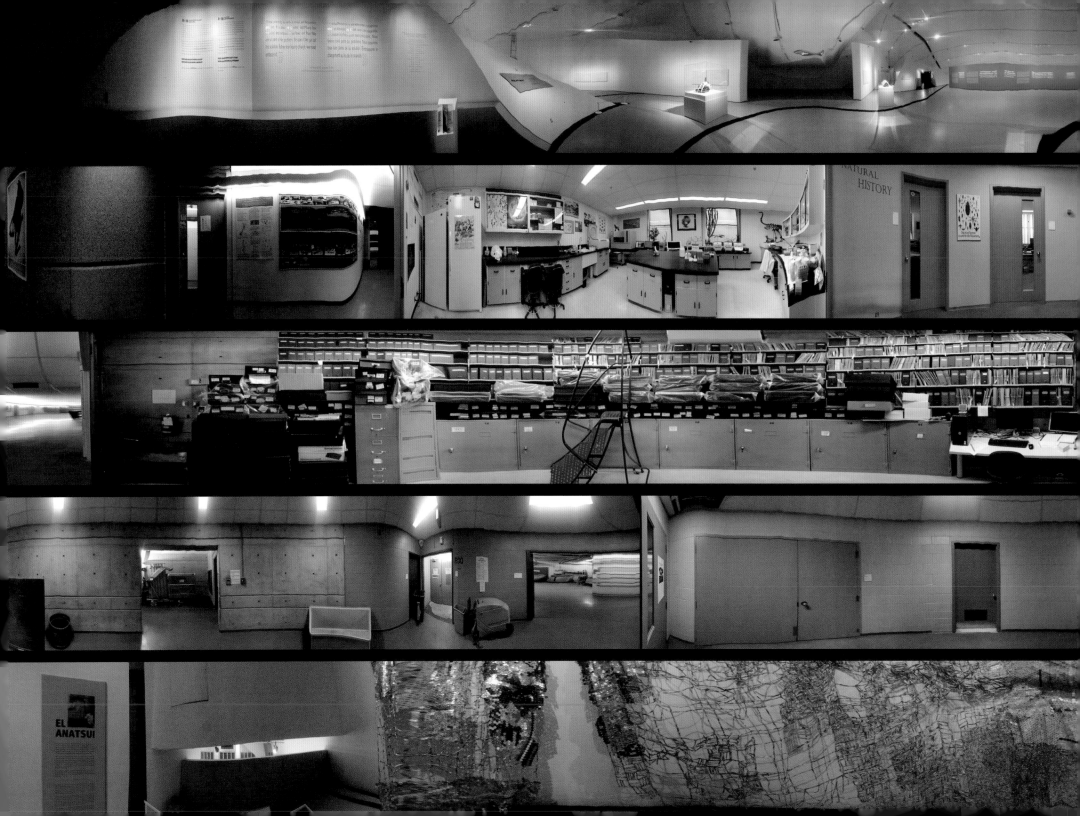

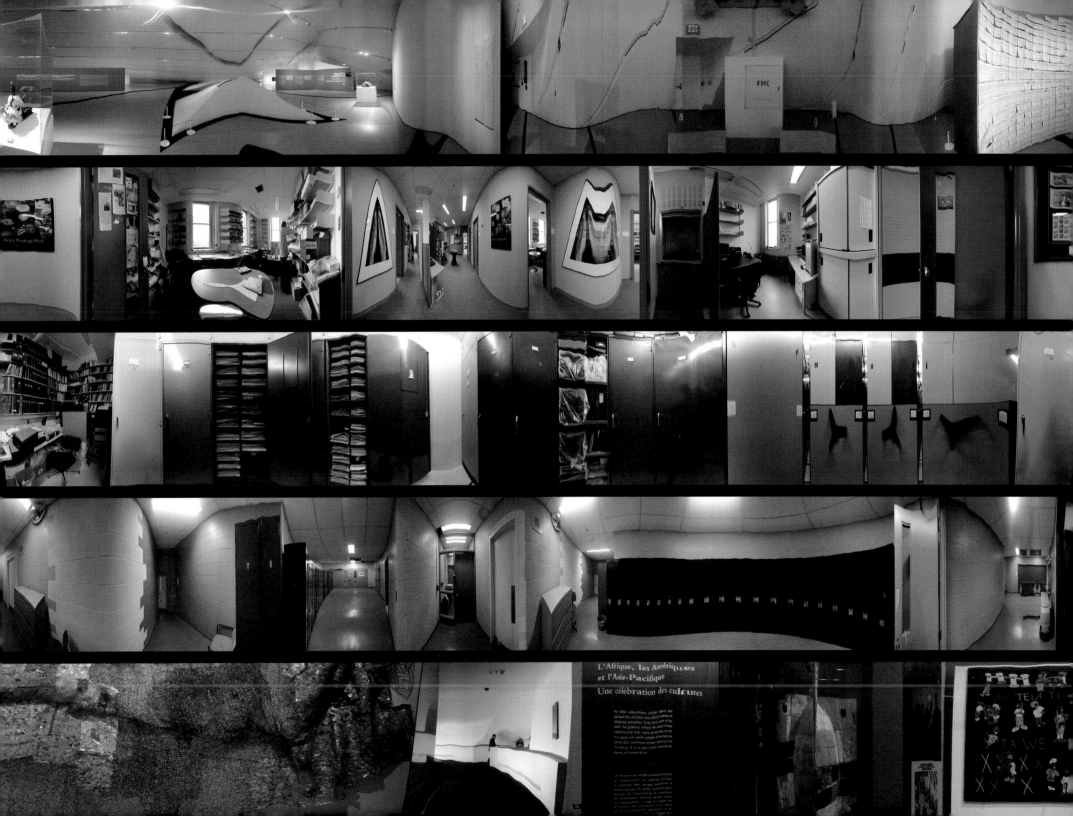

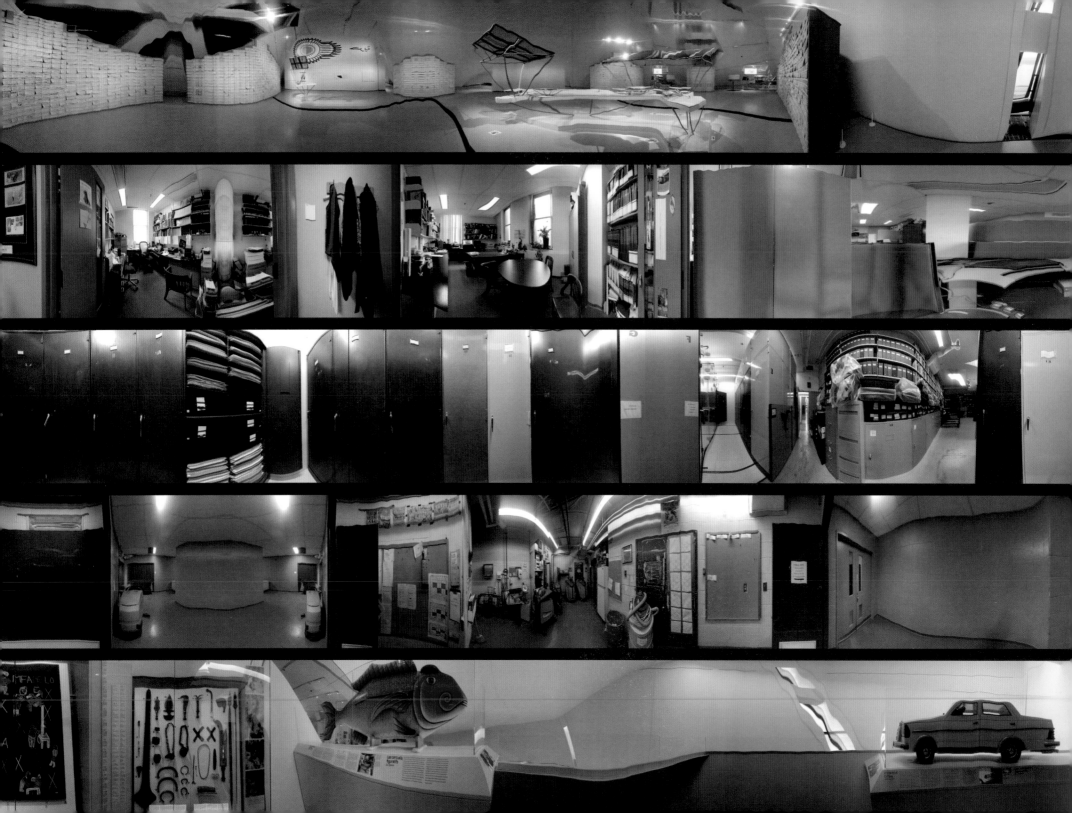

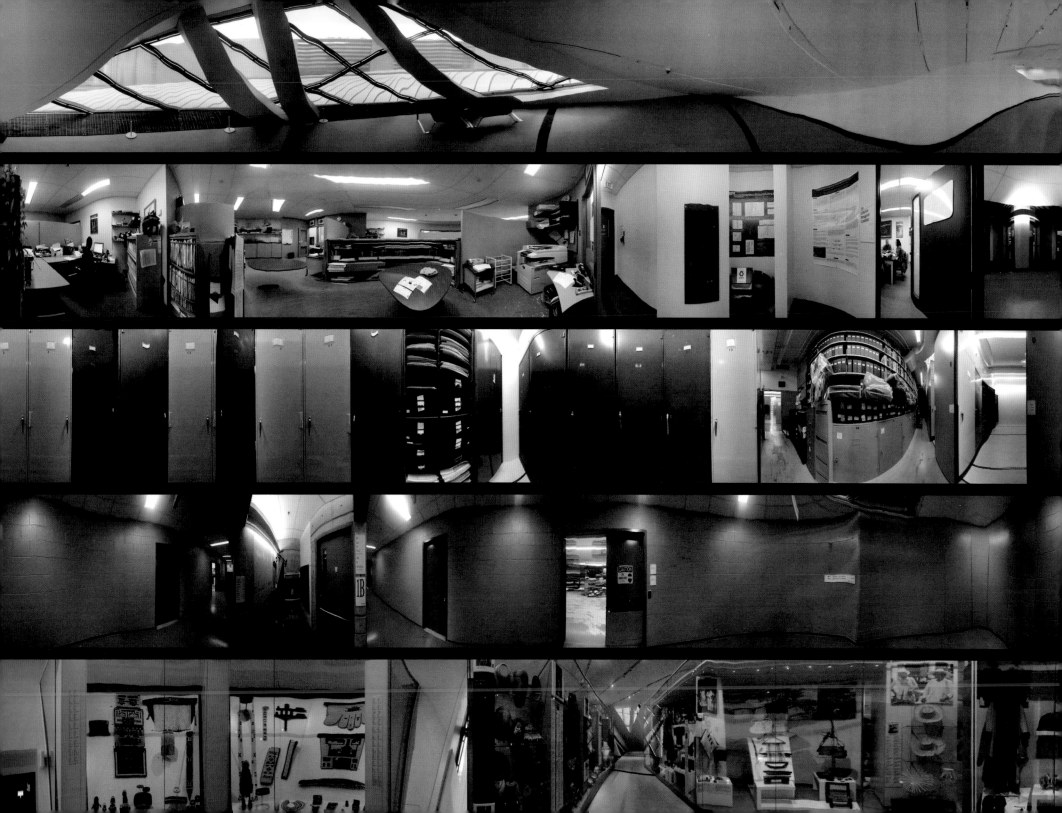

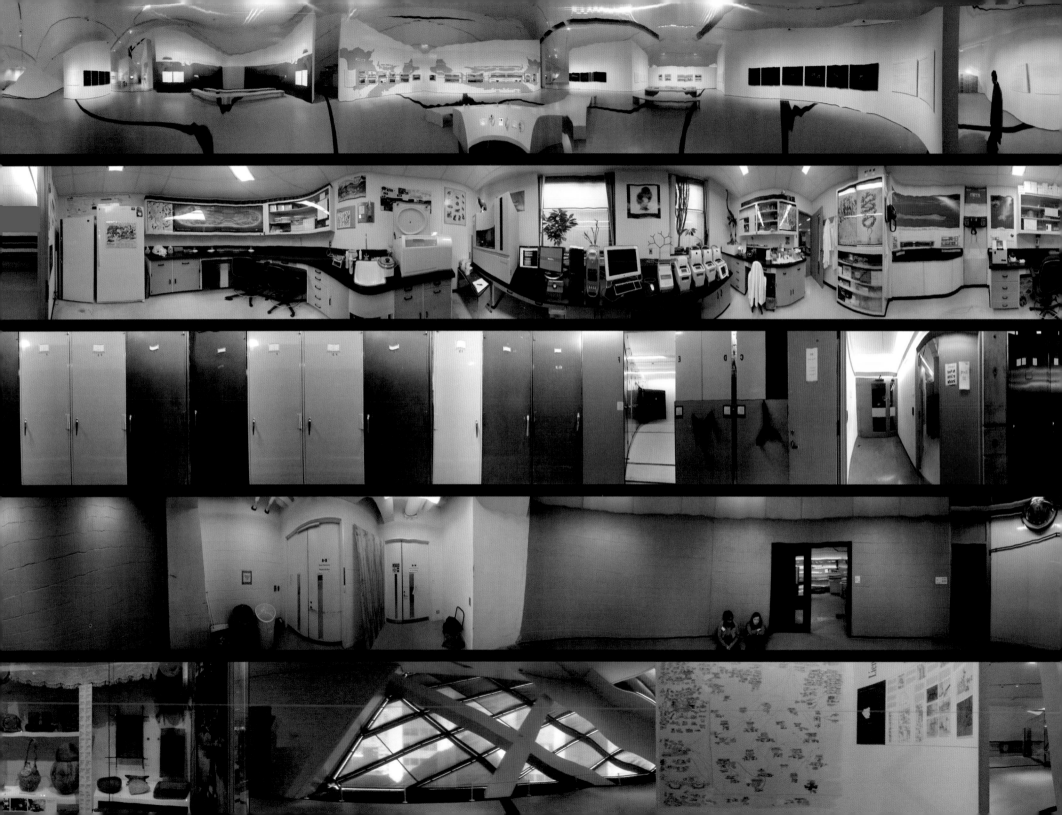

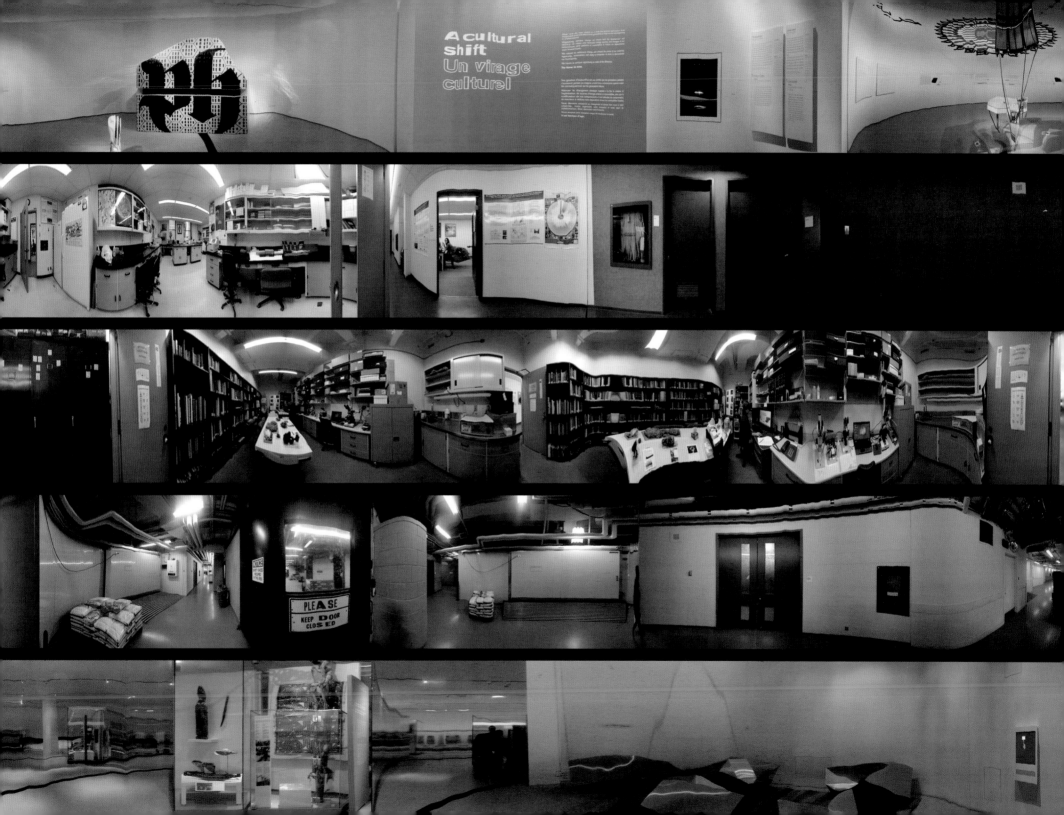

A cultural
shift
Un virage
culturel

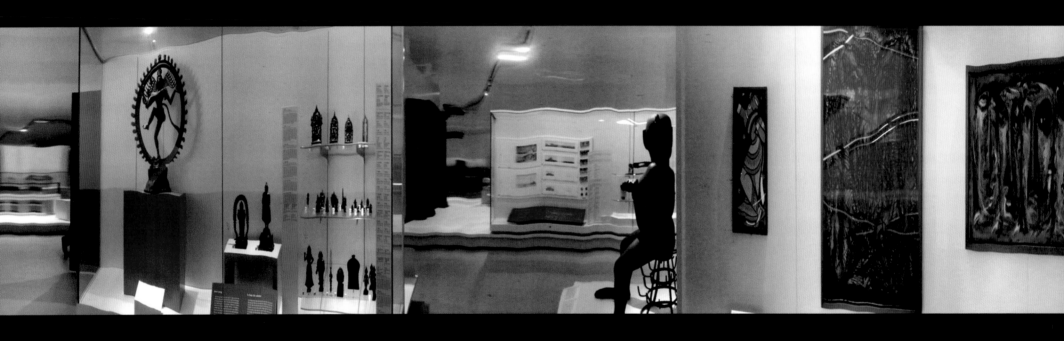

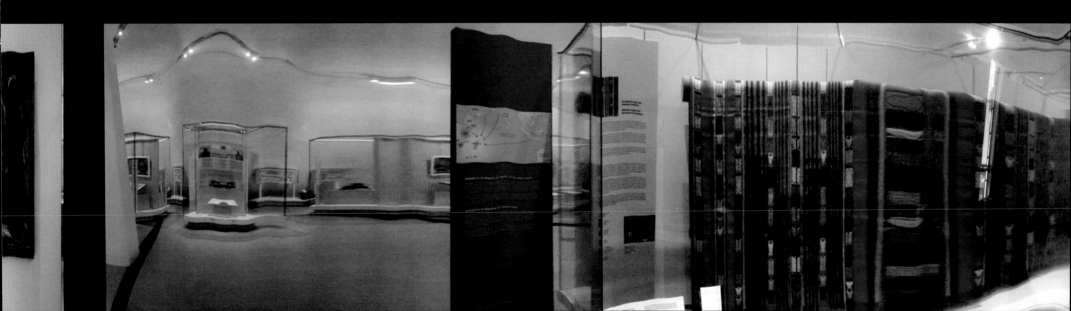

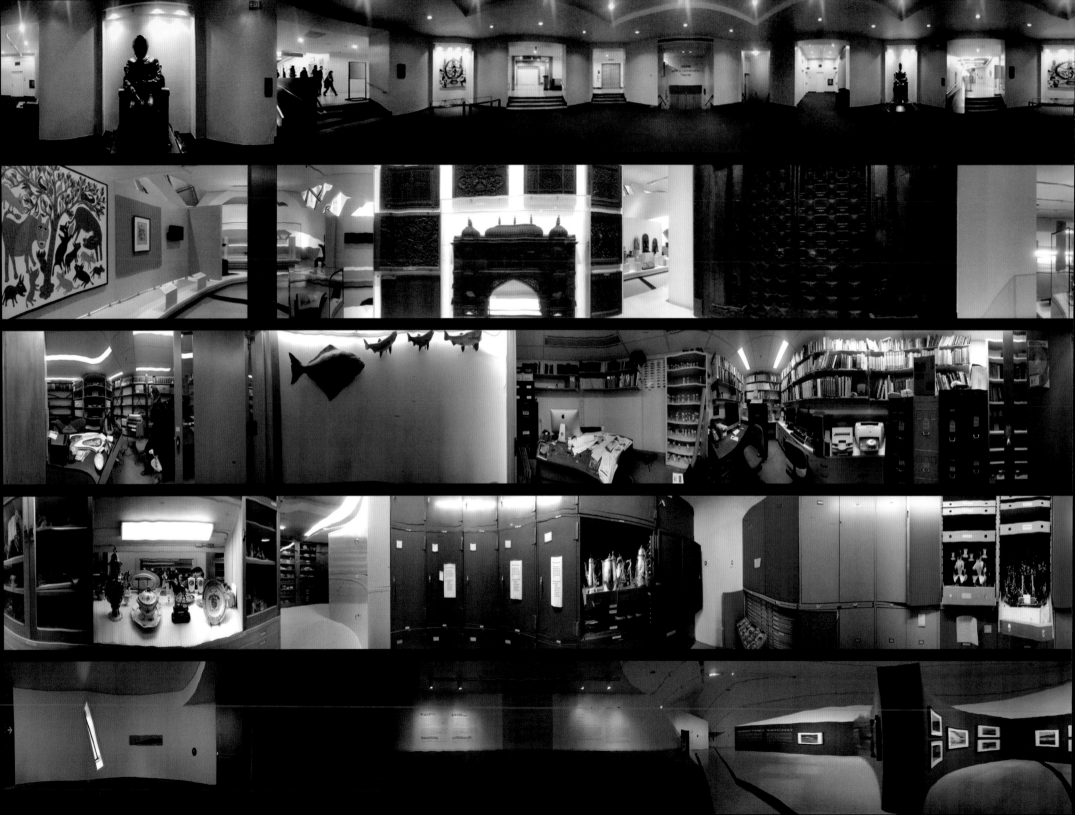

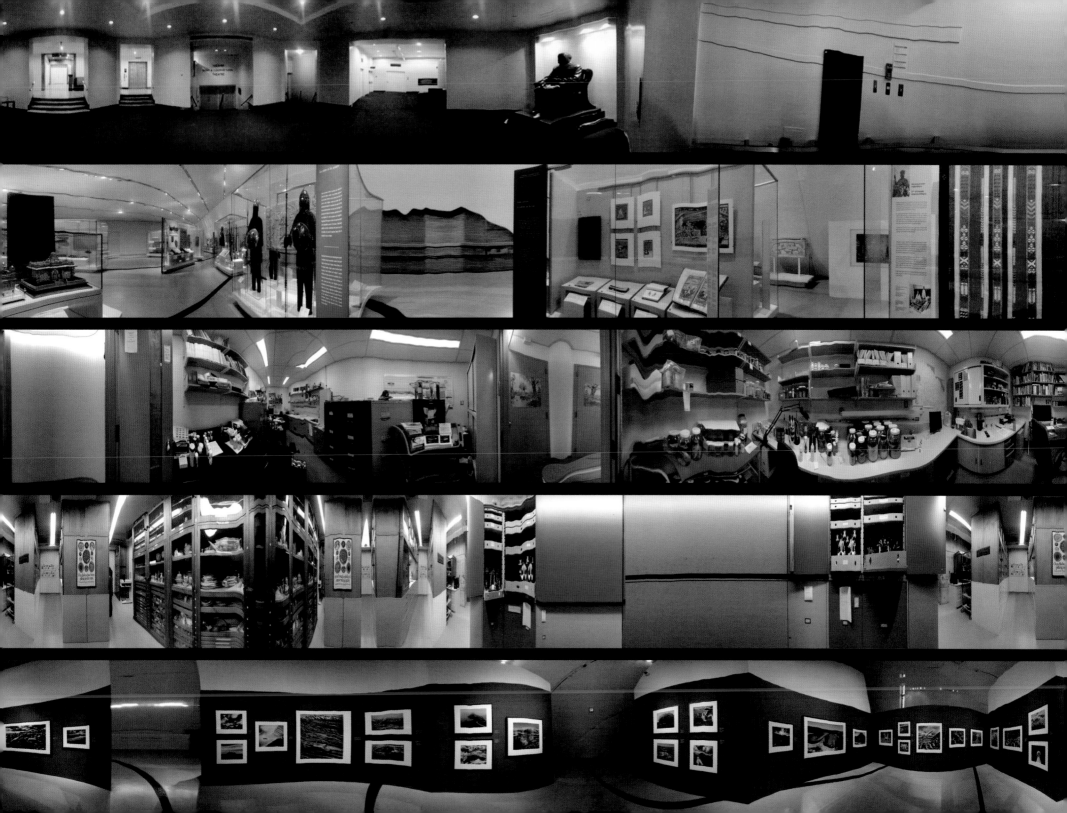

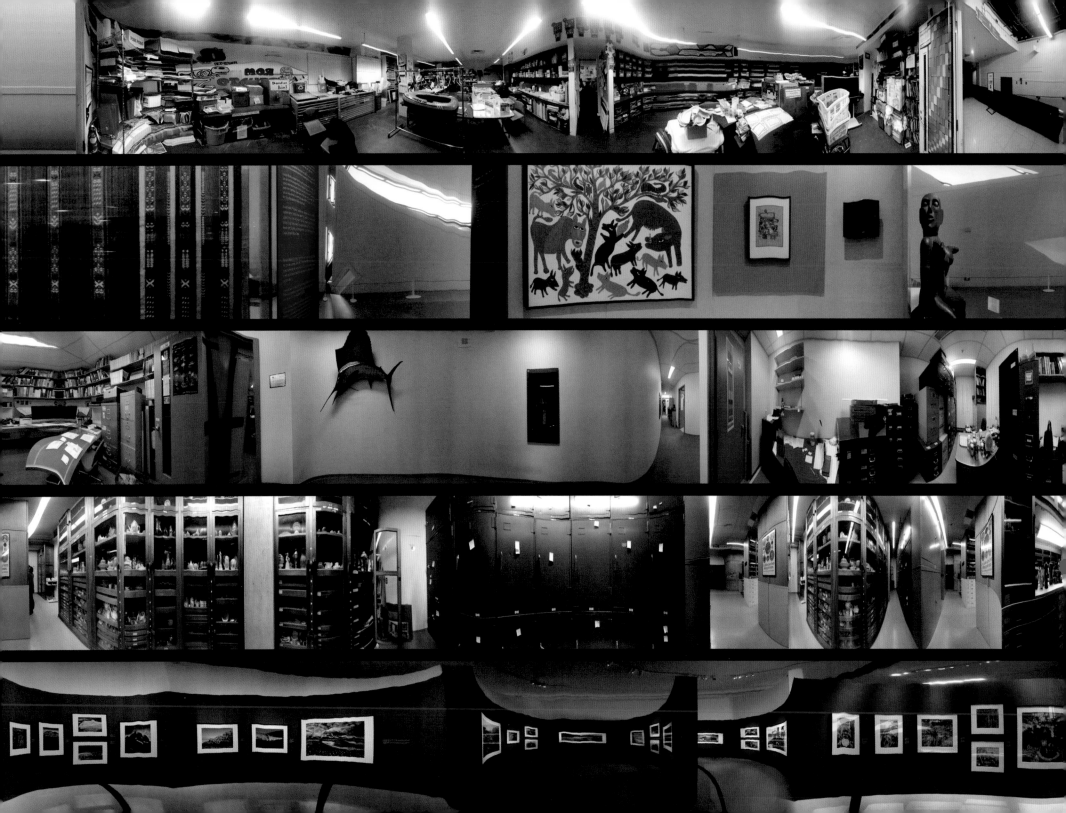

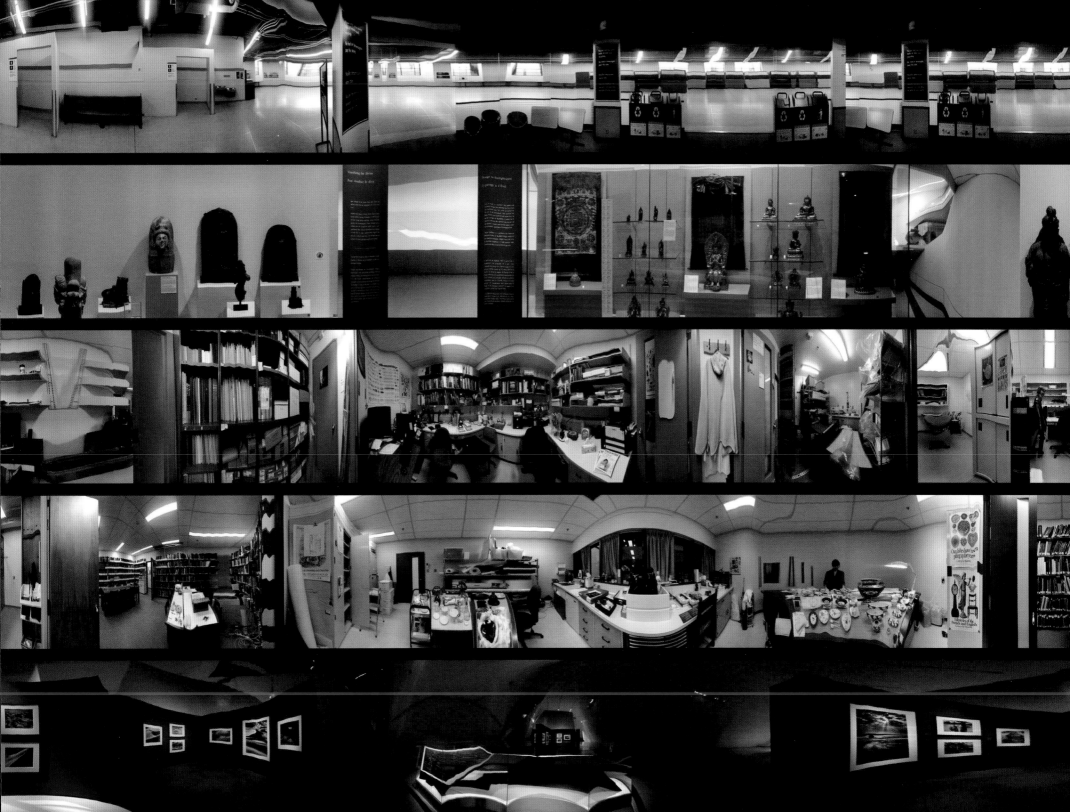

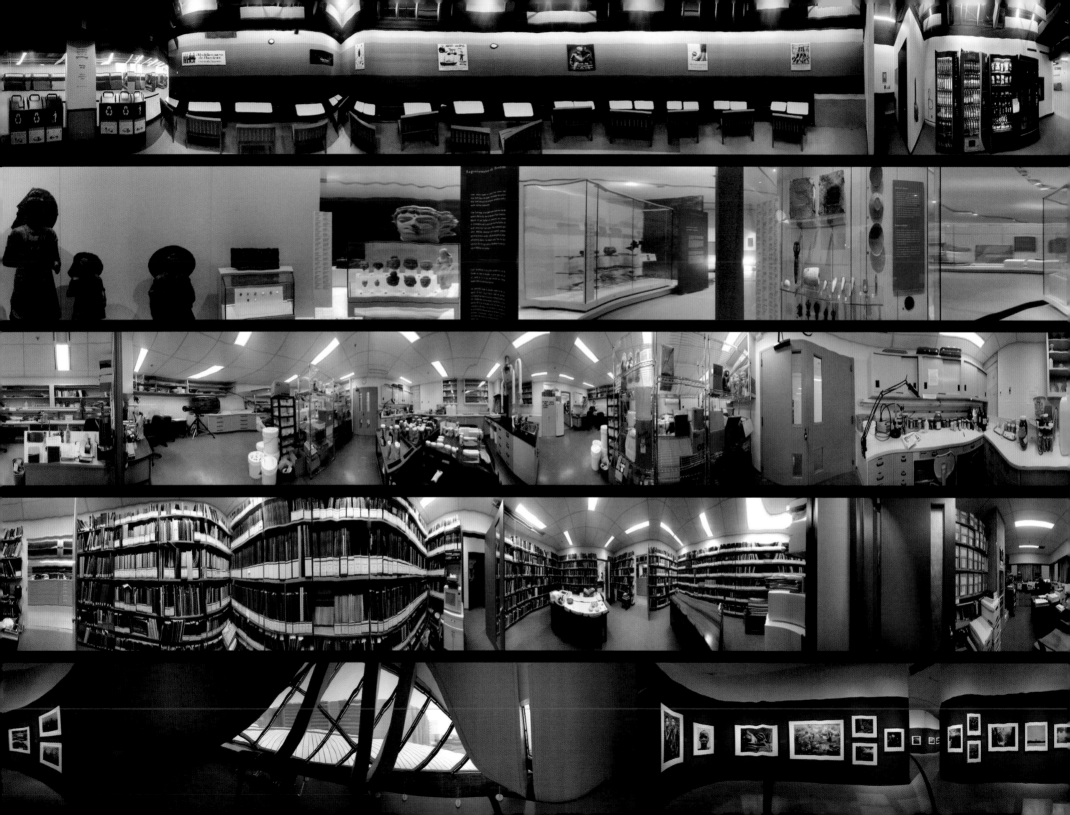

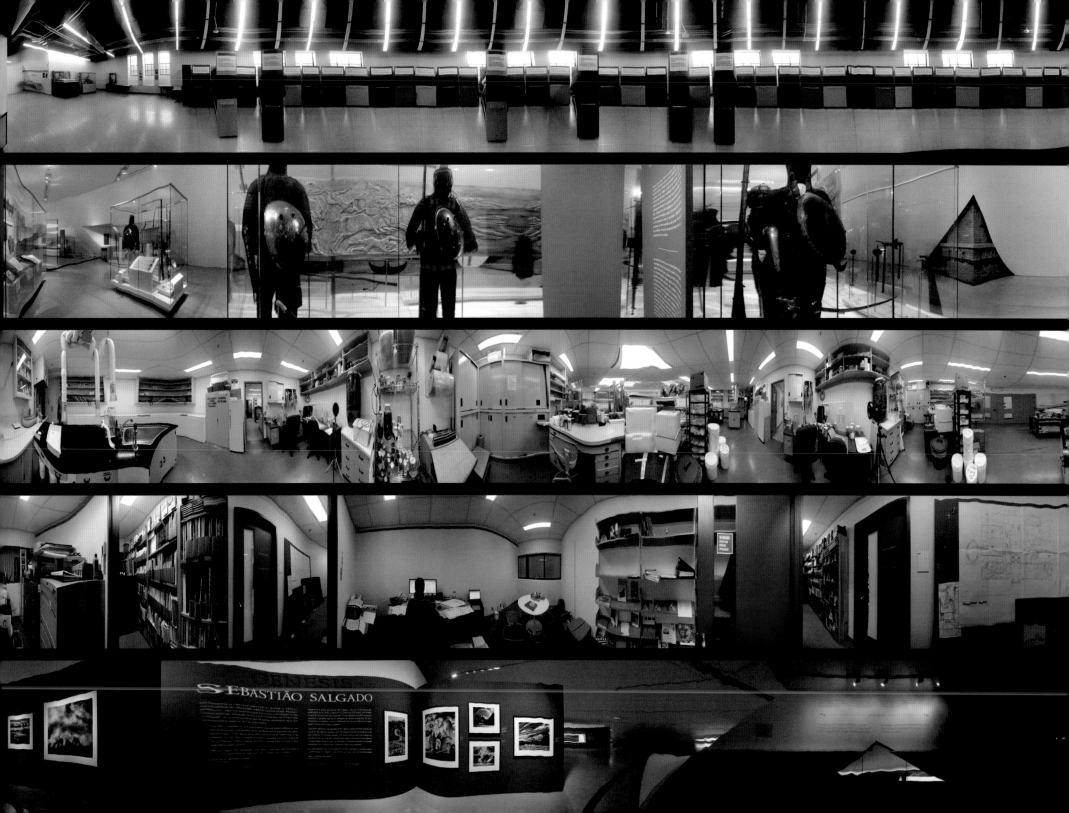

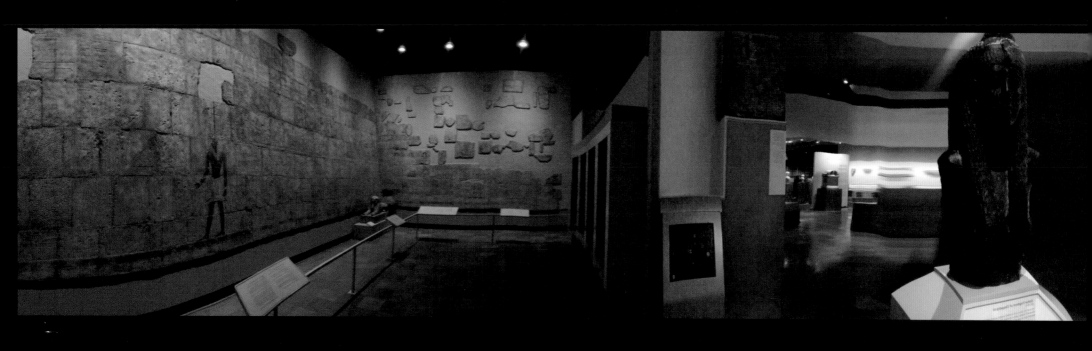

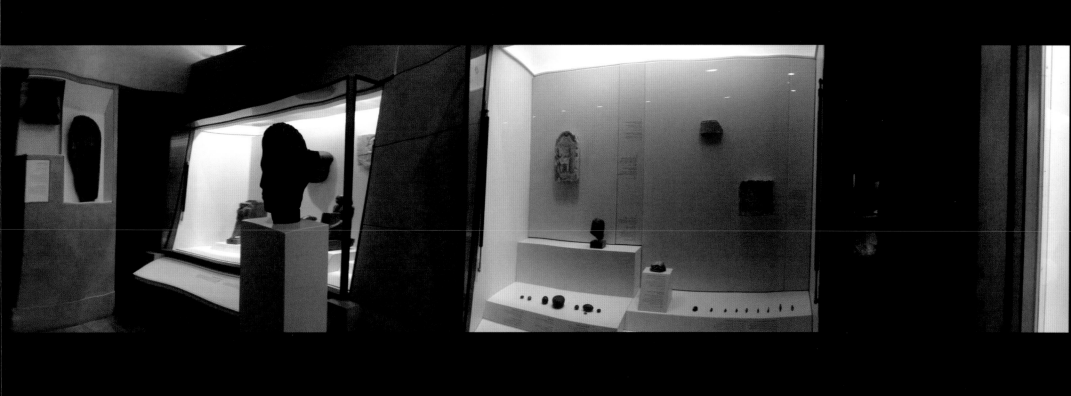

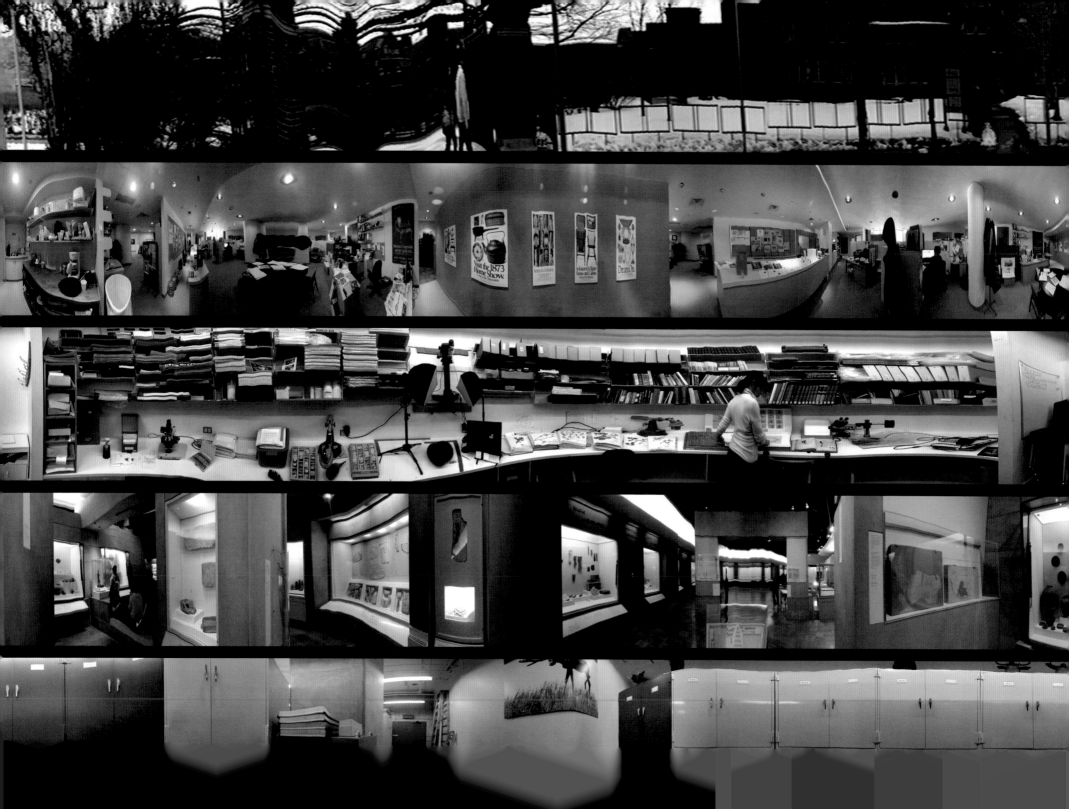

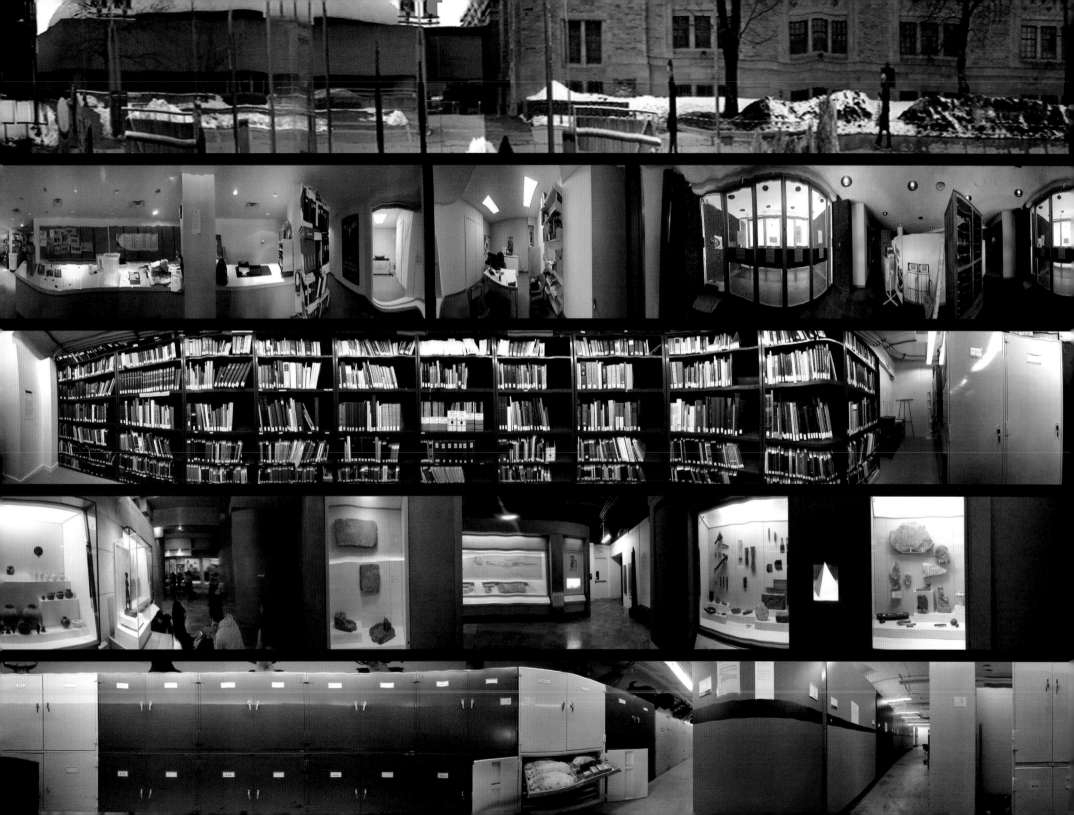

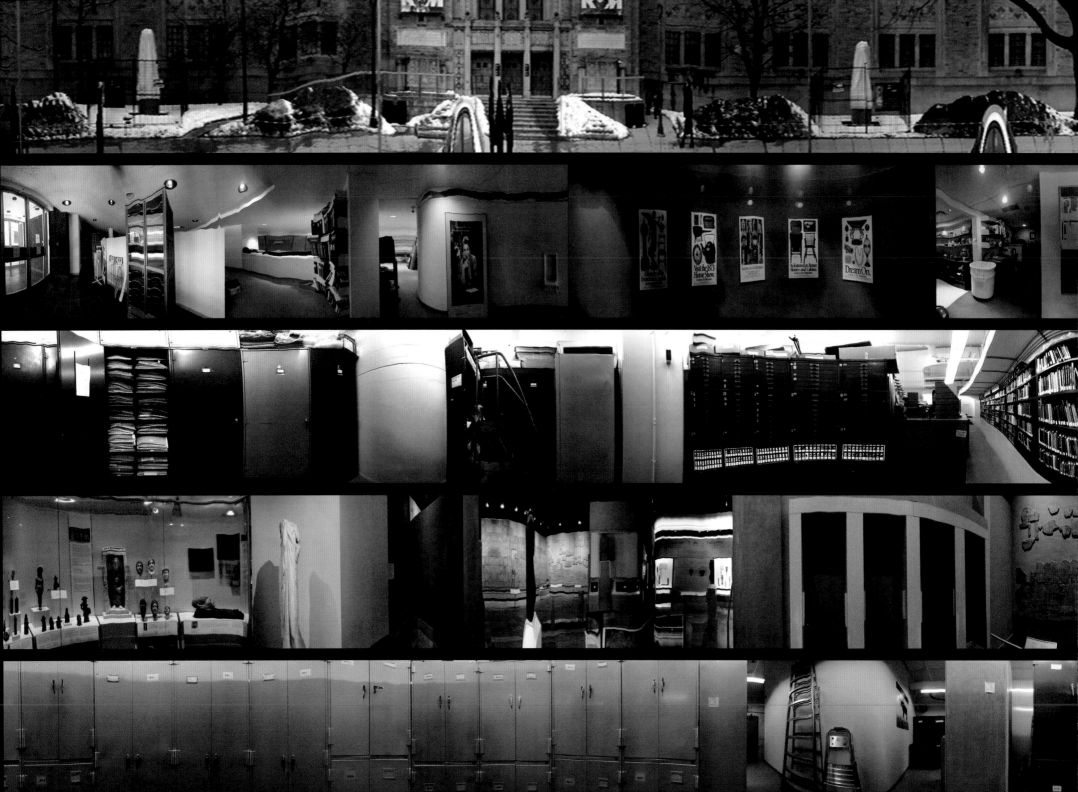

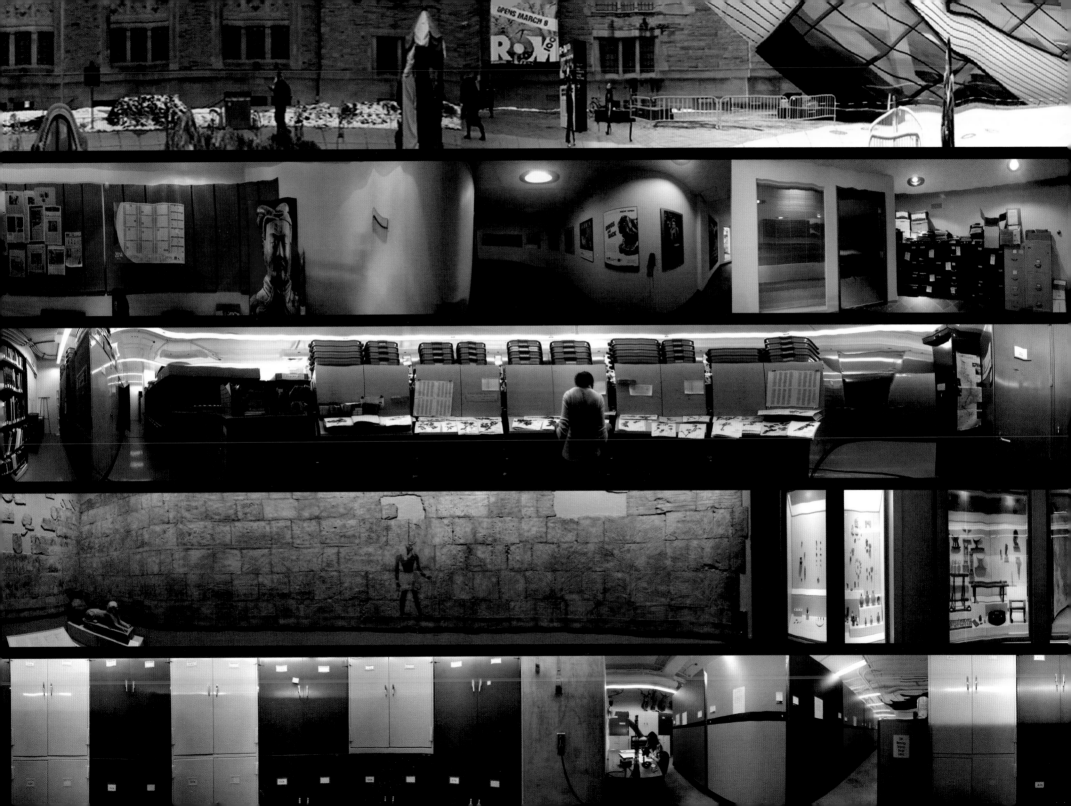

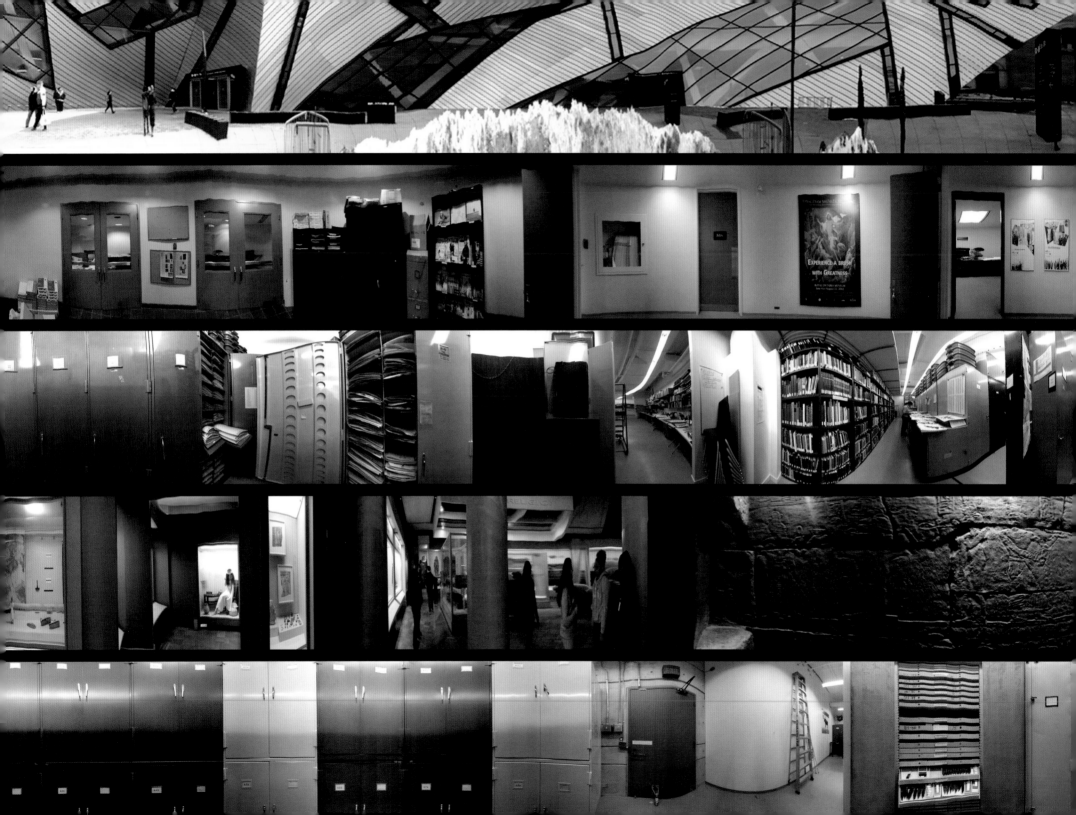

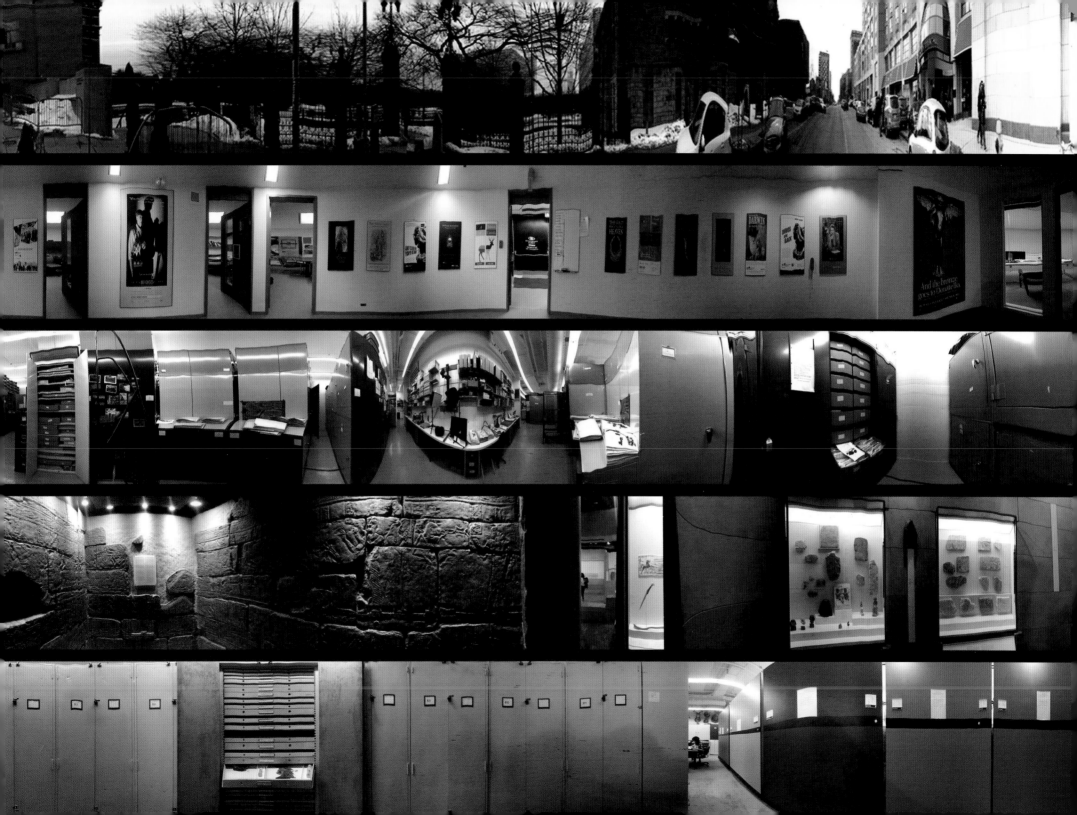

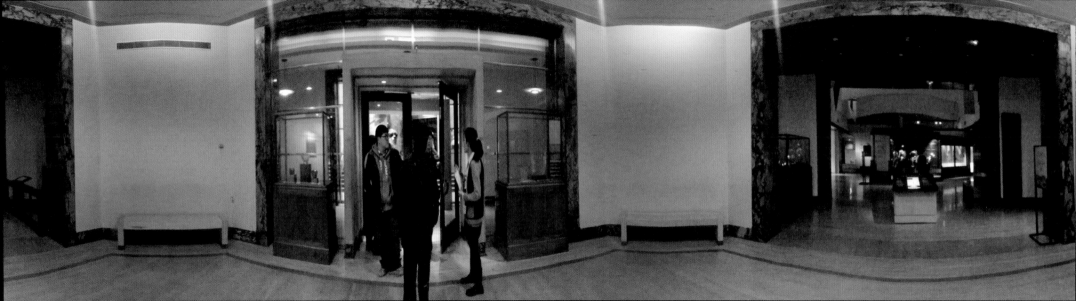

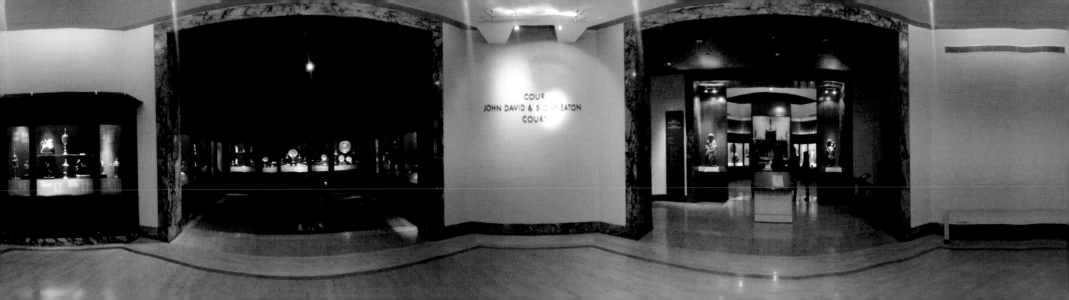

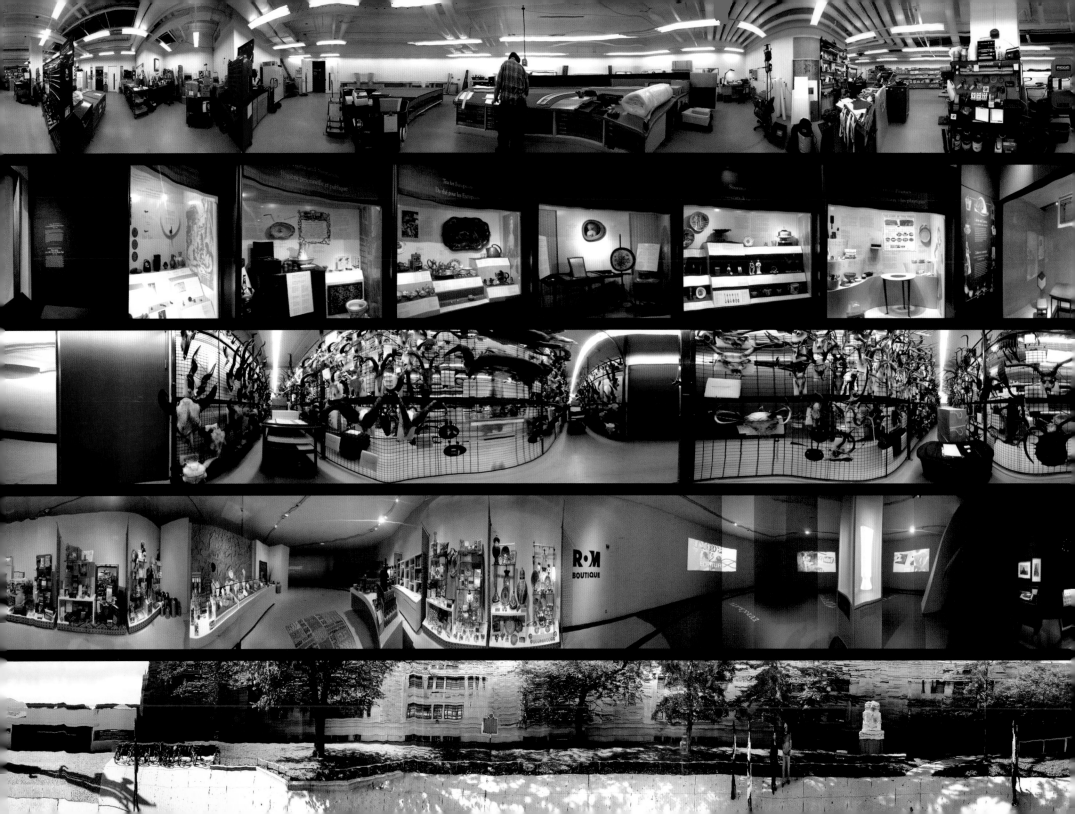

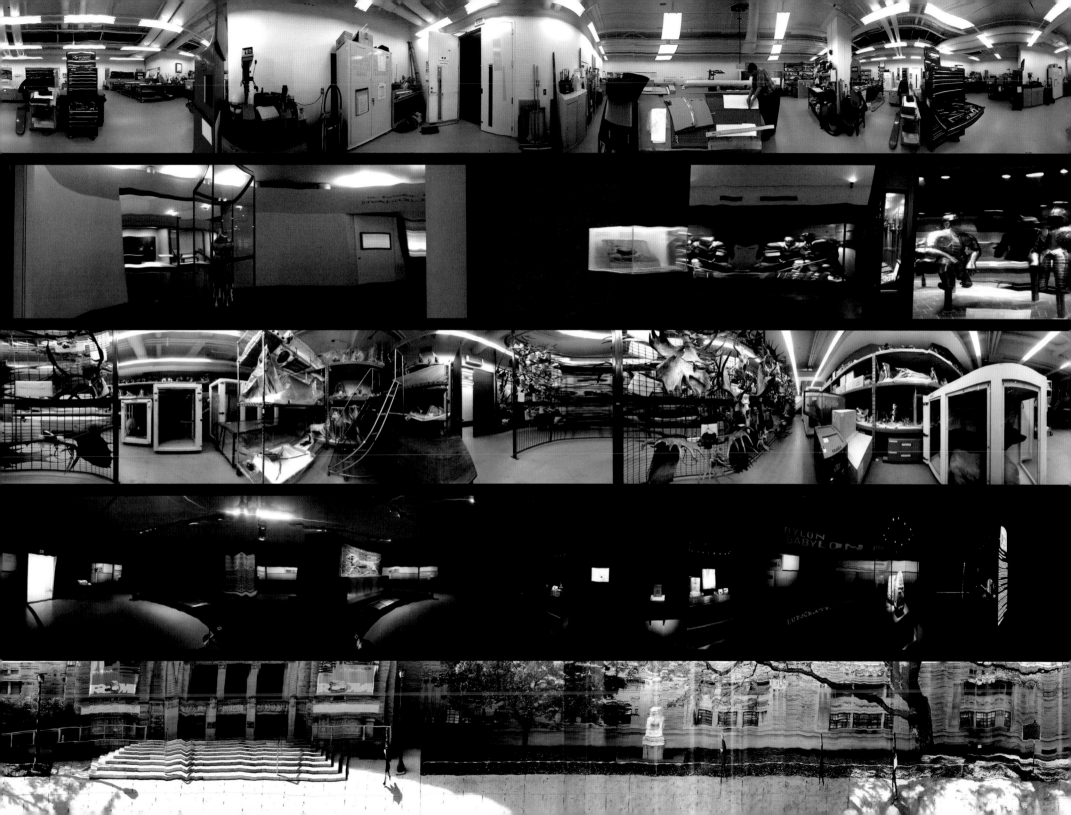

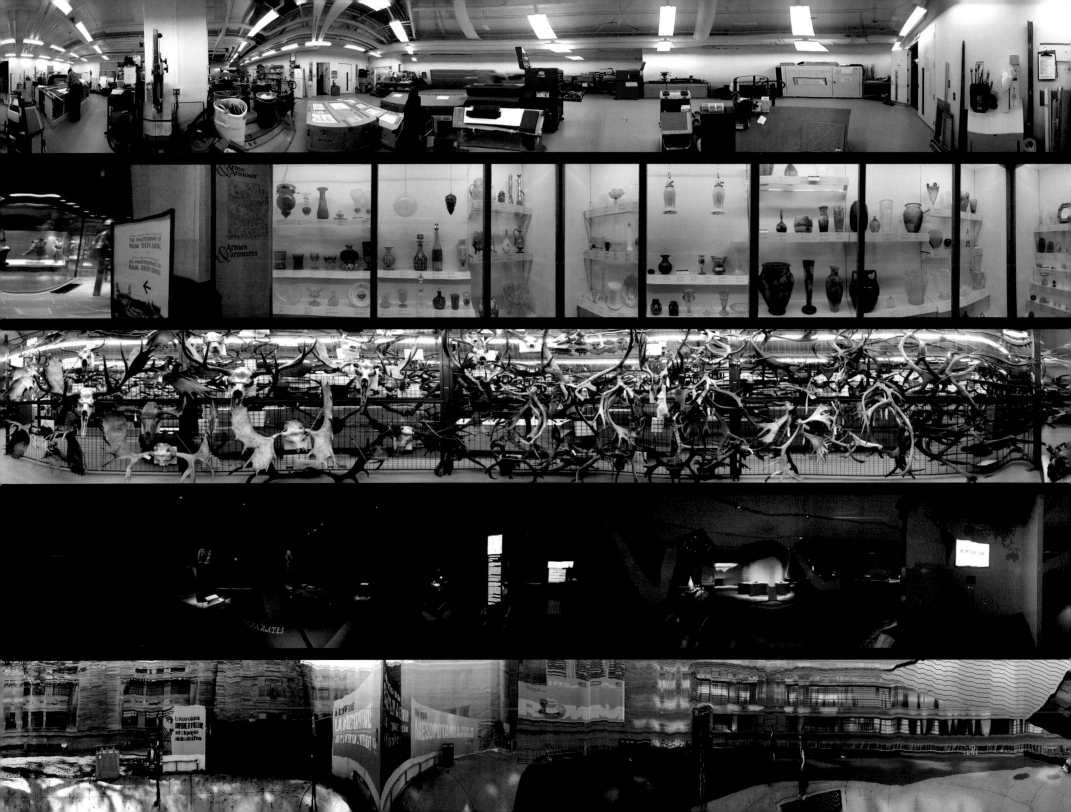

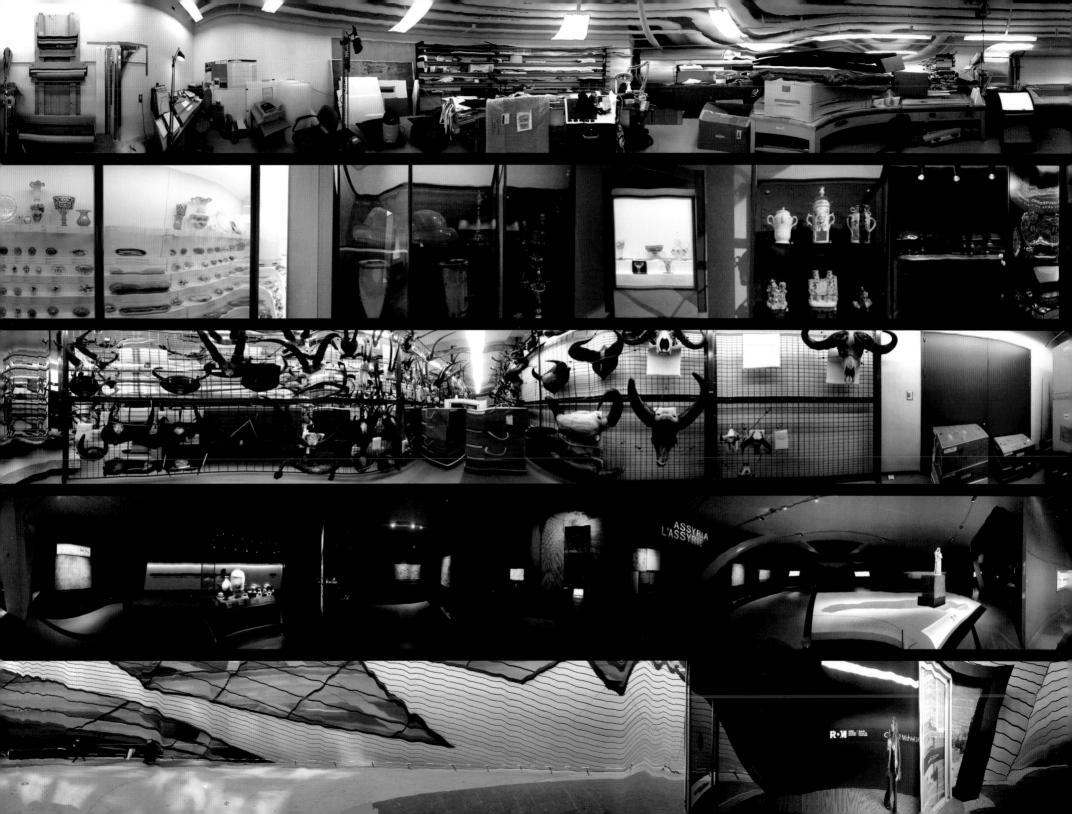

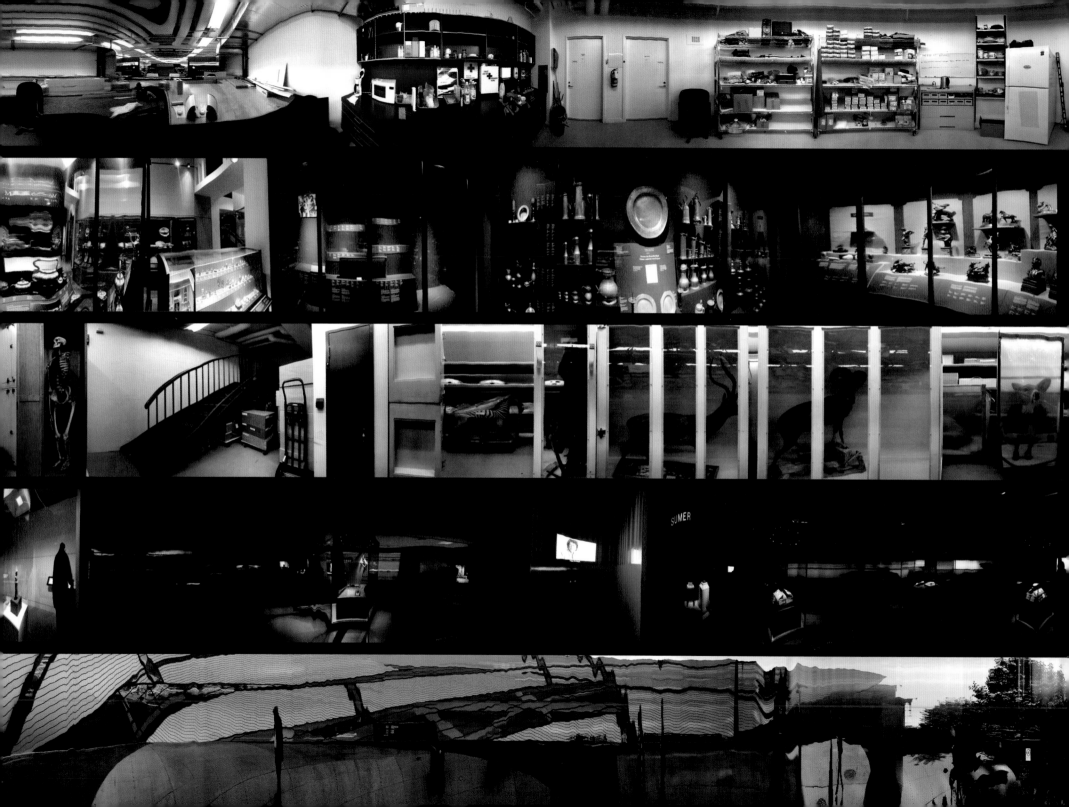

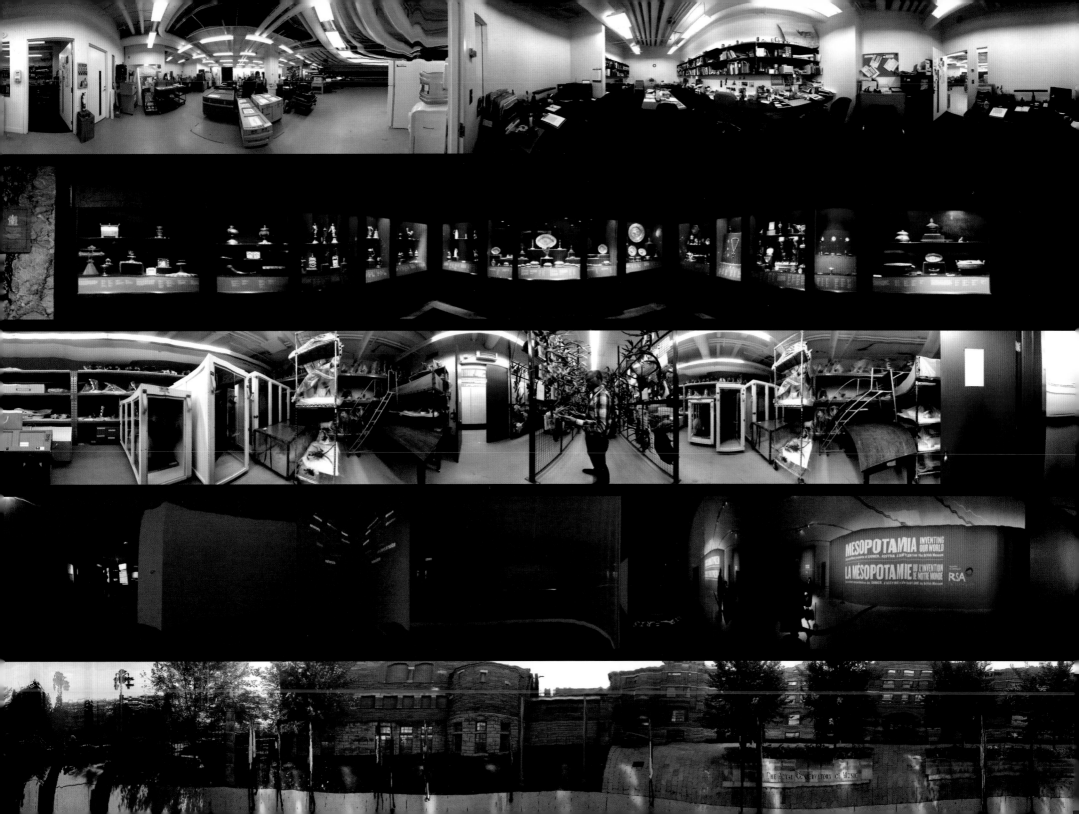

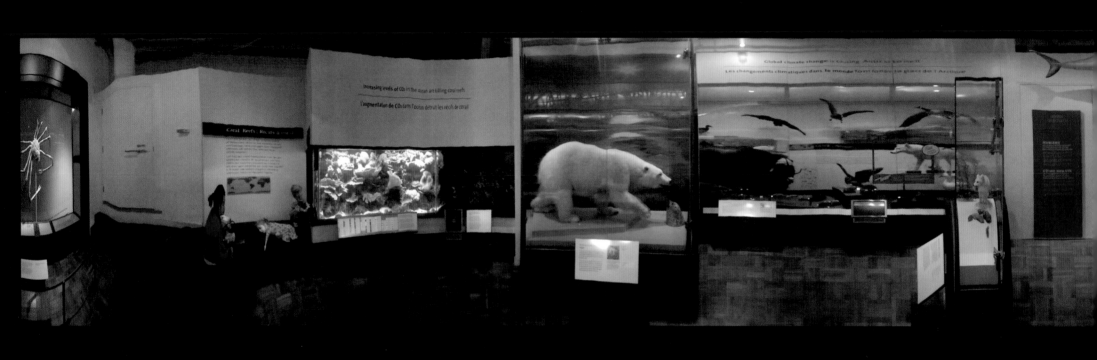

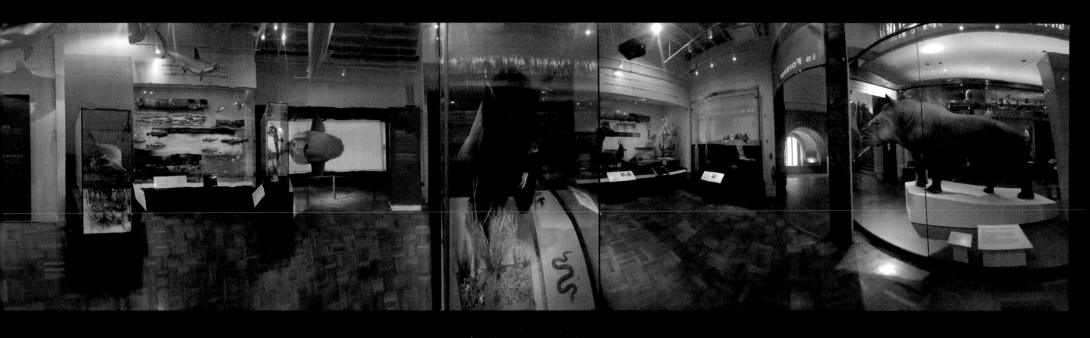

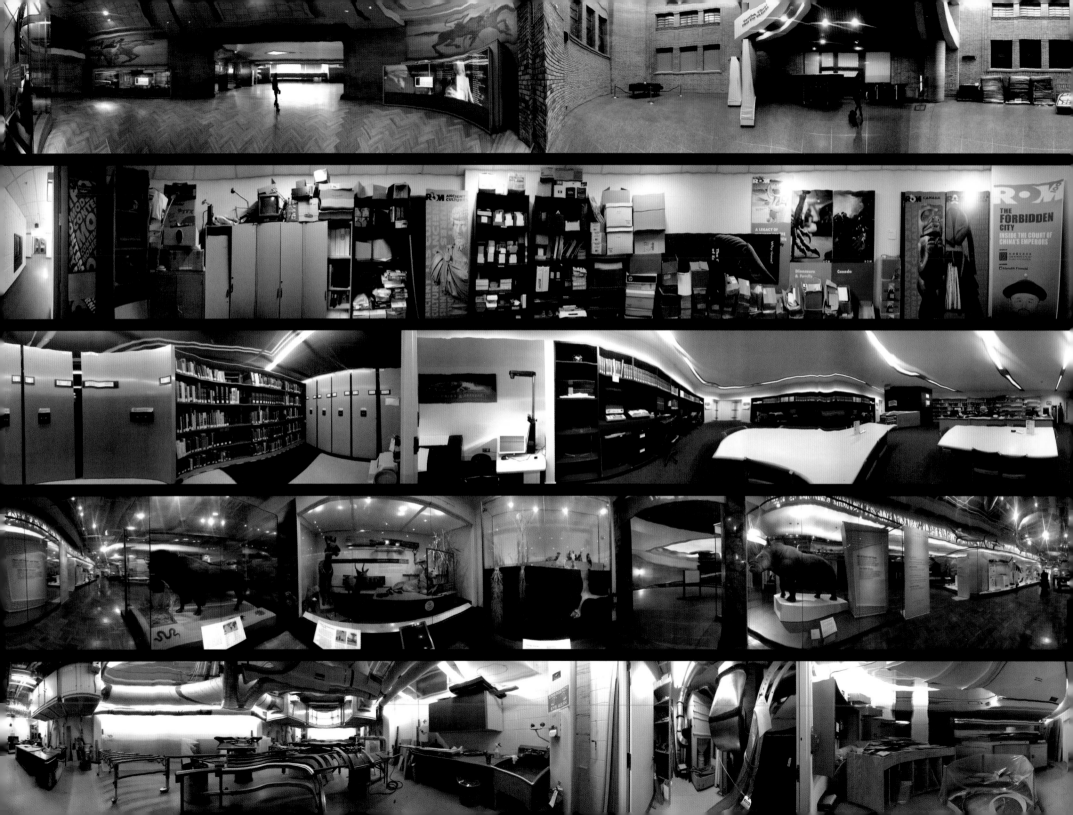

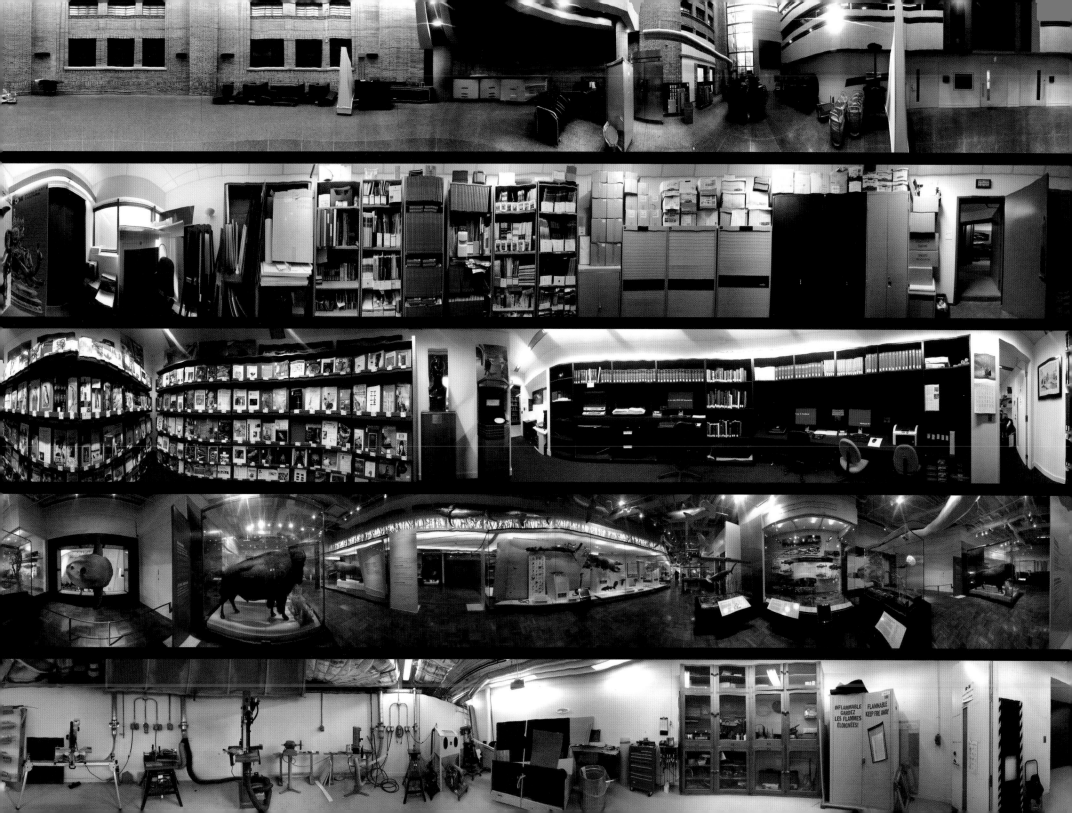

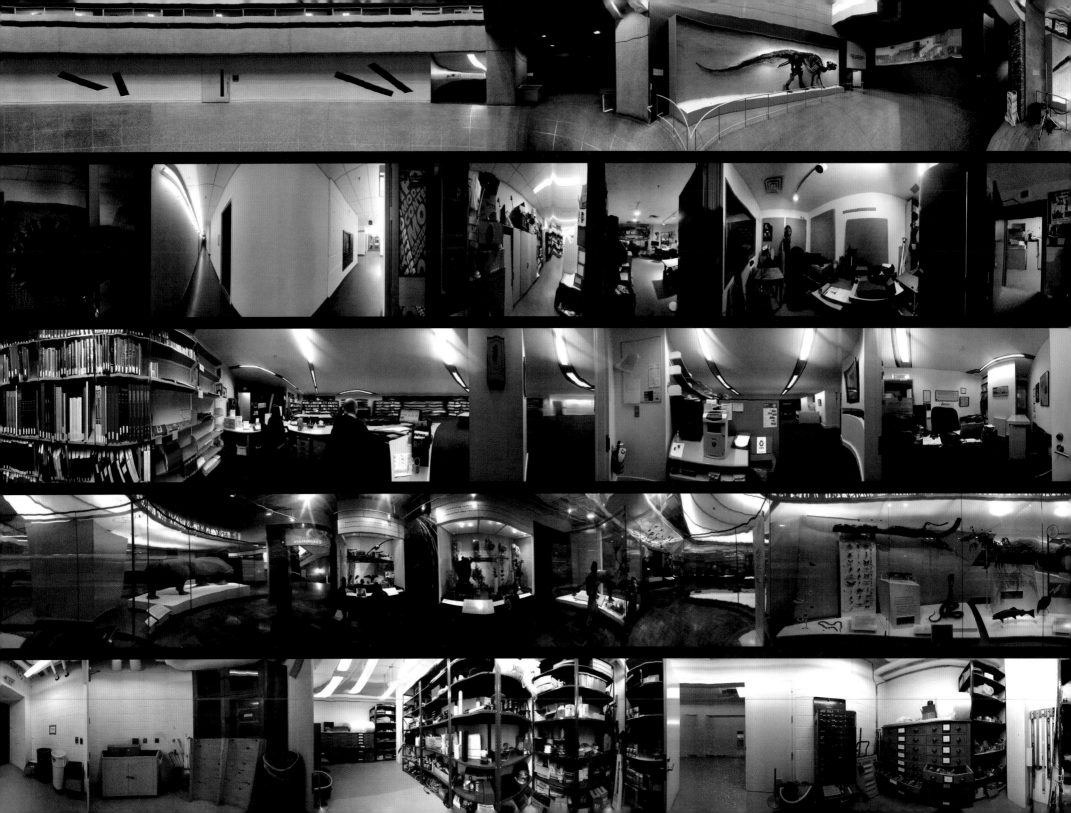

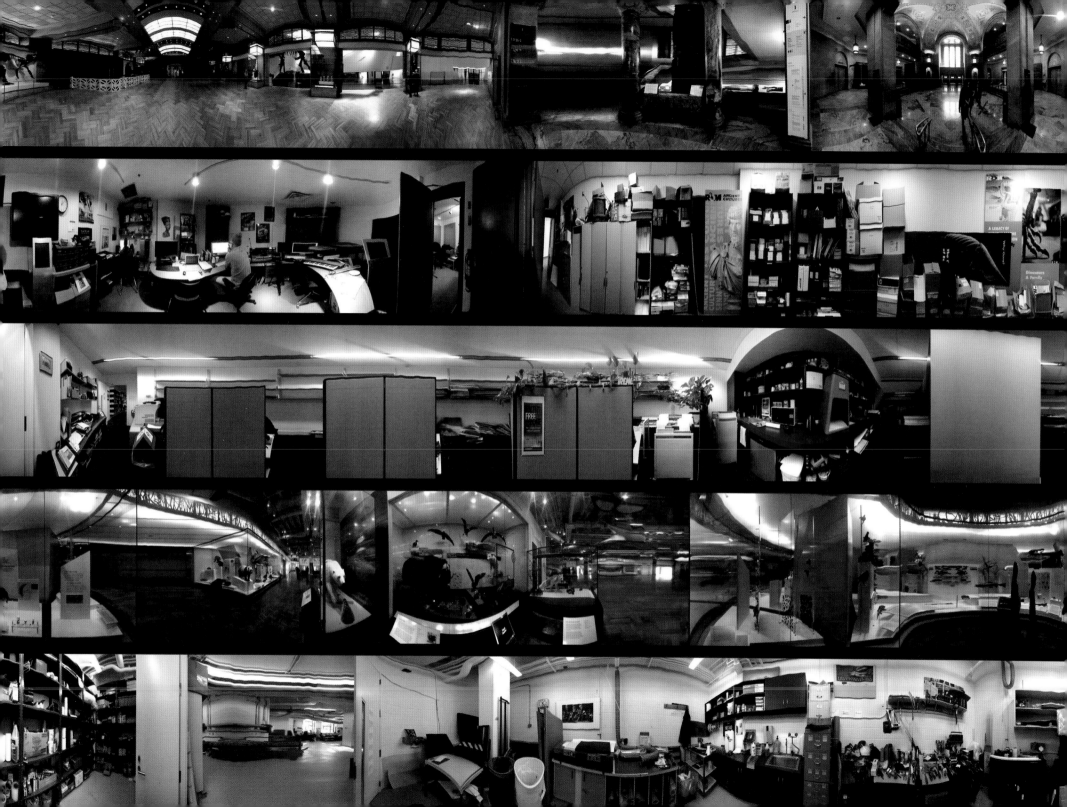

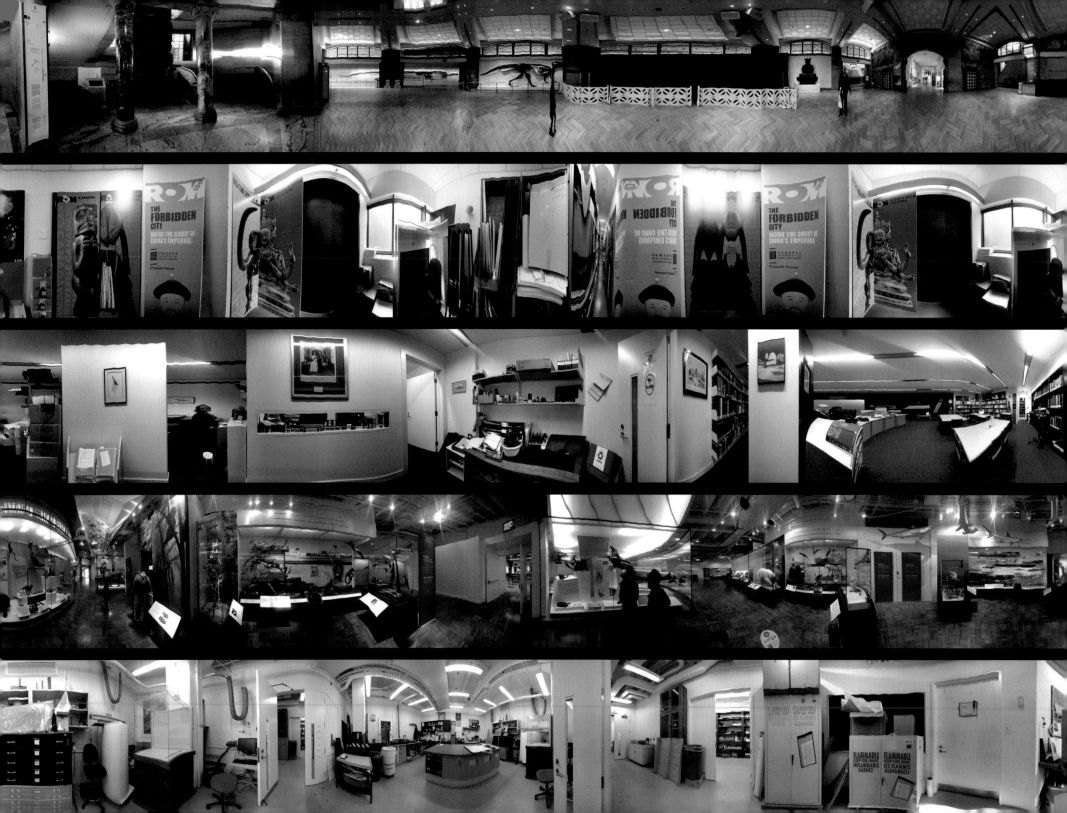

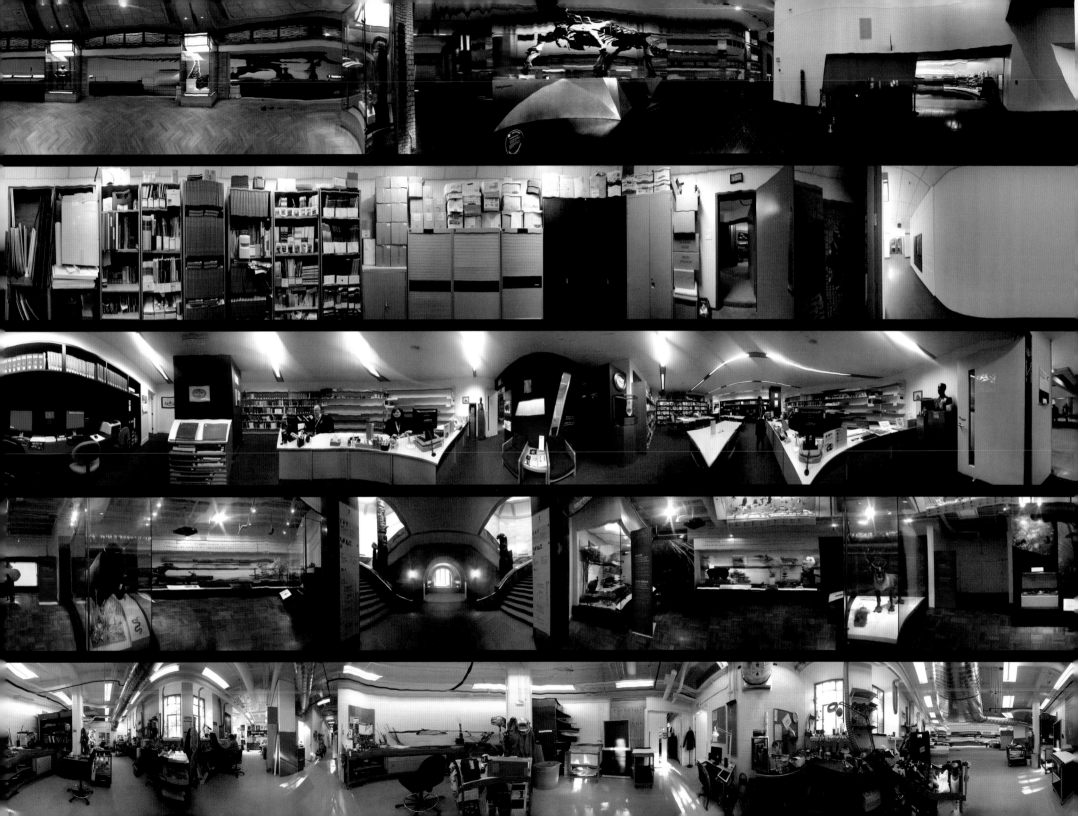

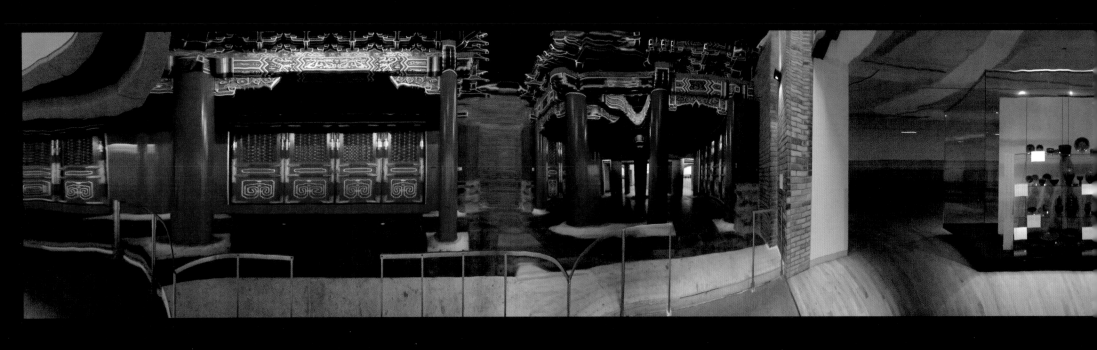

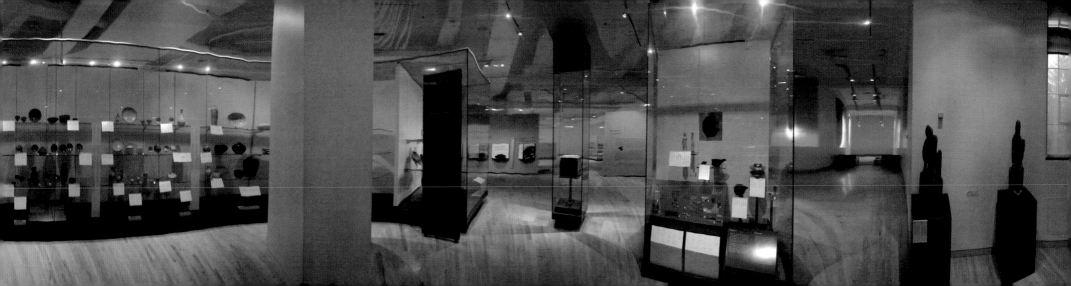

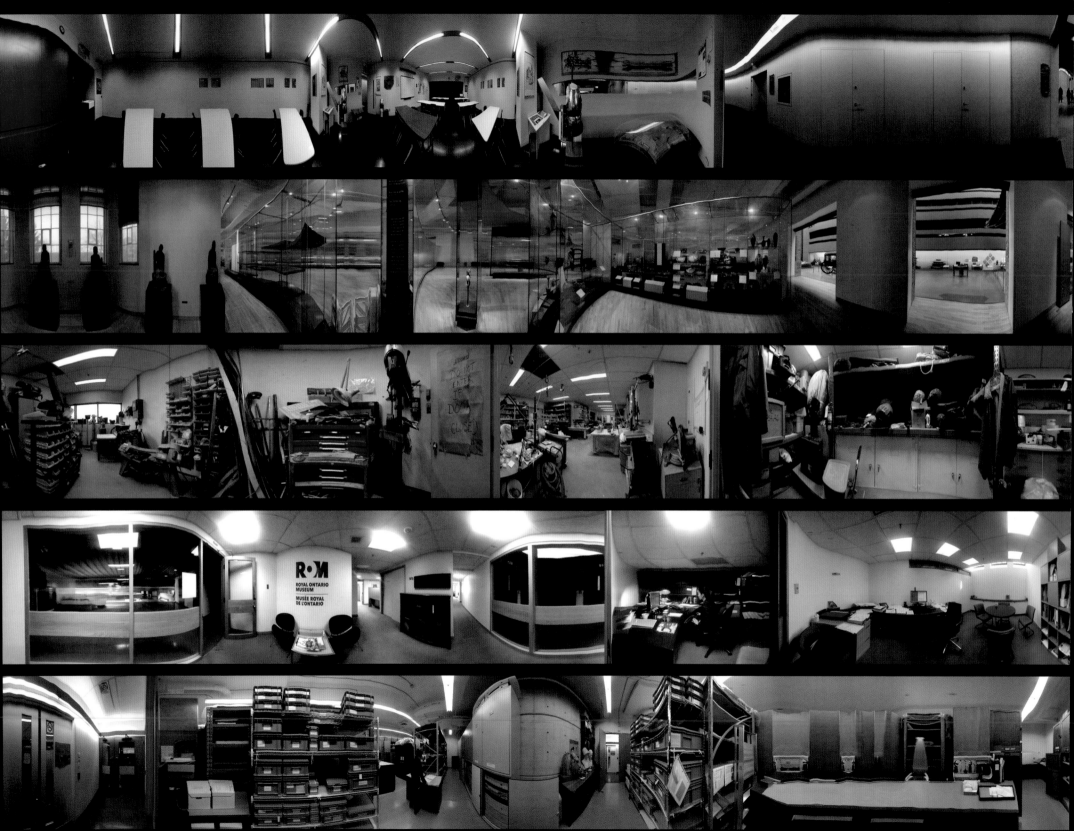

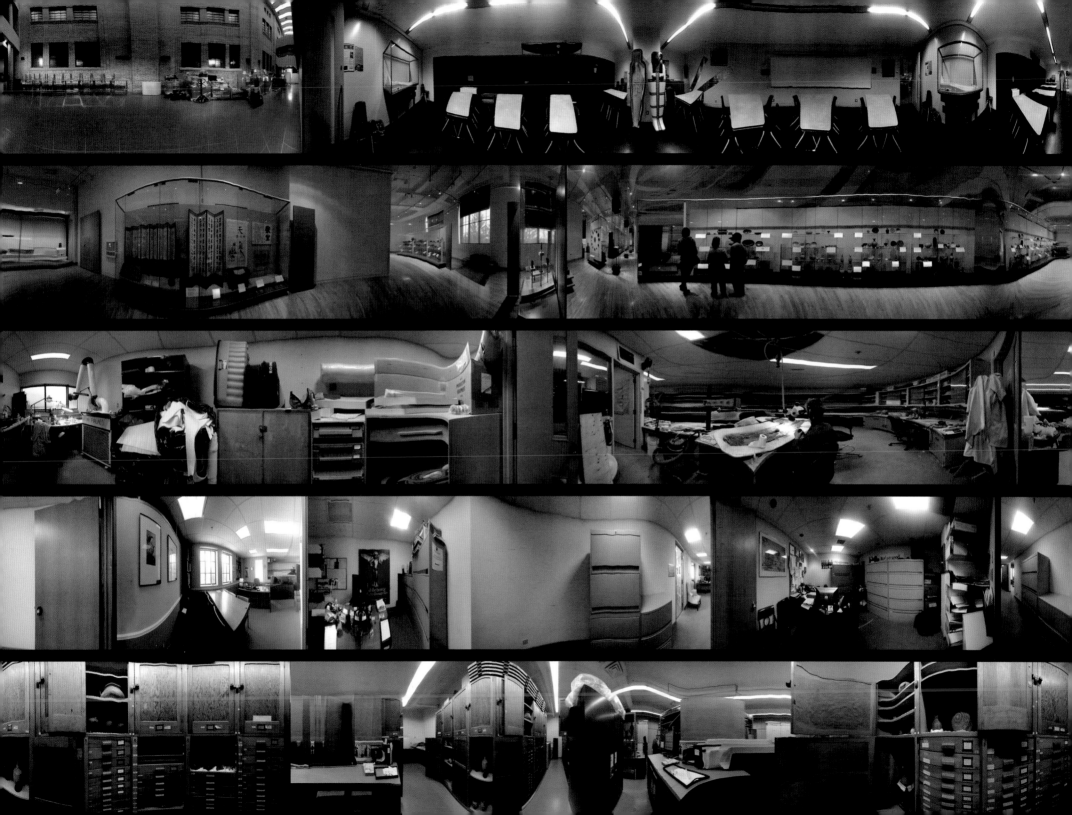

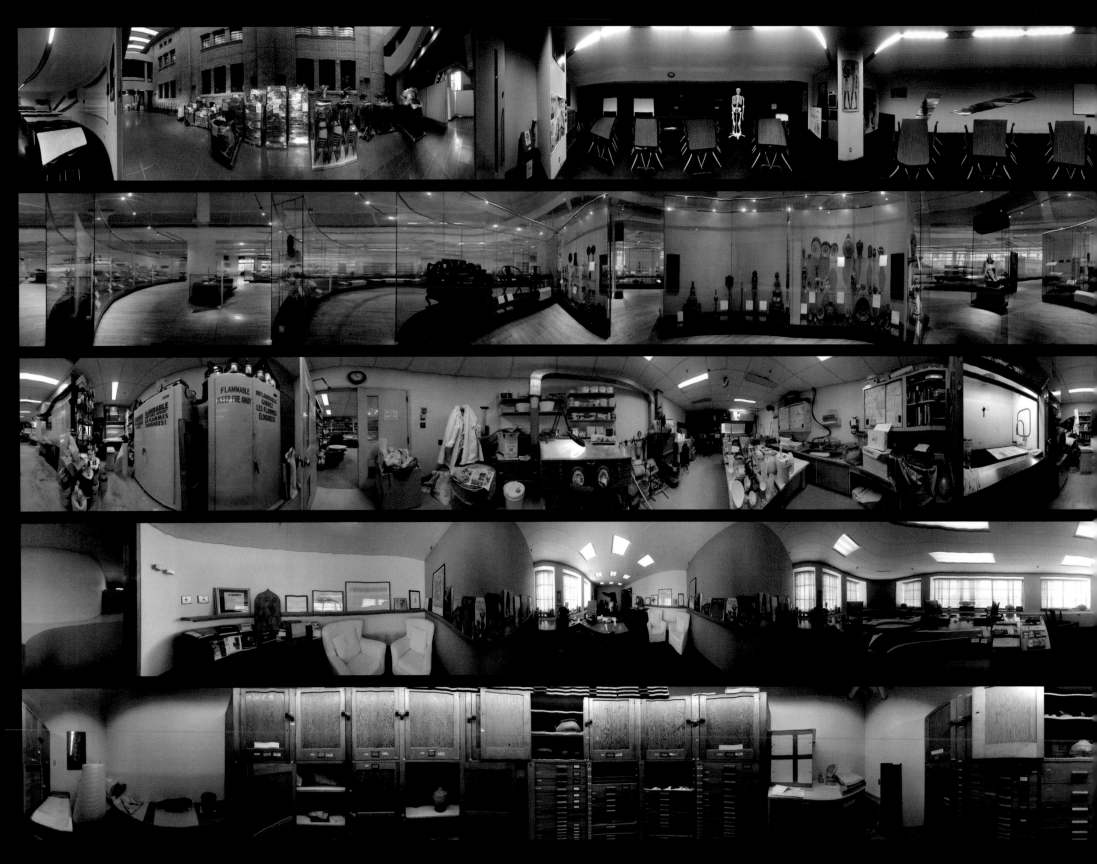

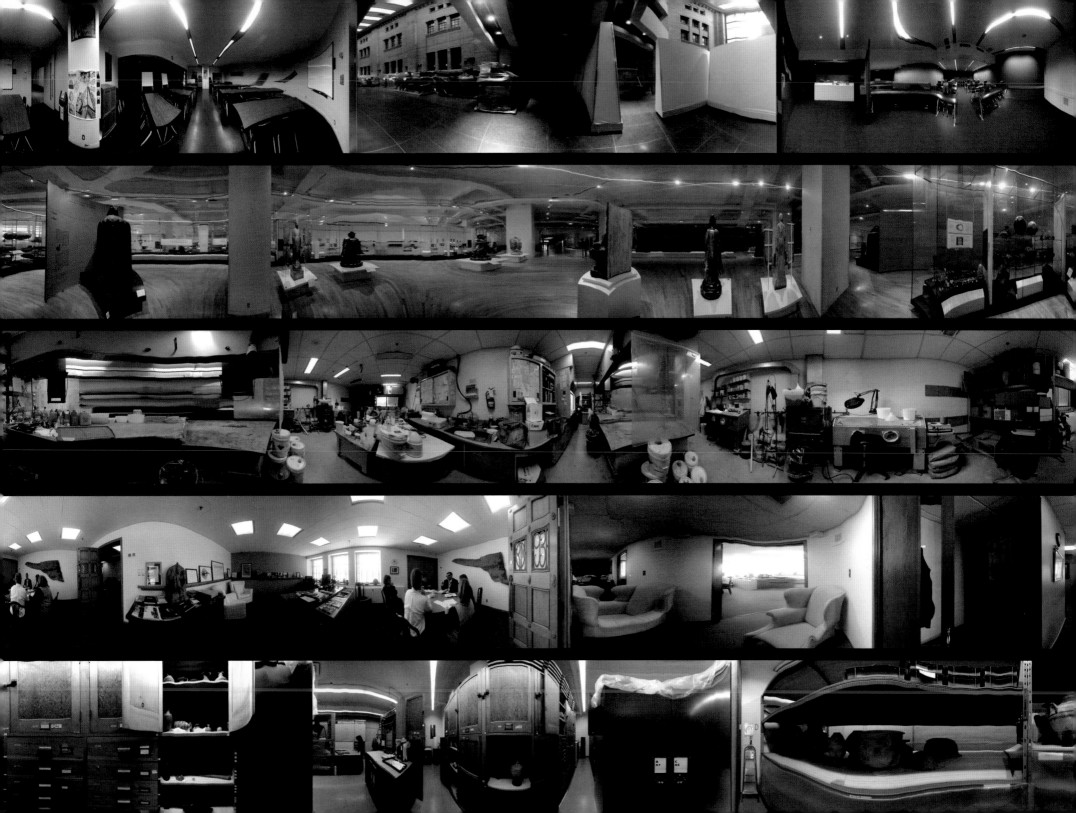

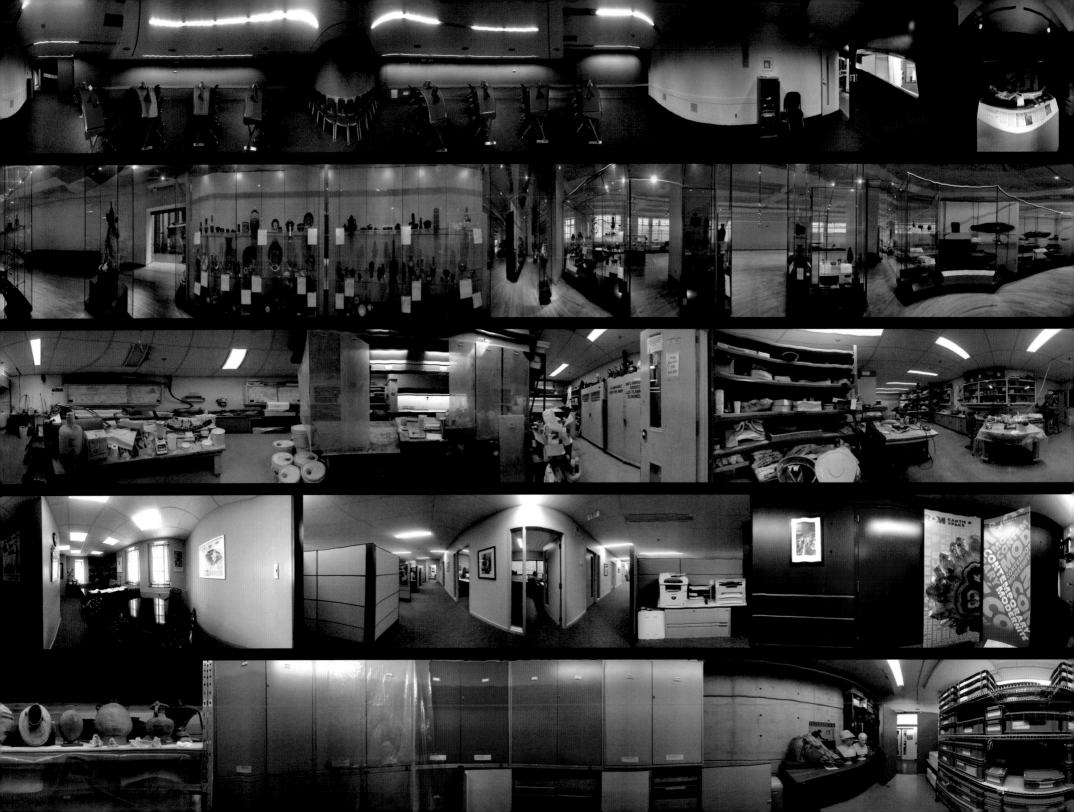

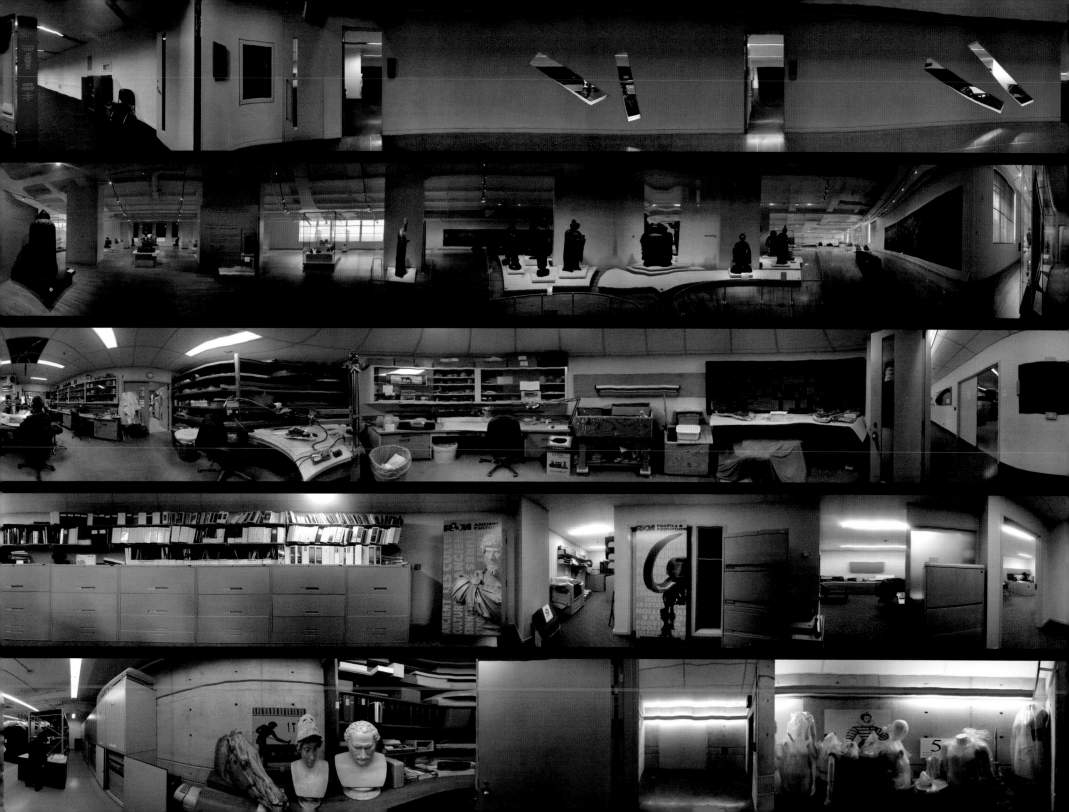

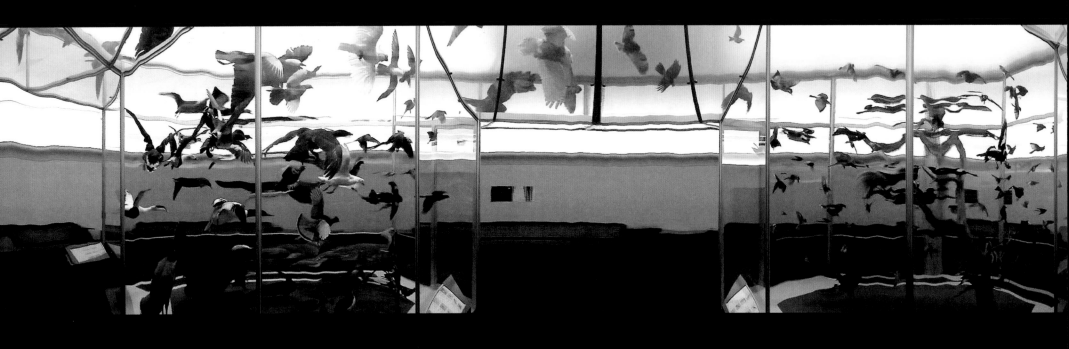

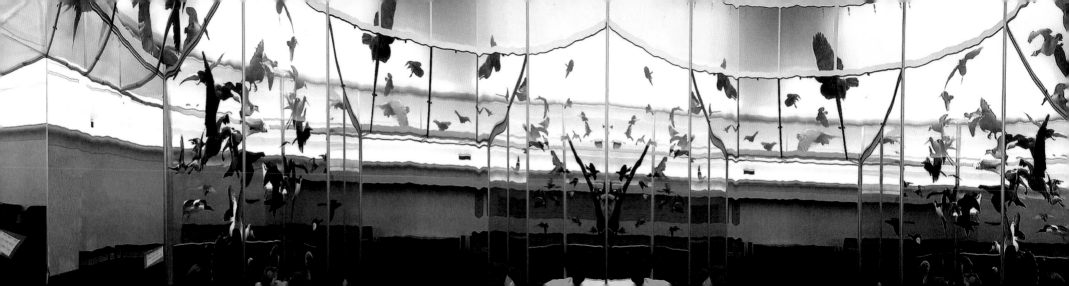

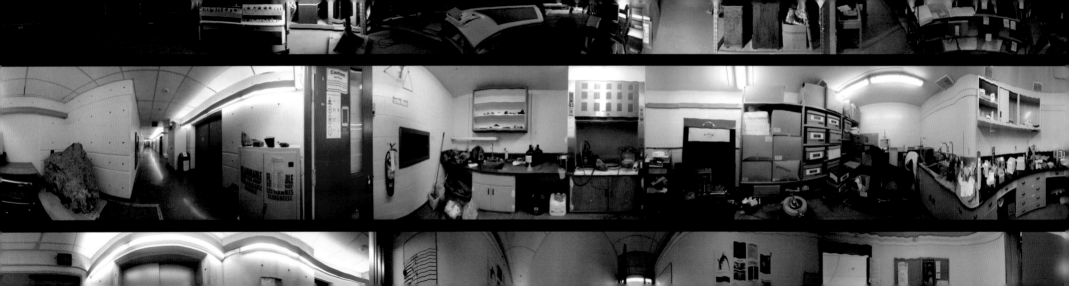

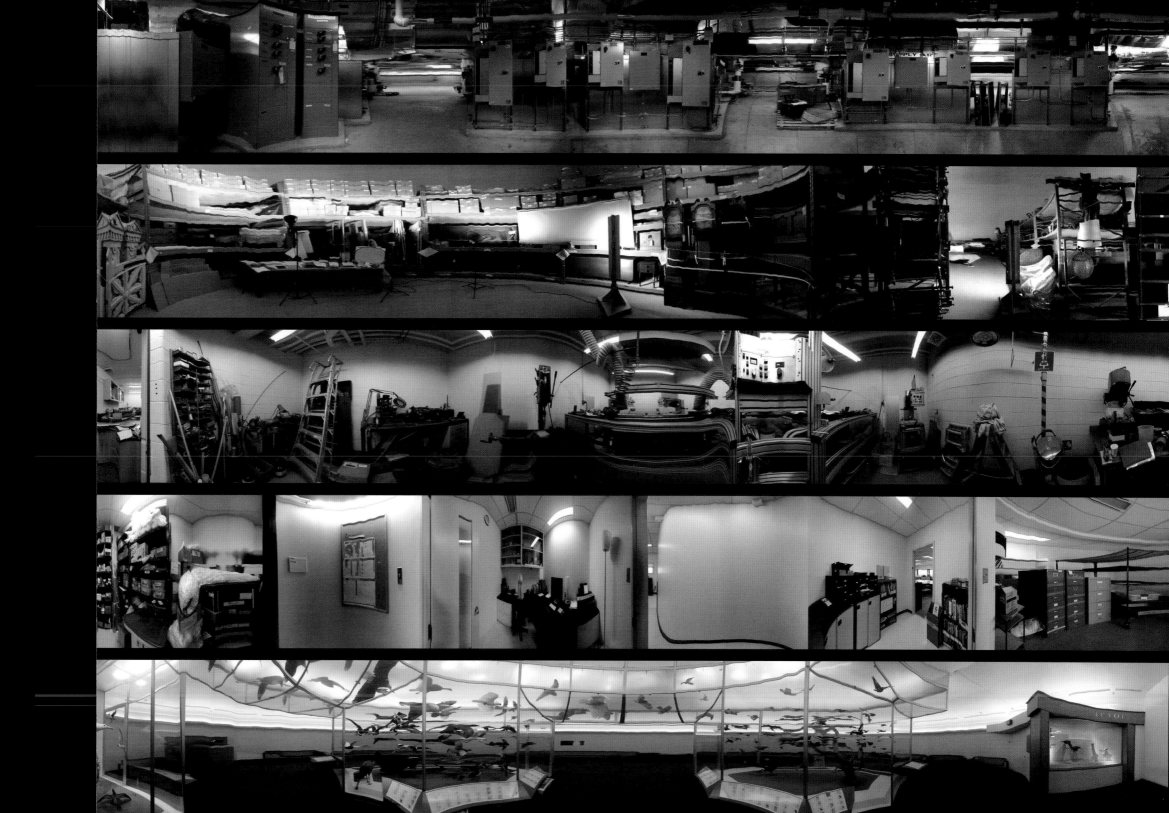

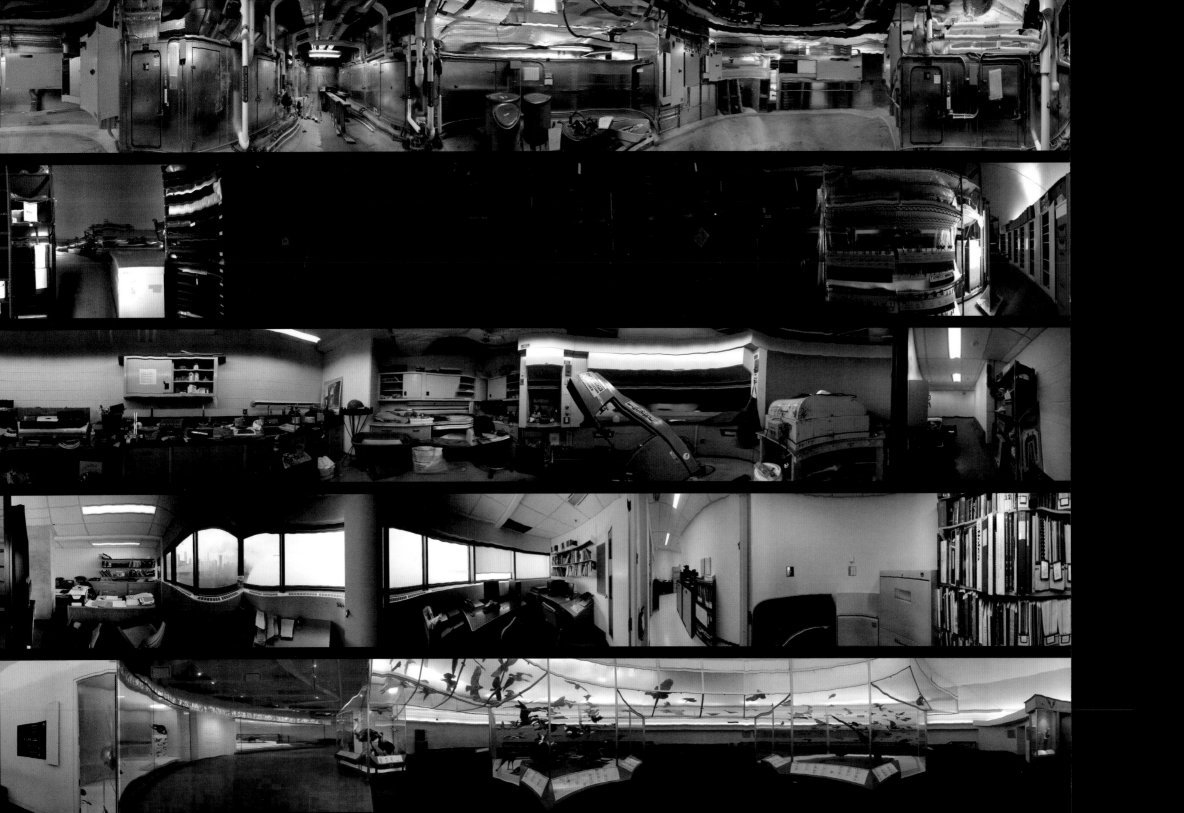

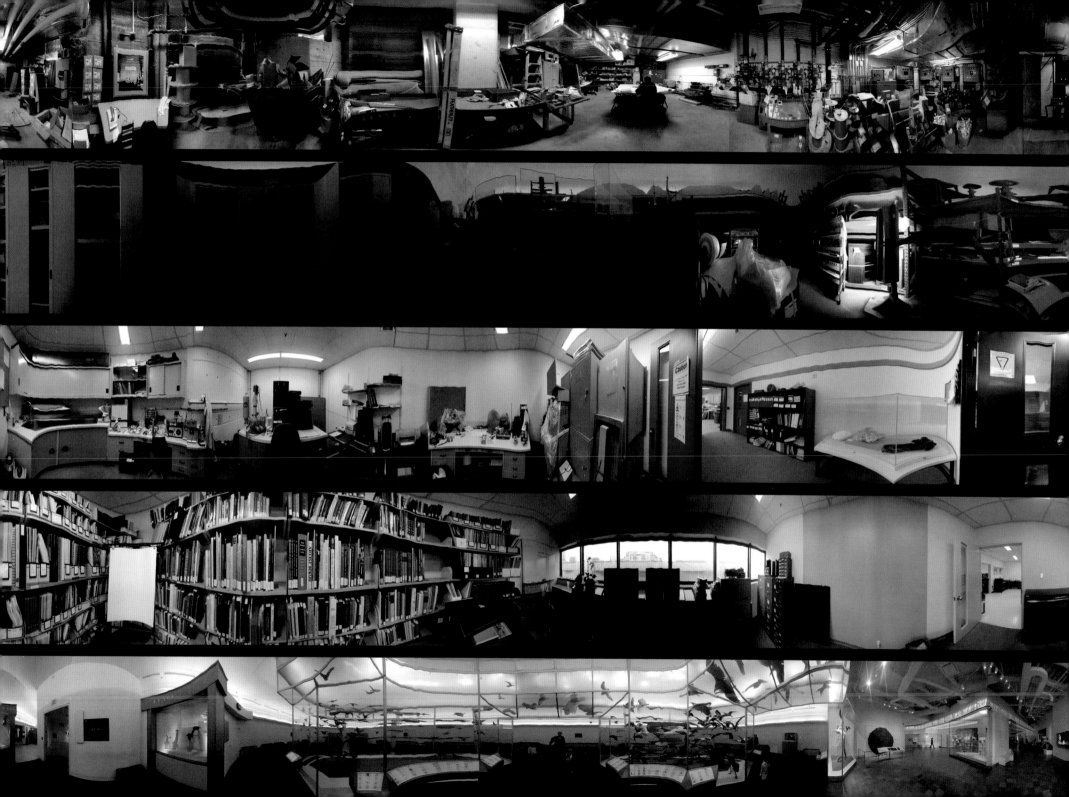

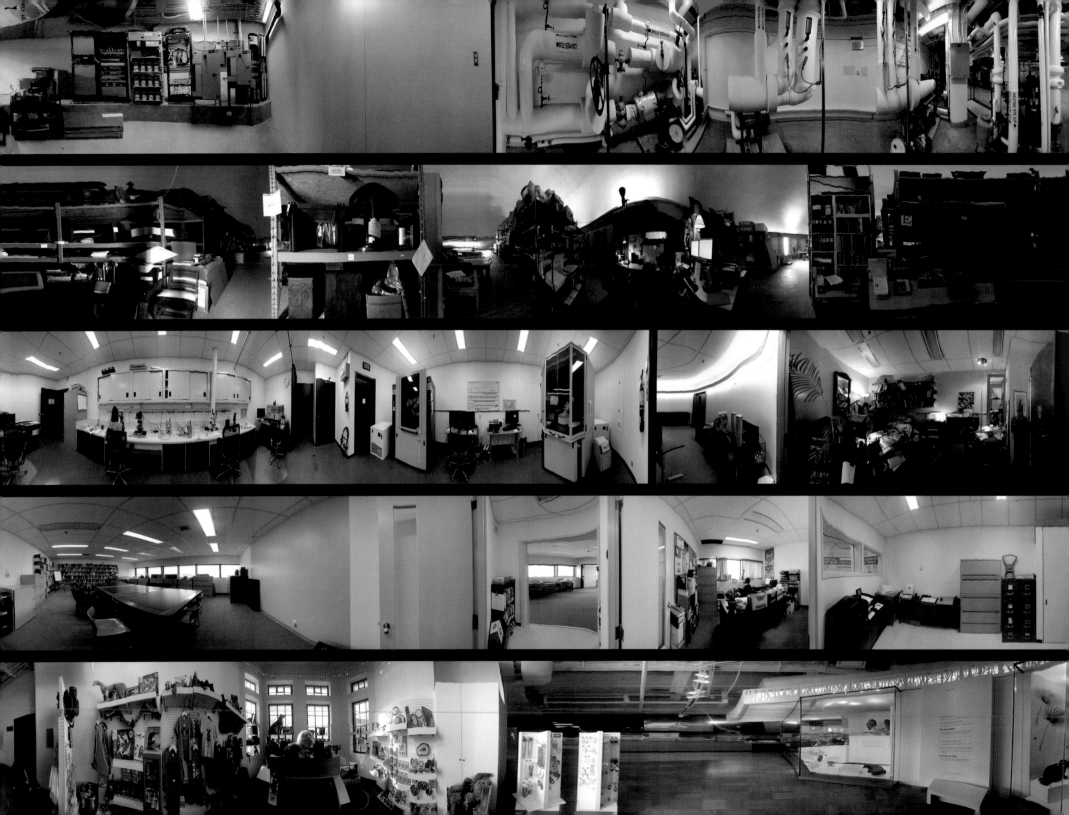

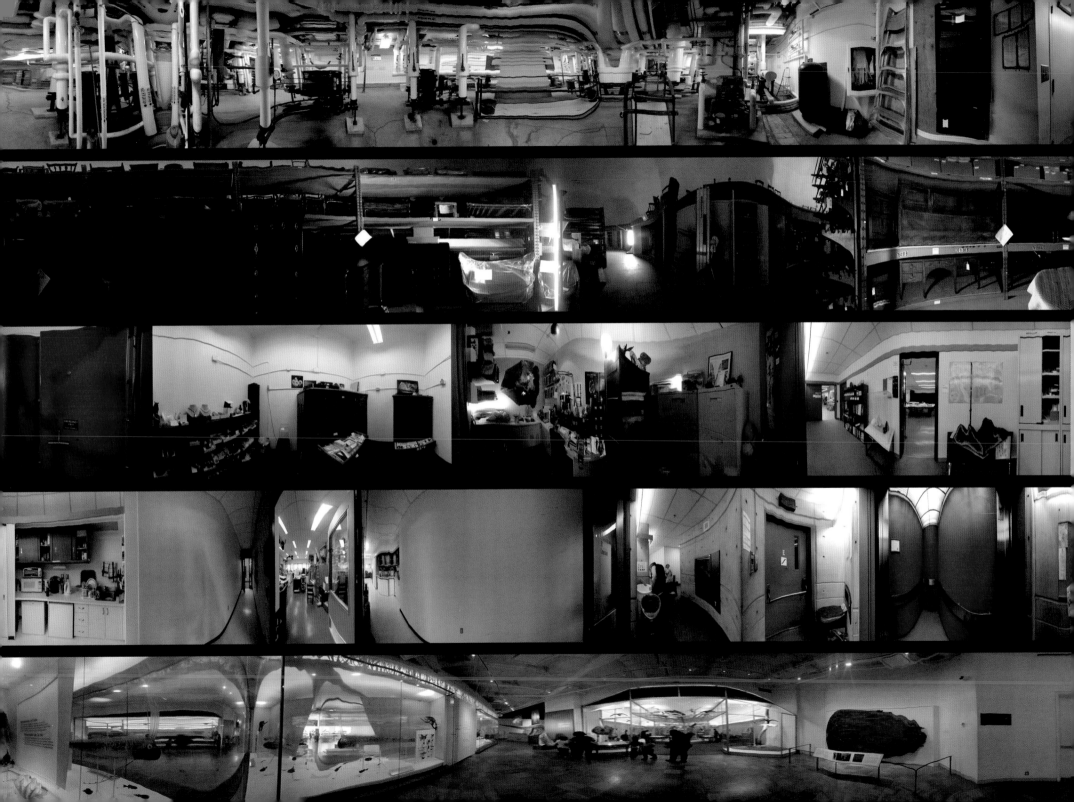

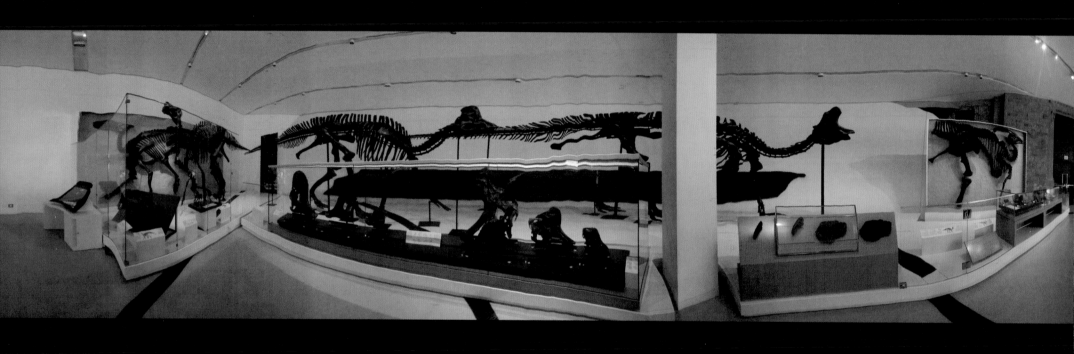

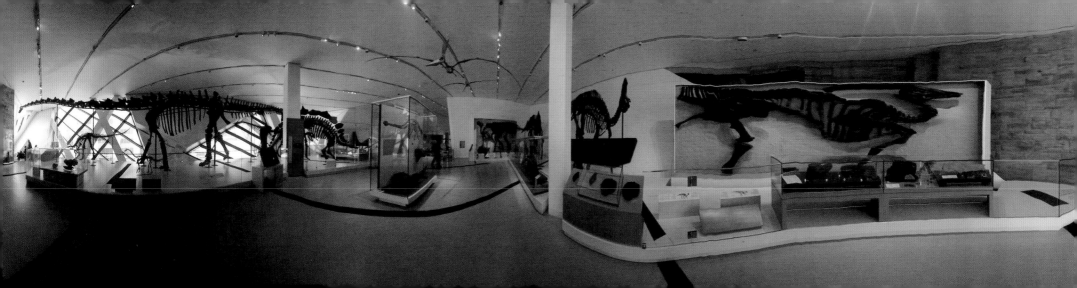

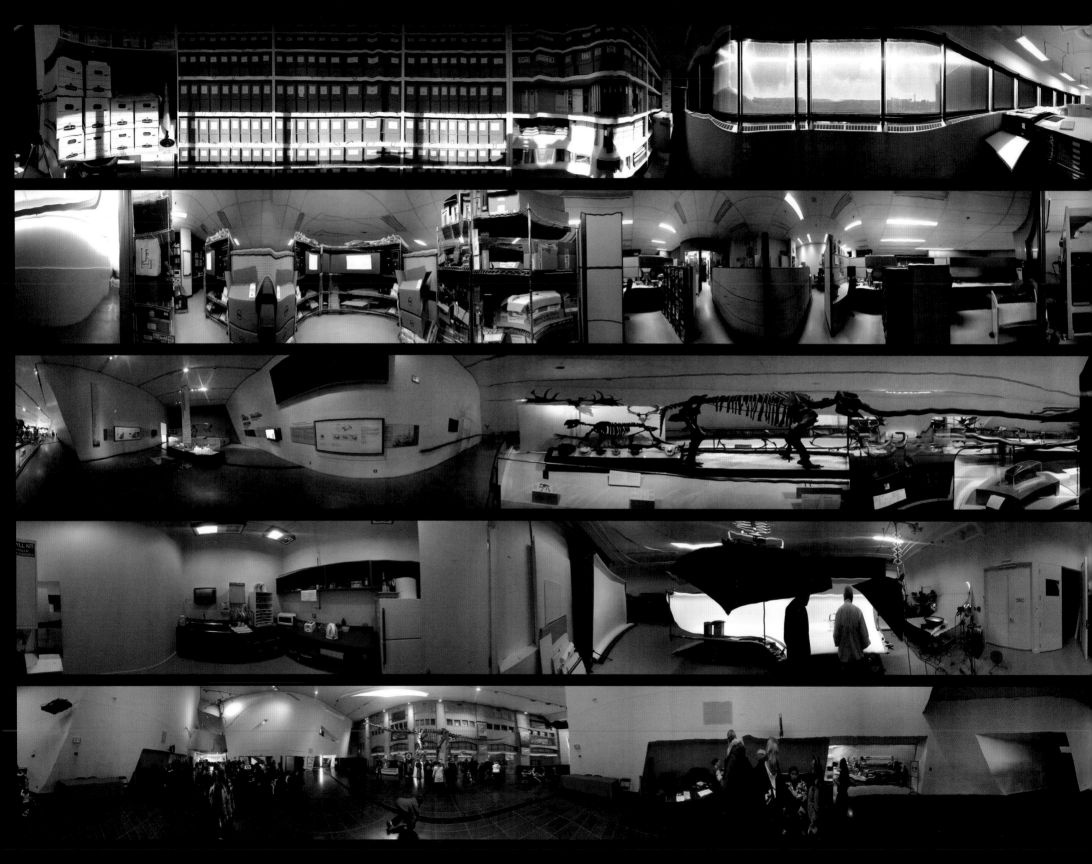

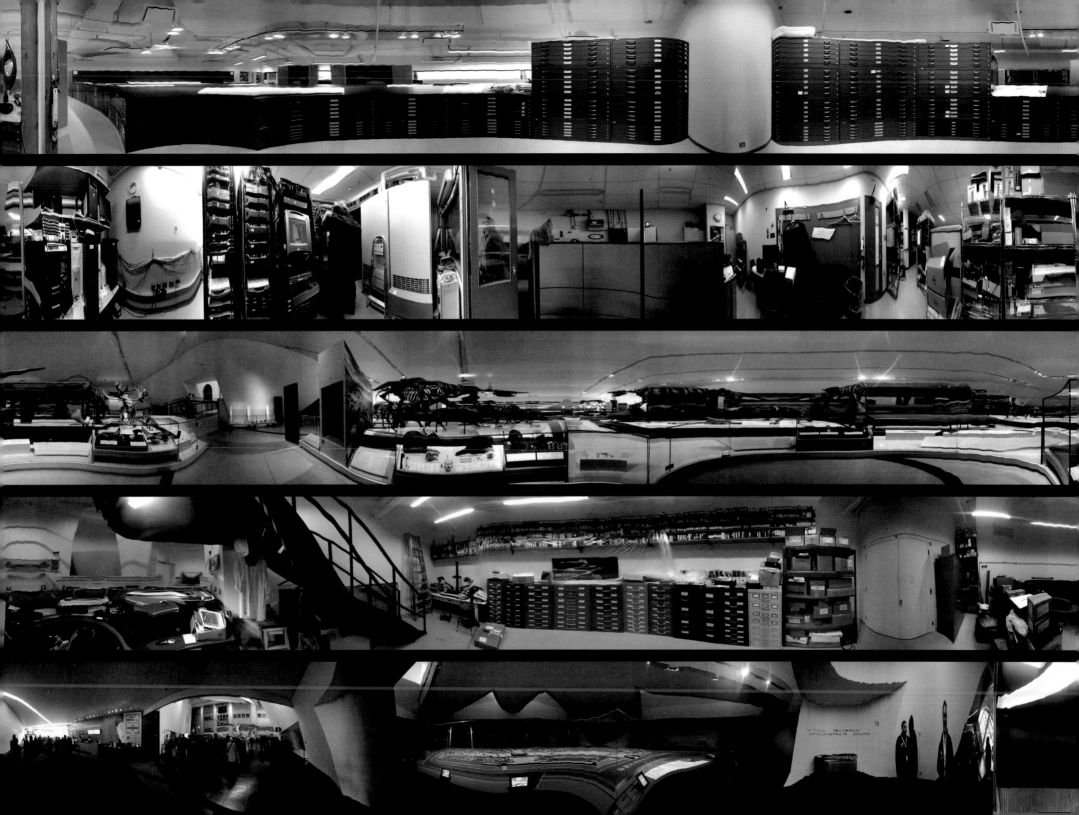

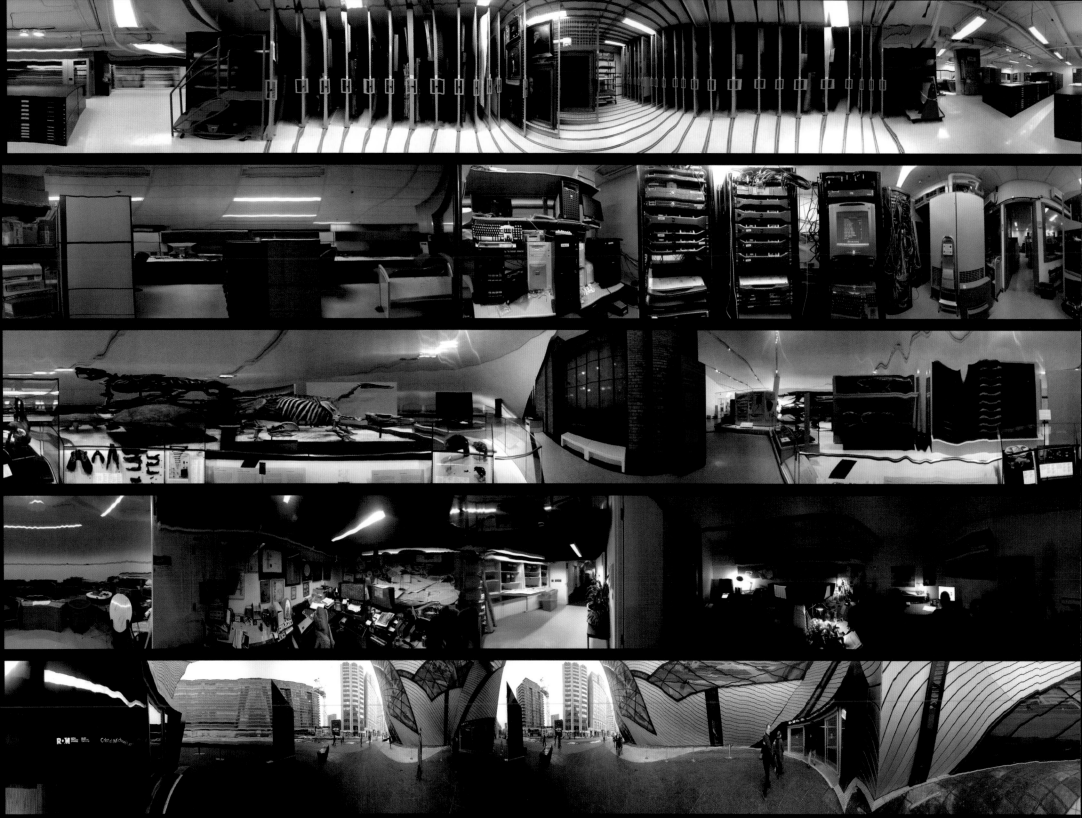

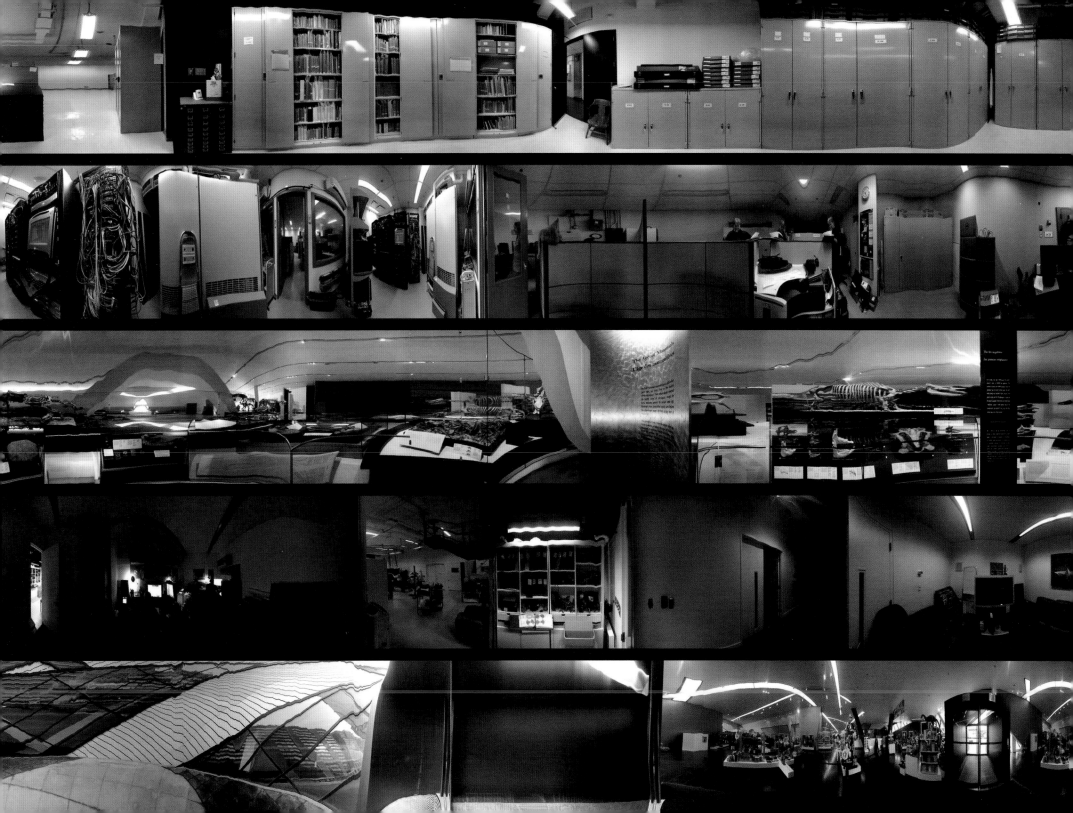

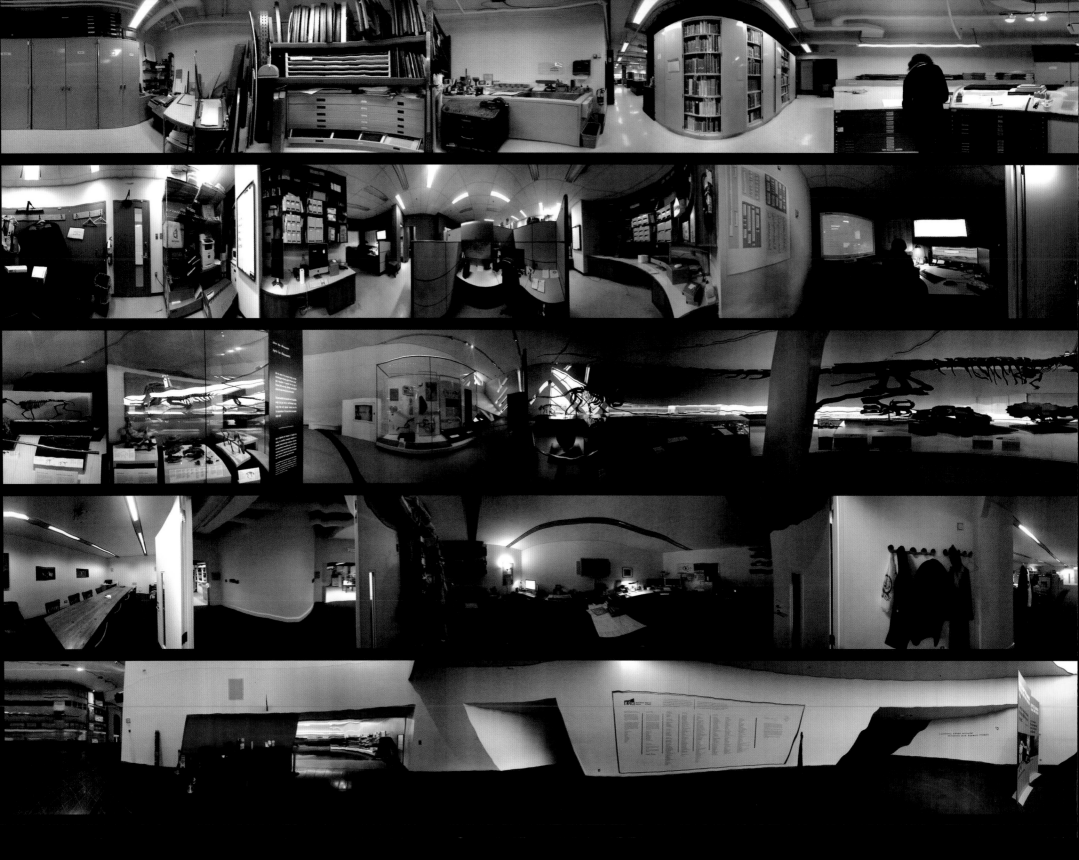

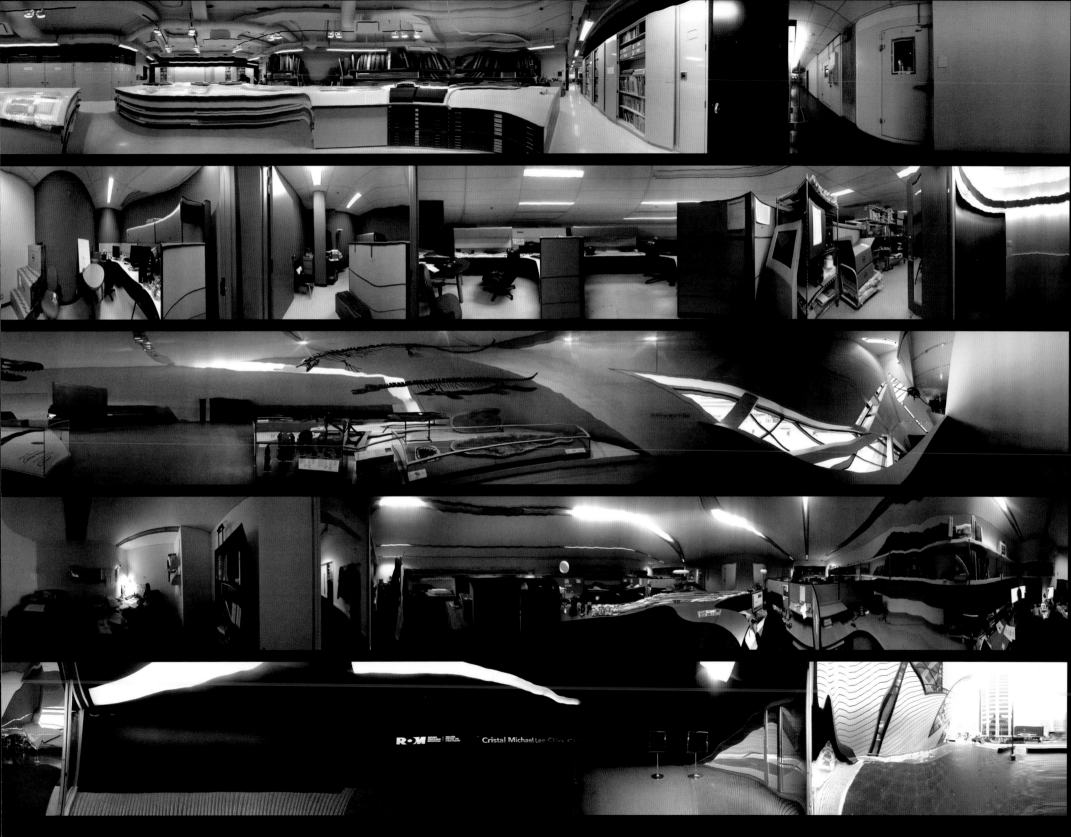

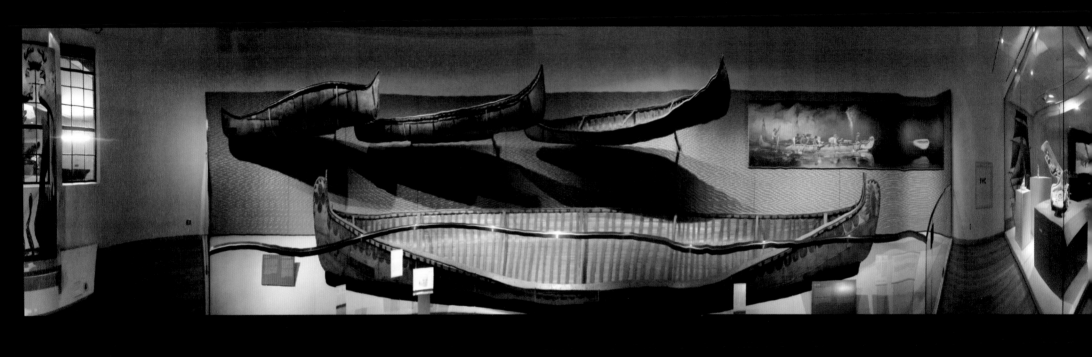

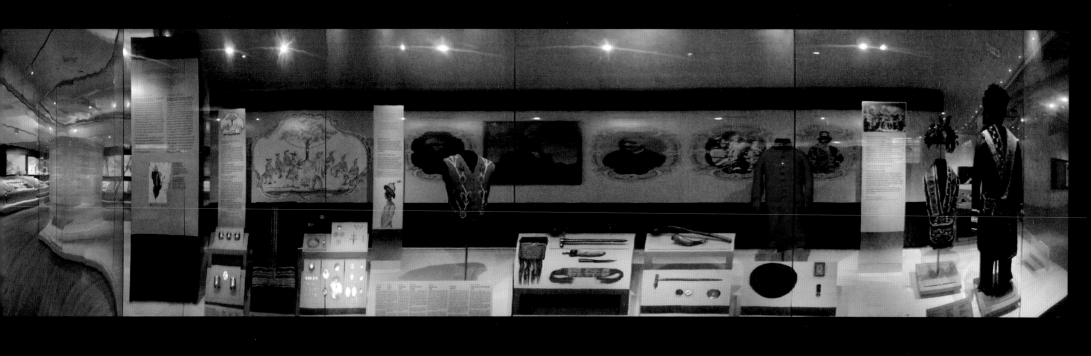

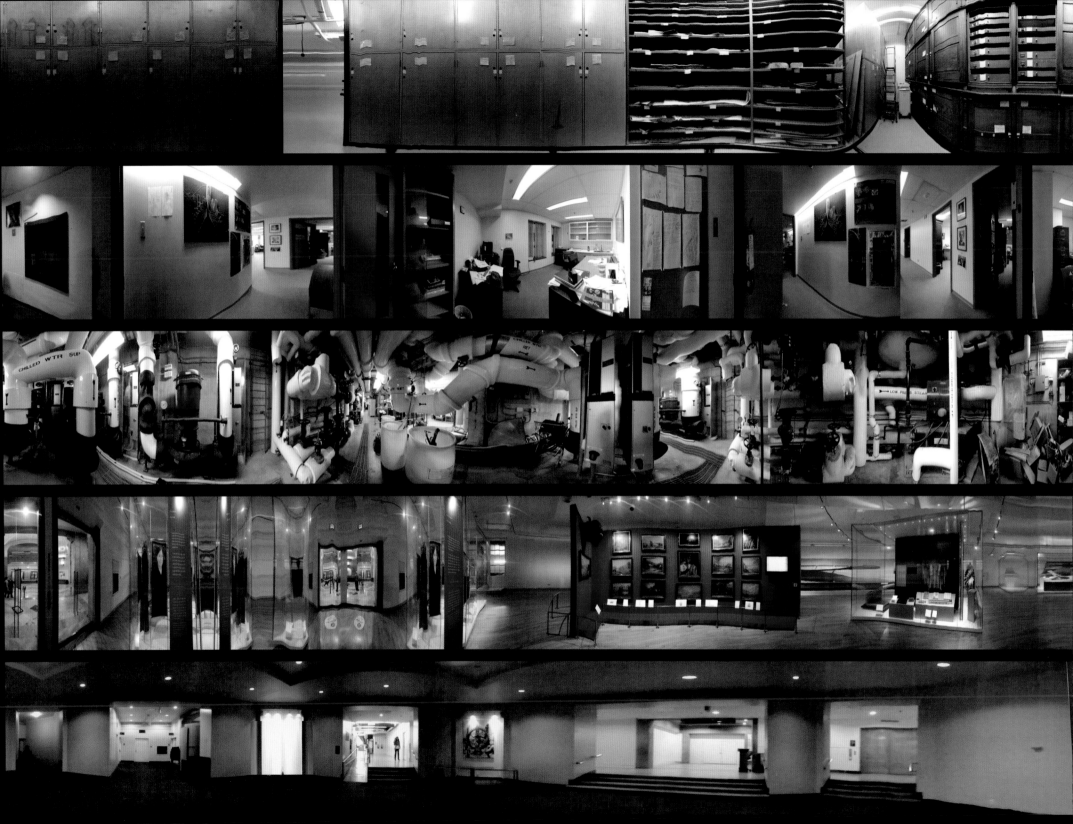

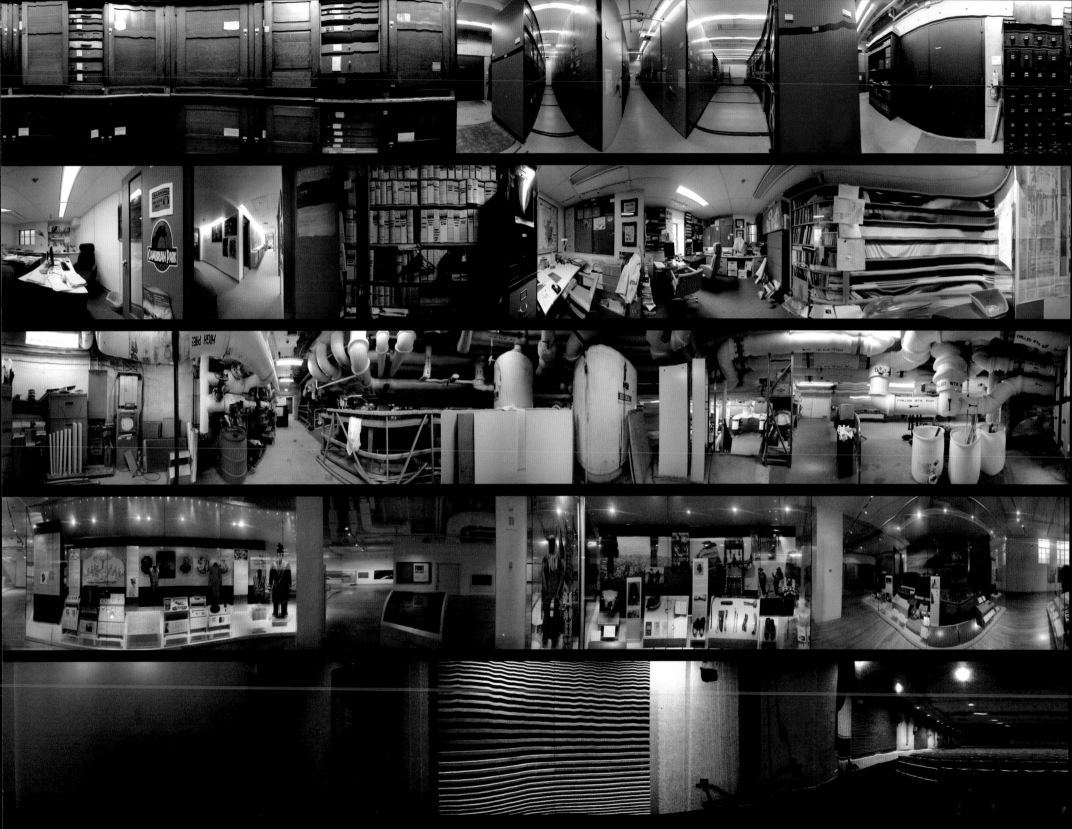

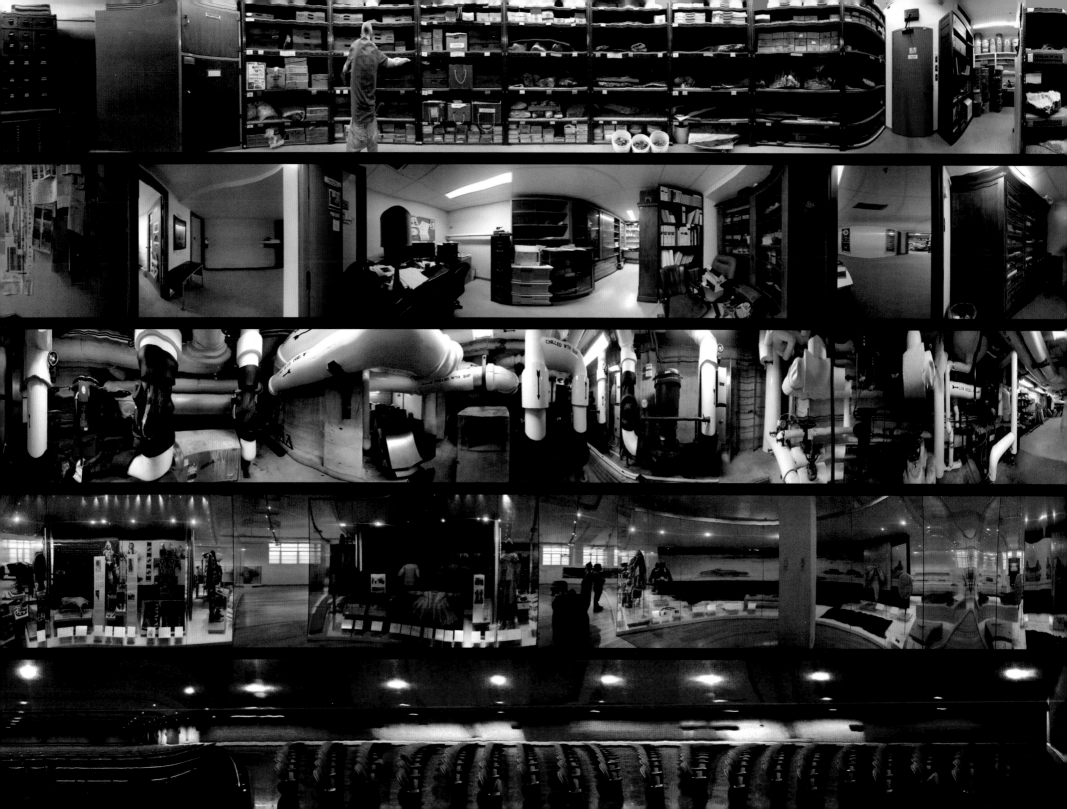

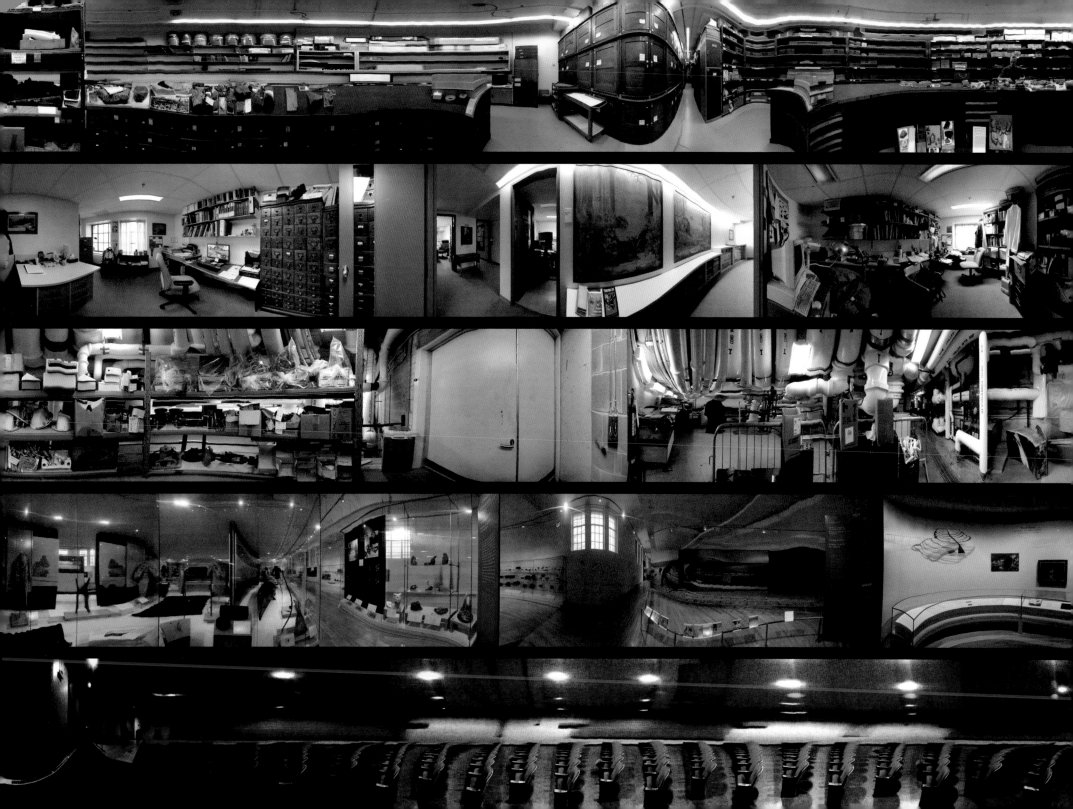

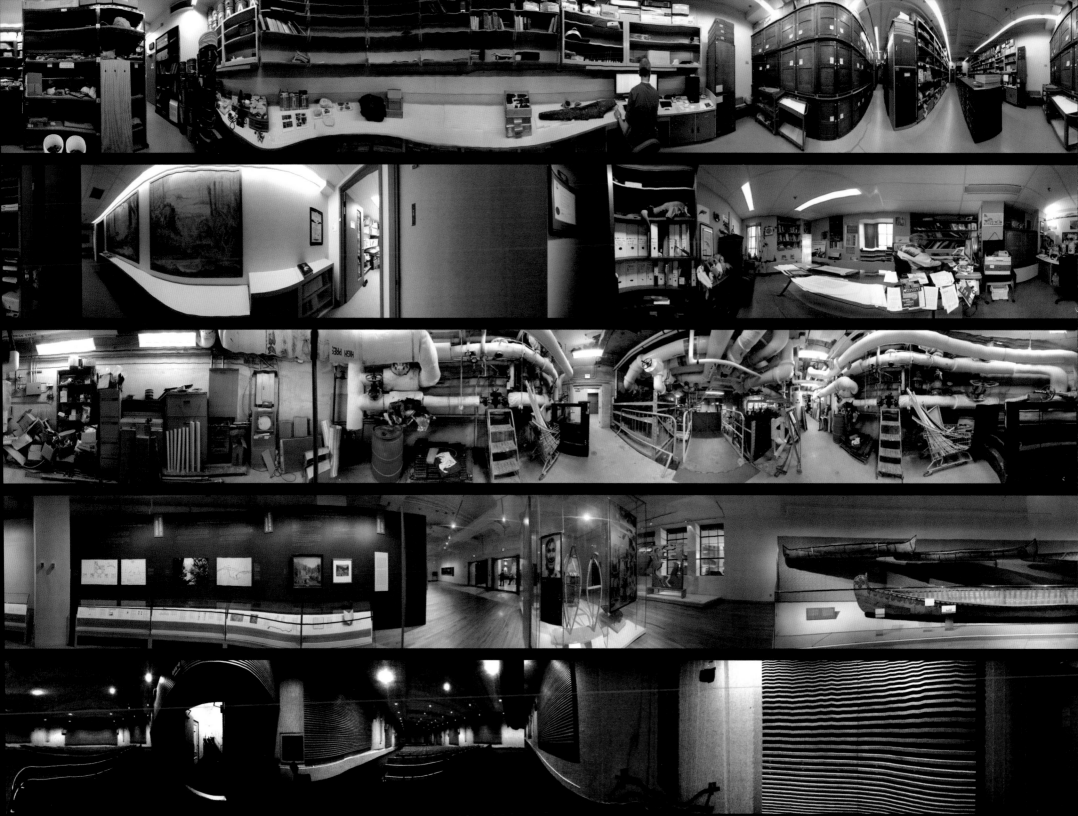

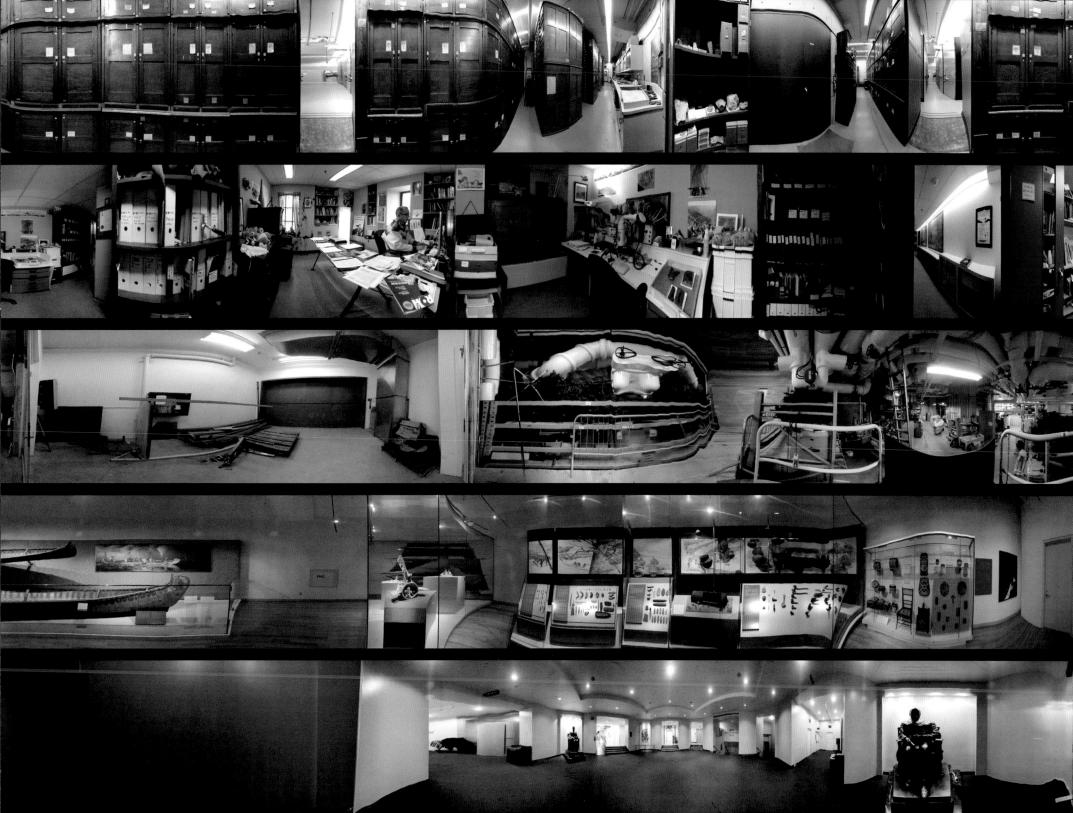

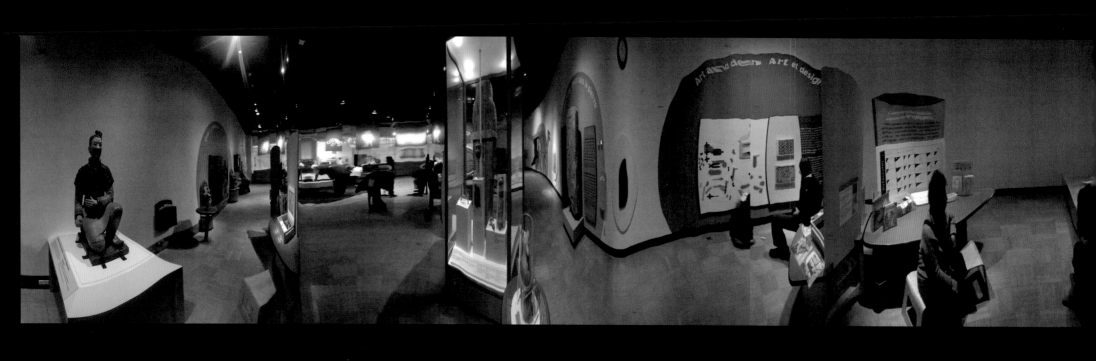

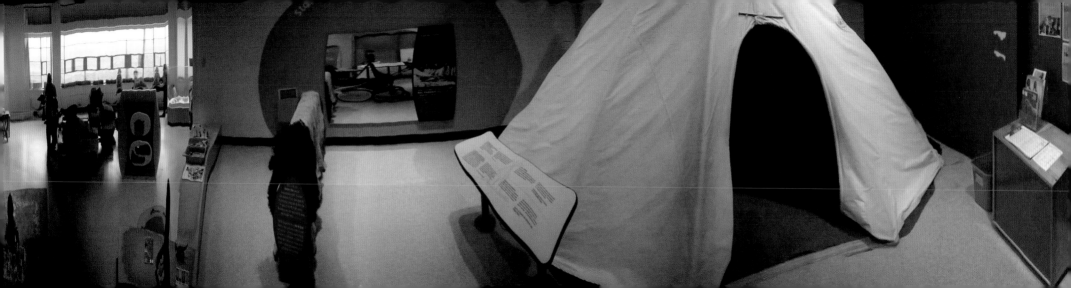

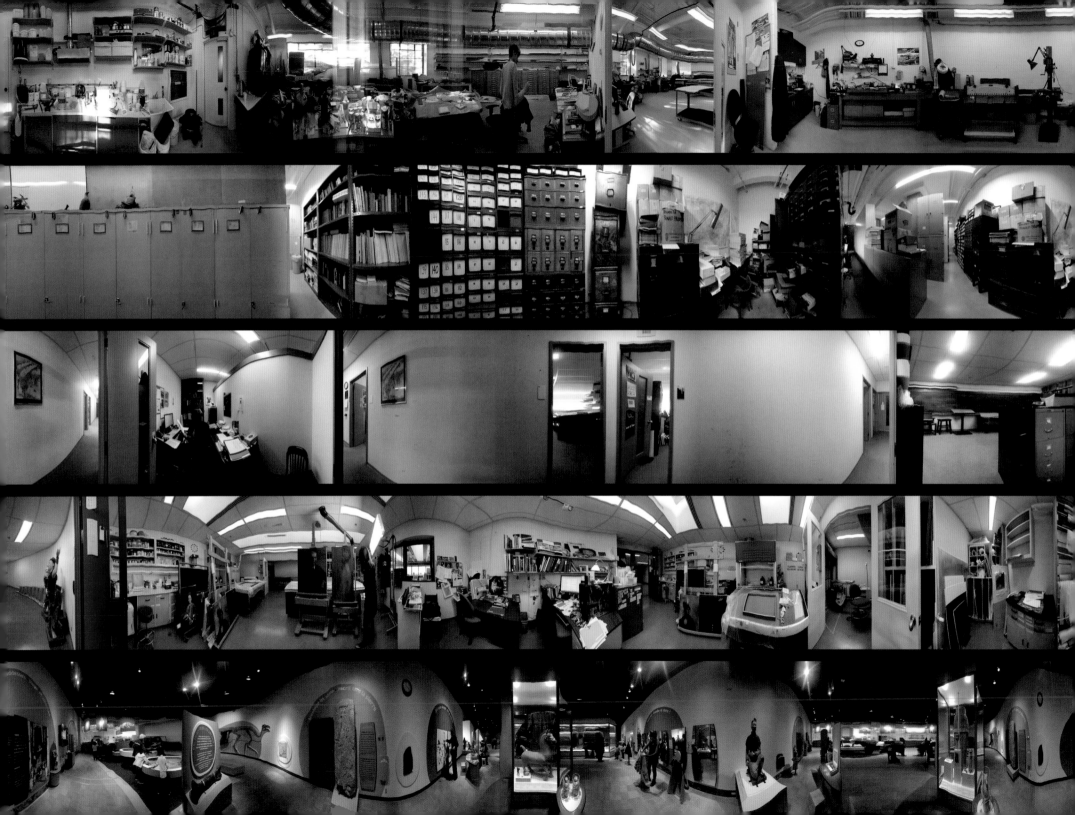

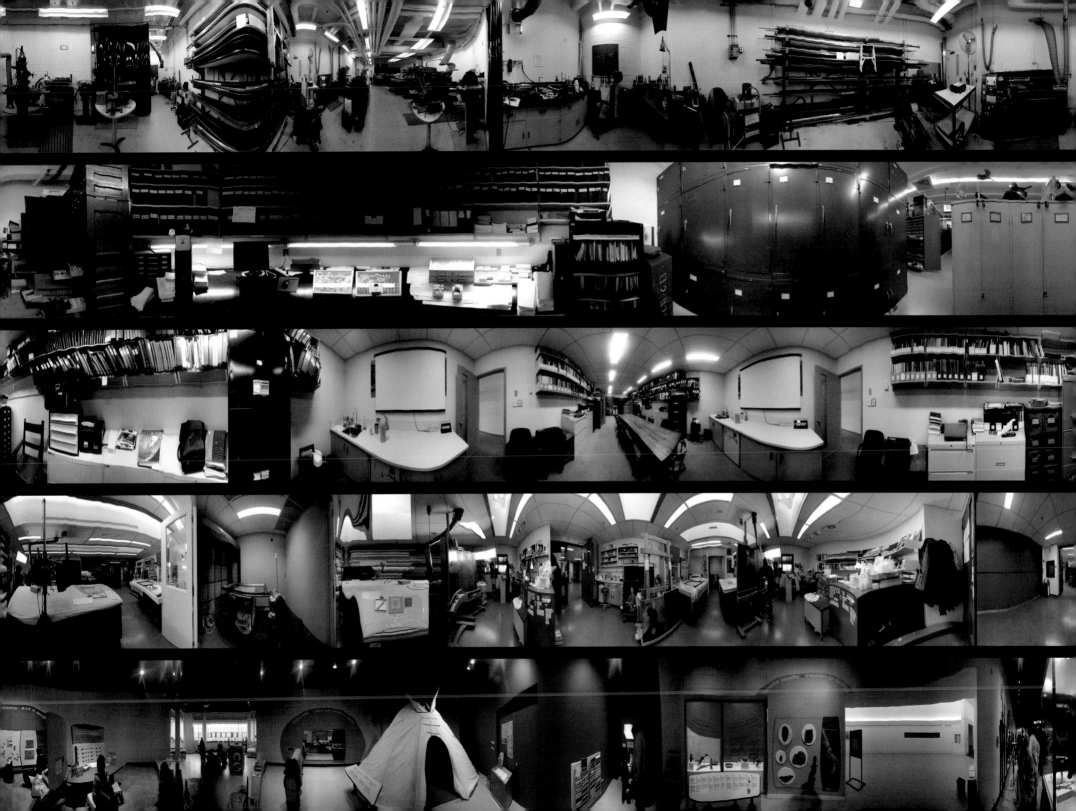

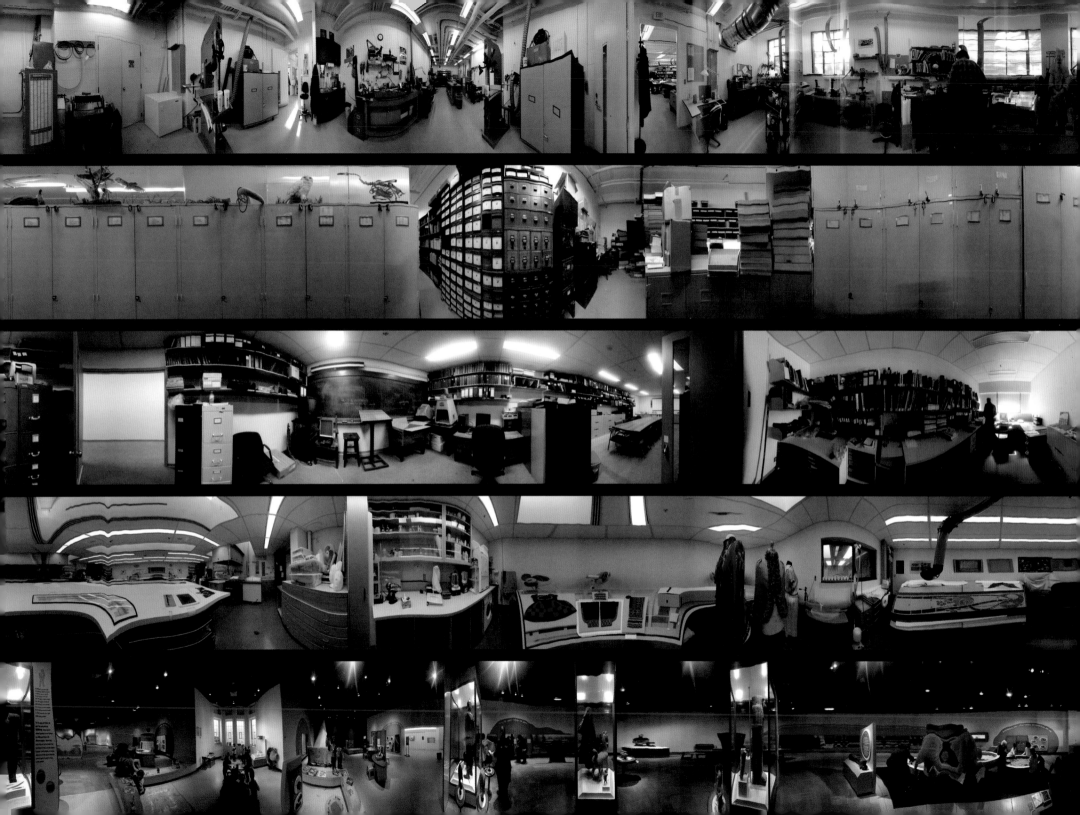

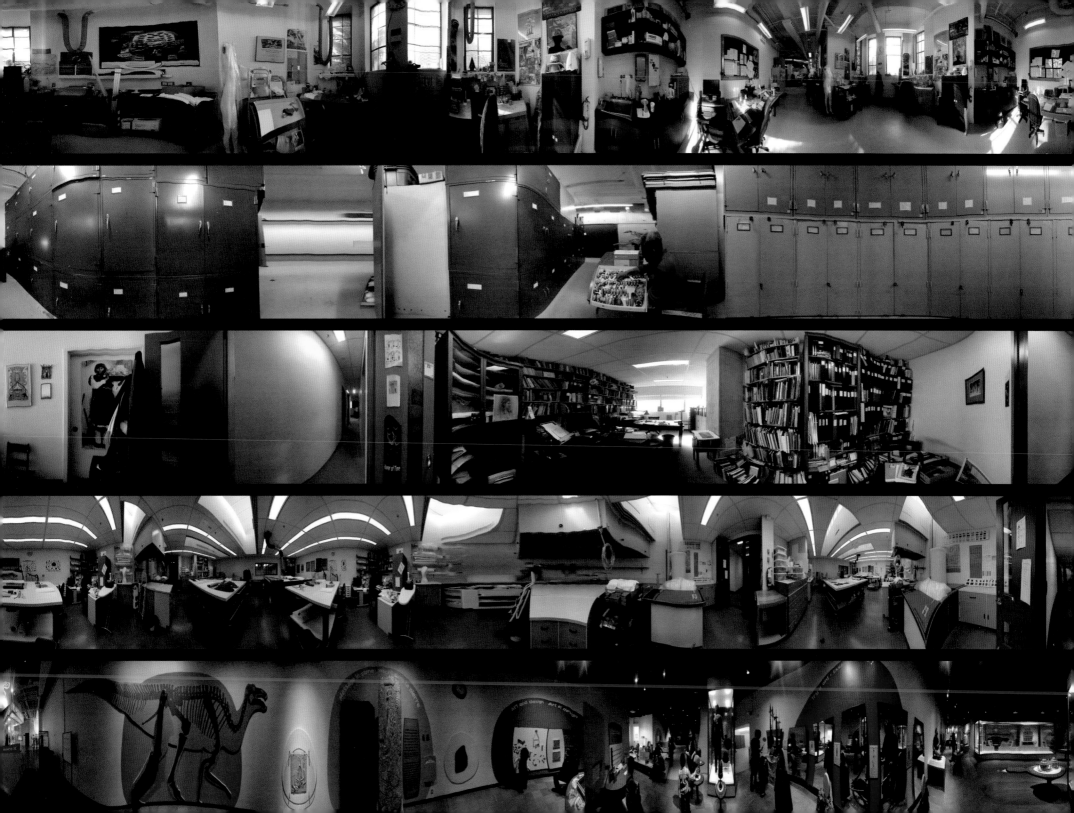

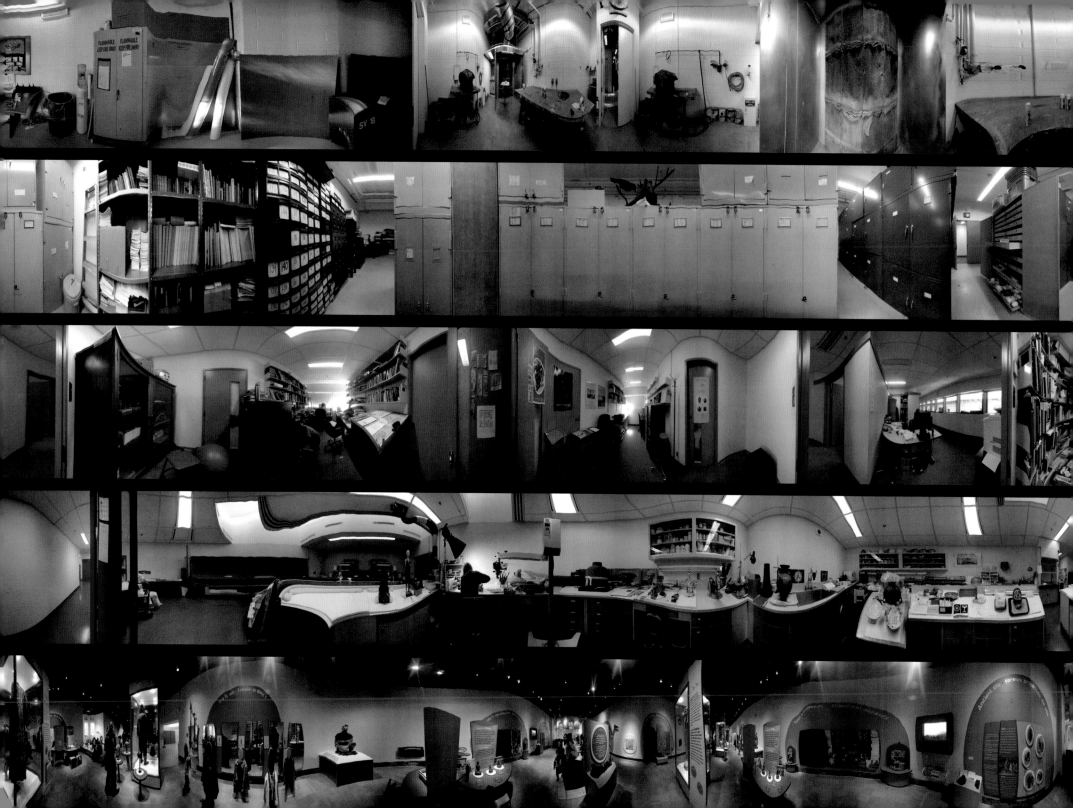

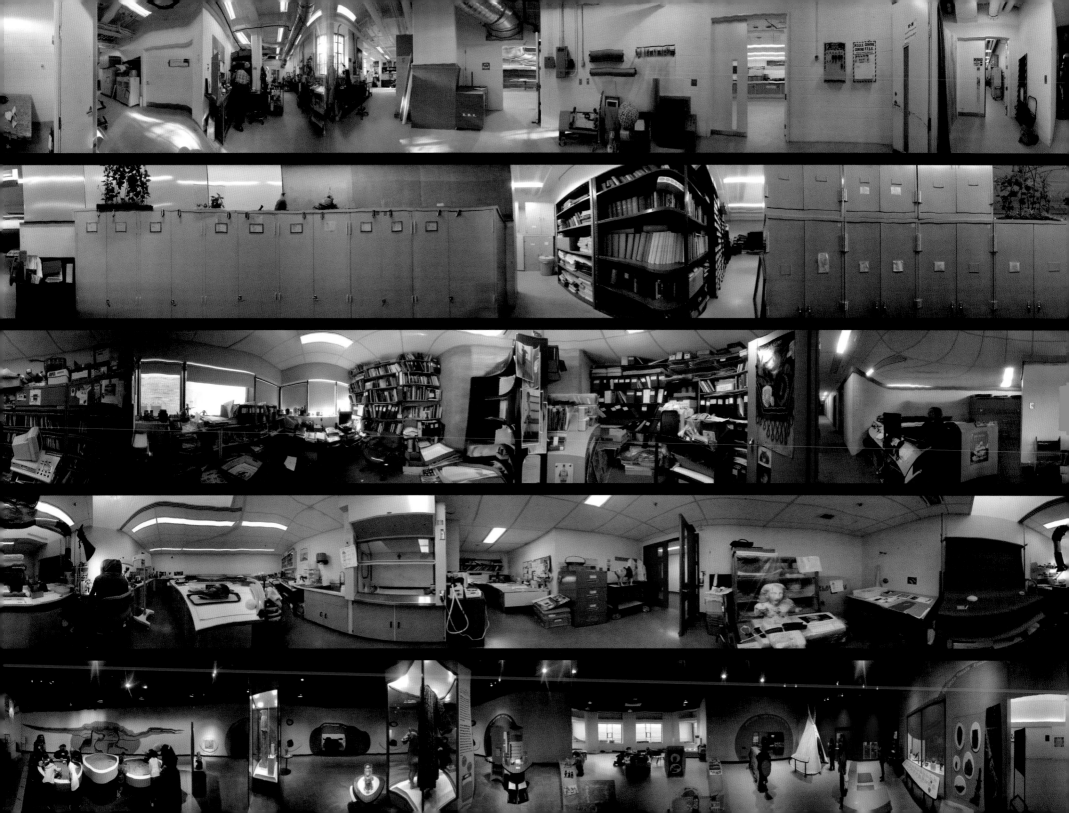

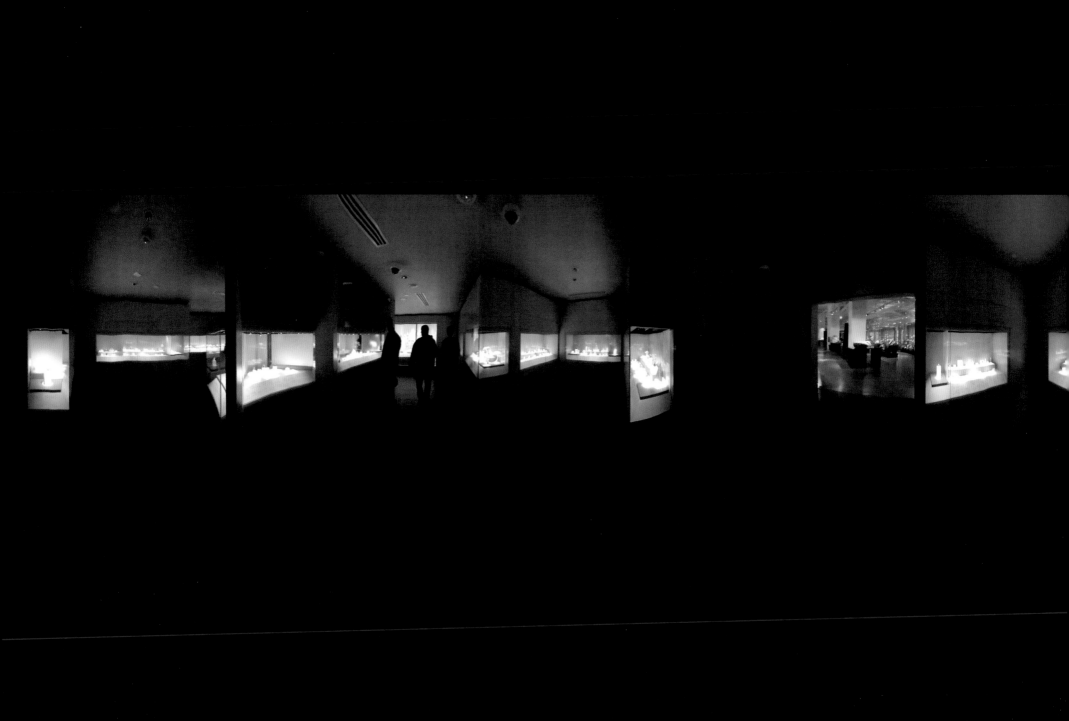

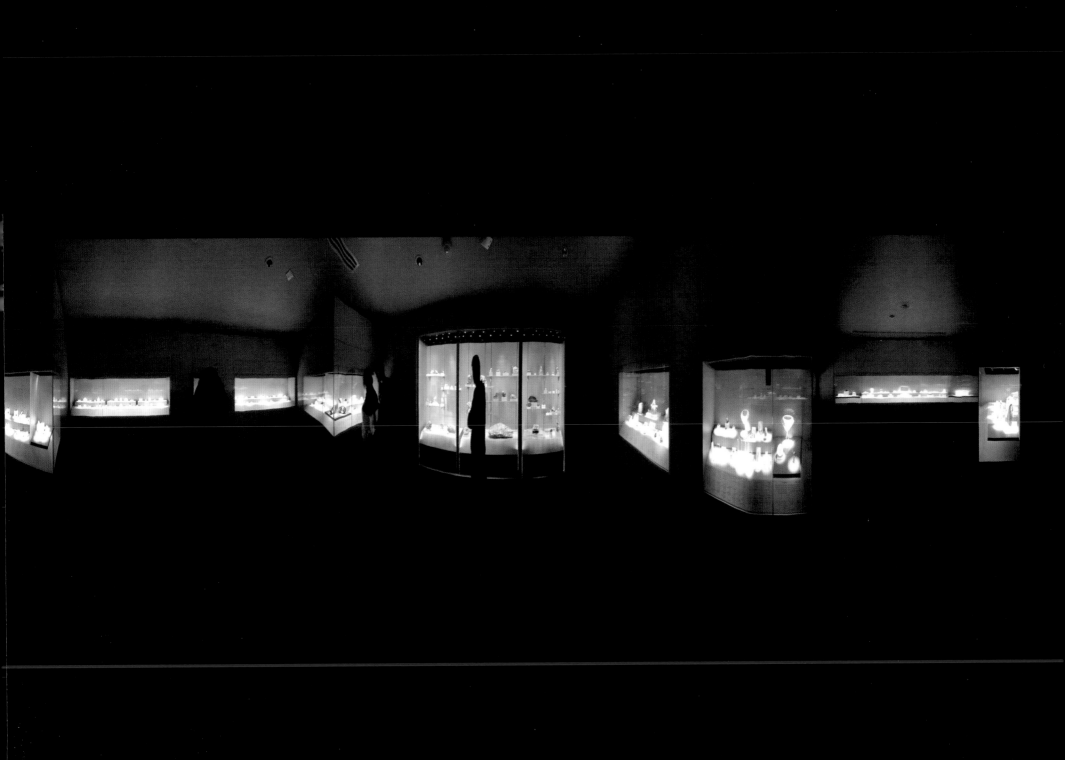

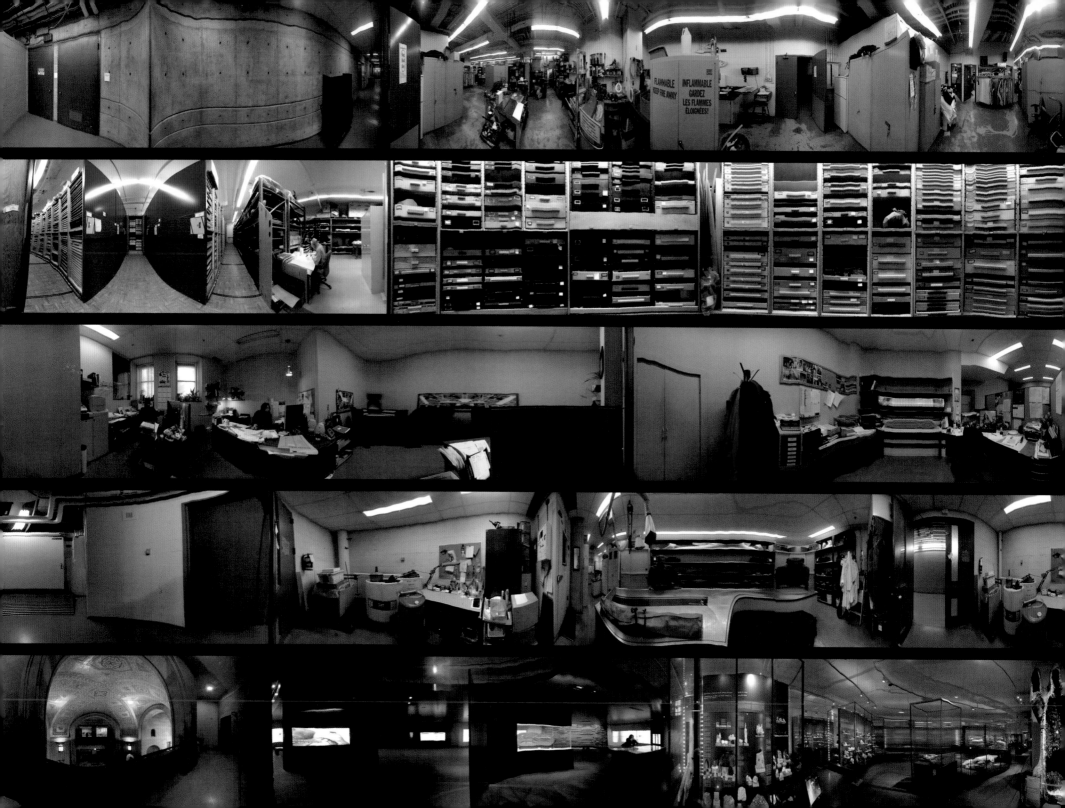

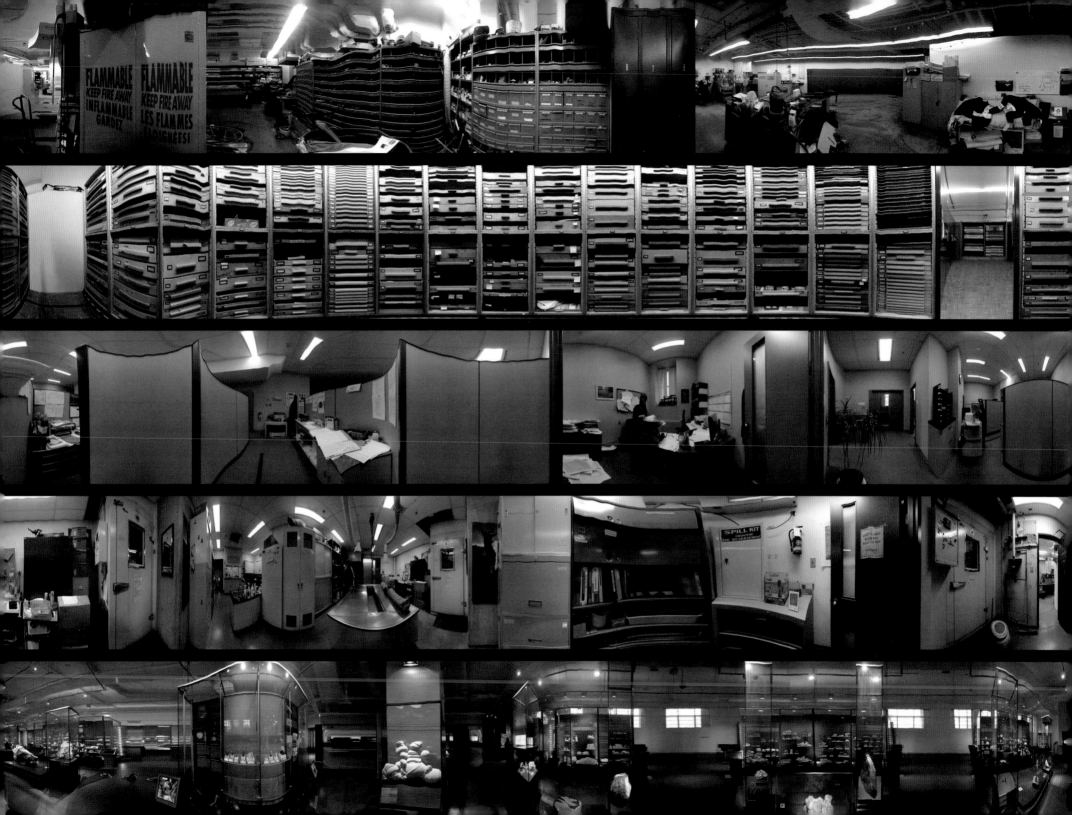

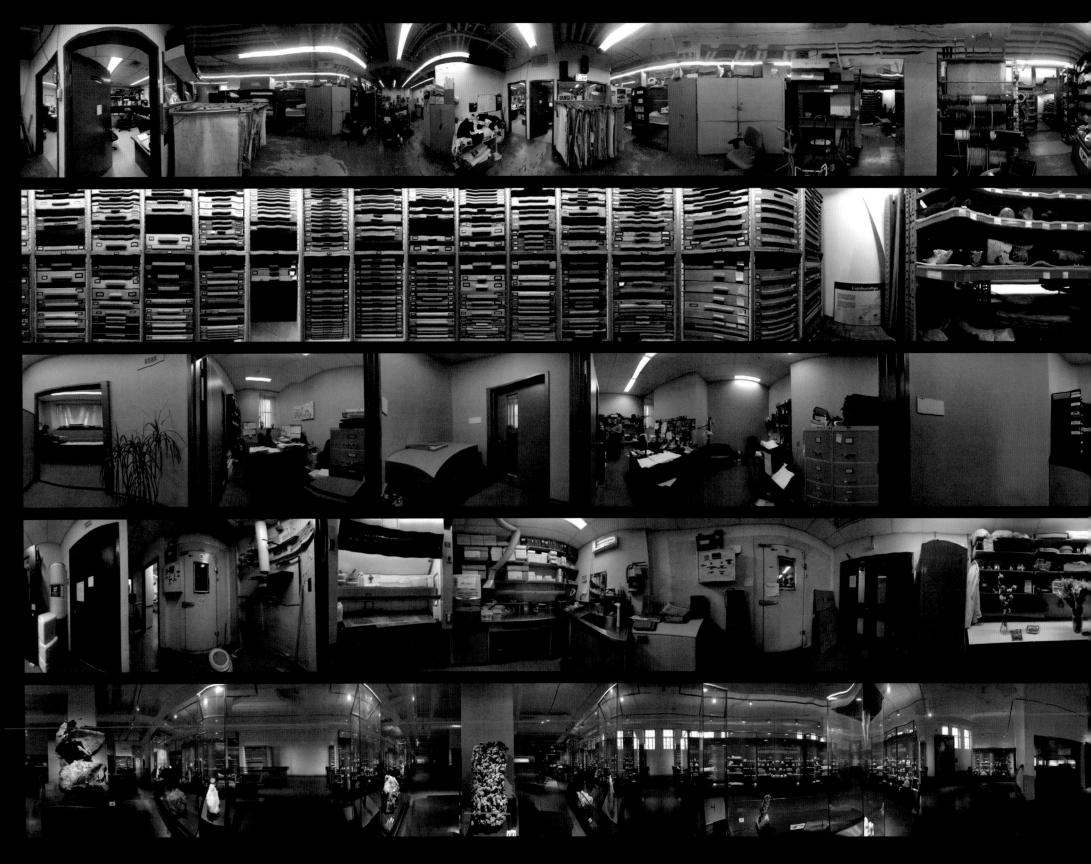

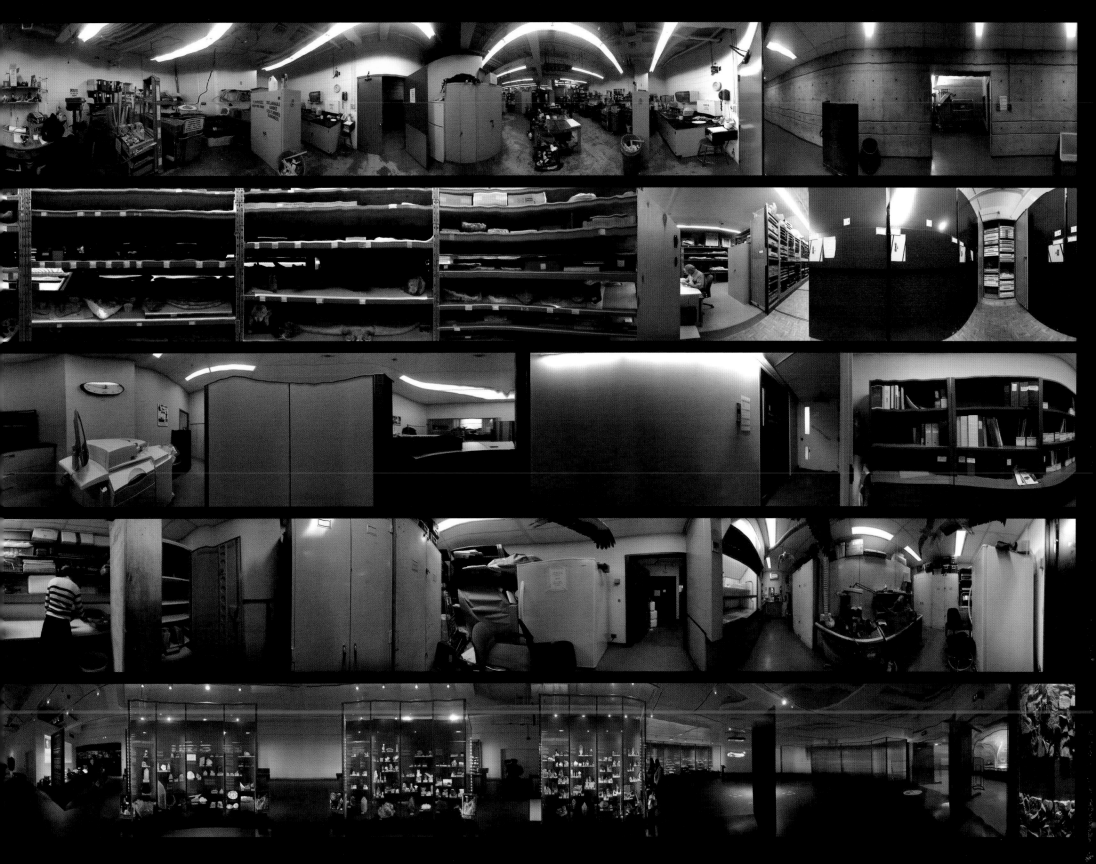

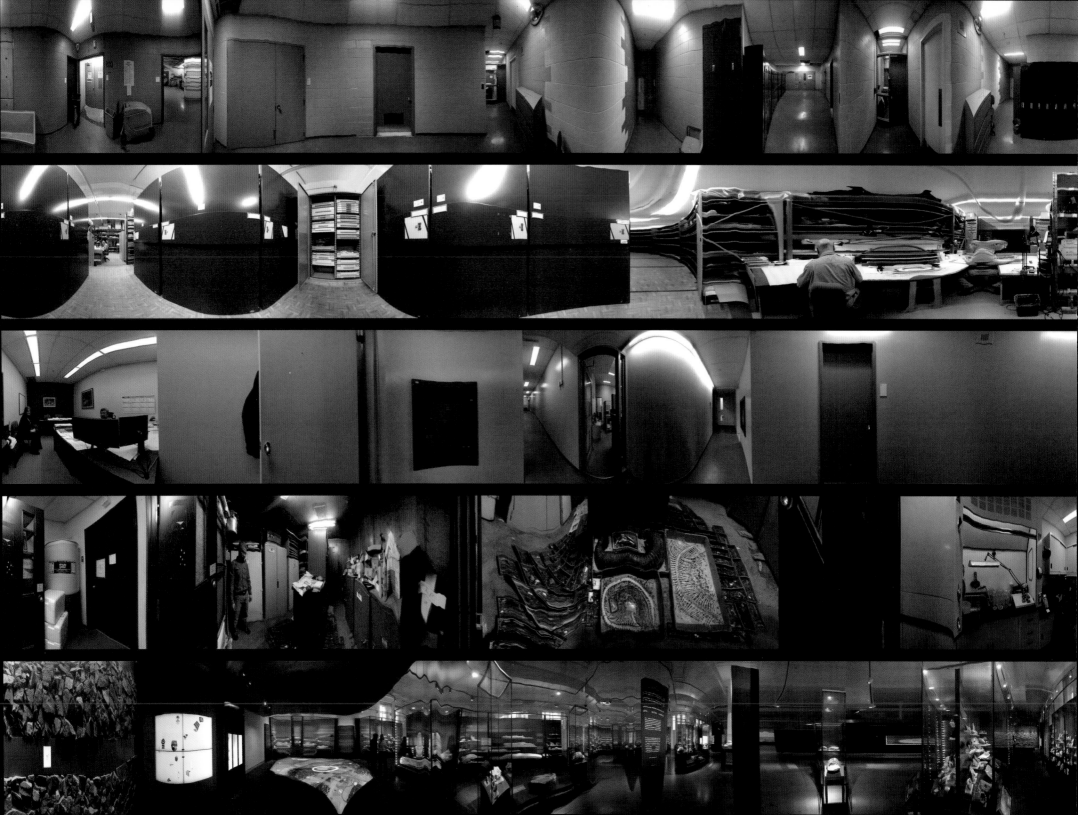

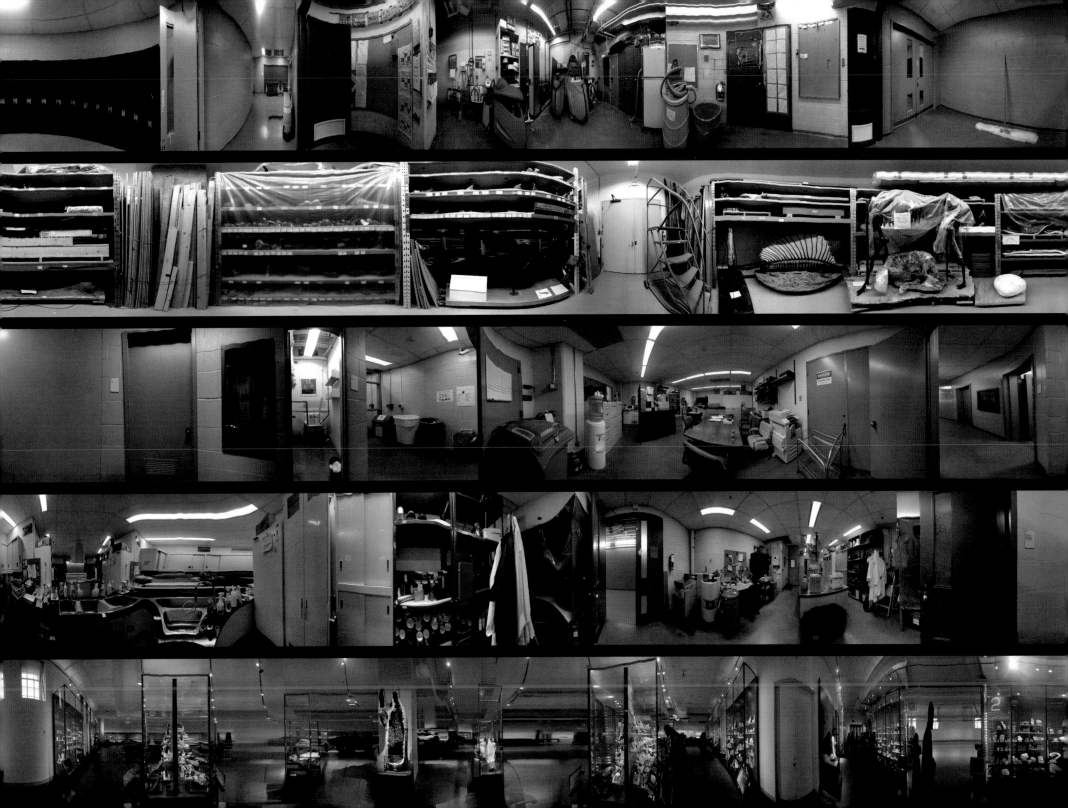

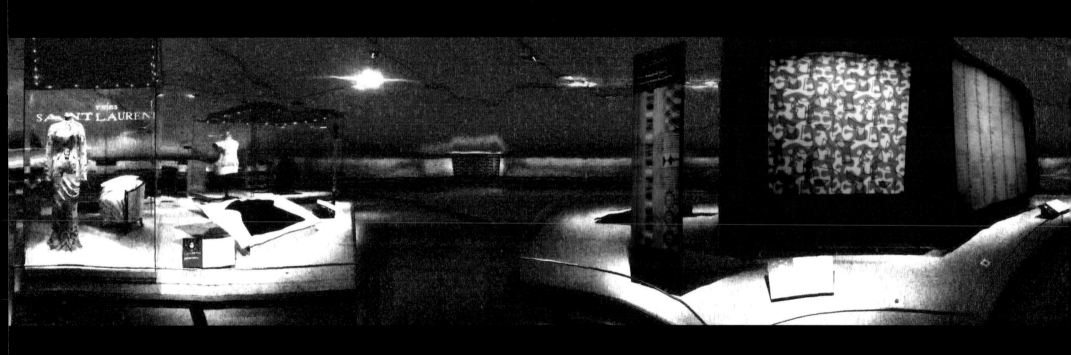

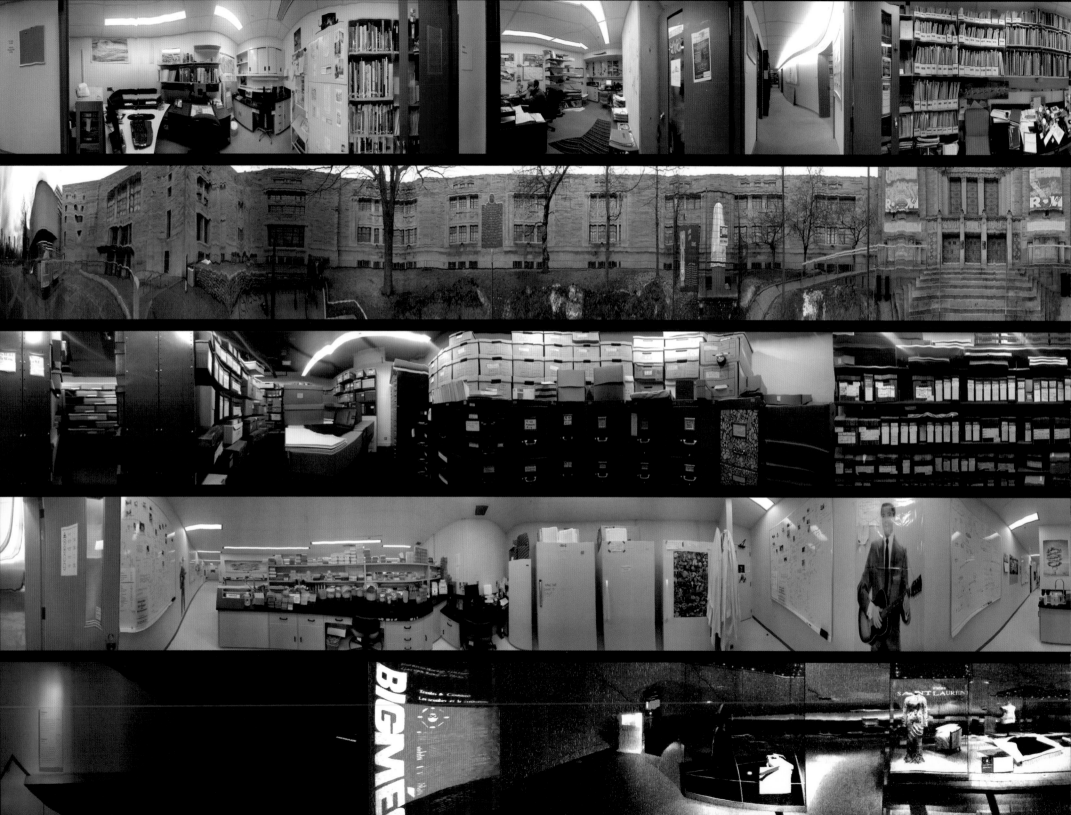

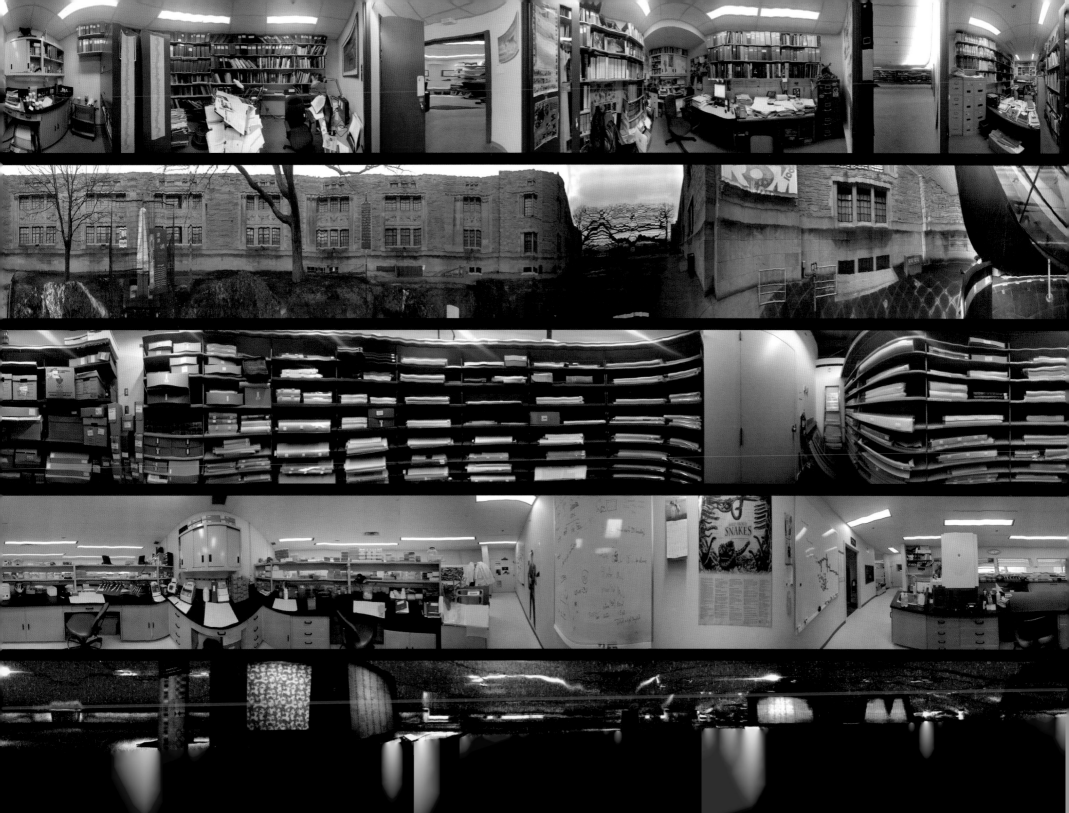

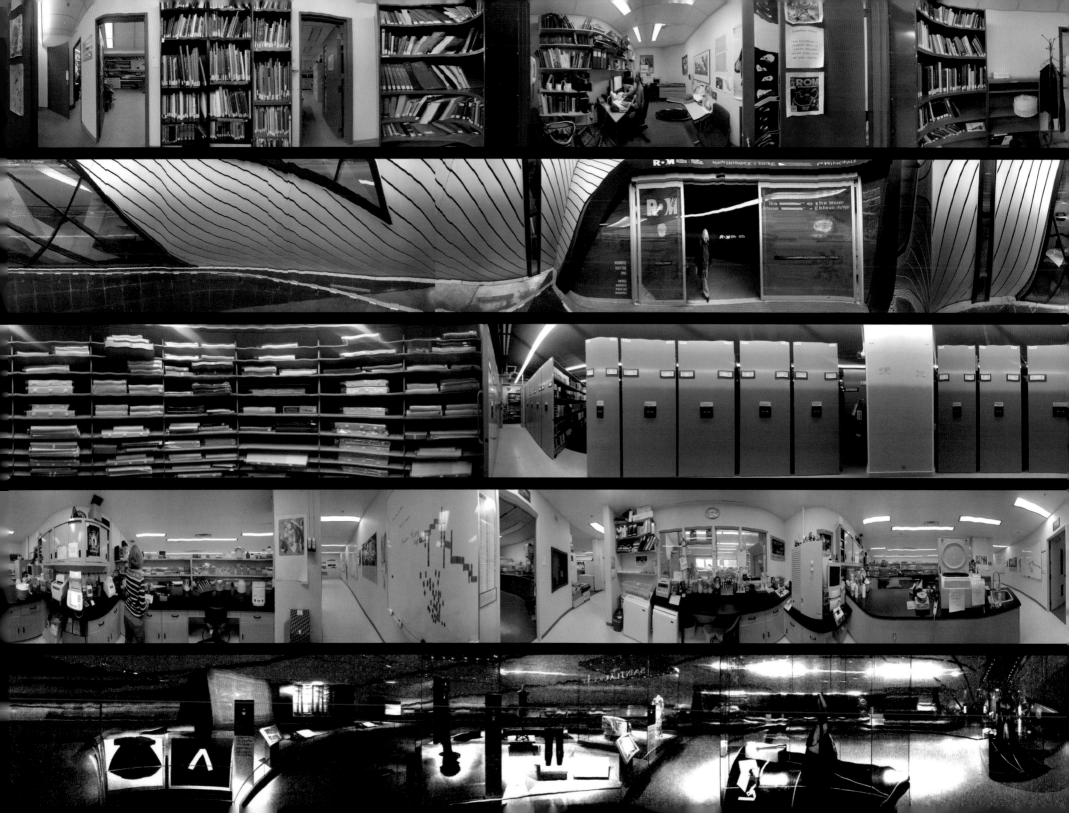

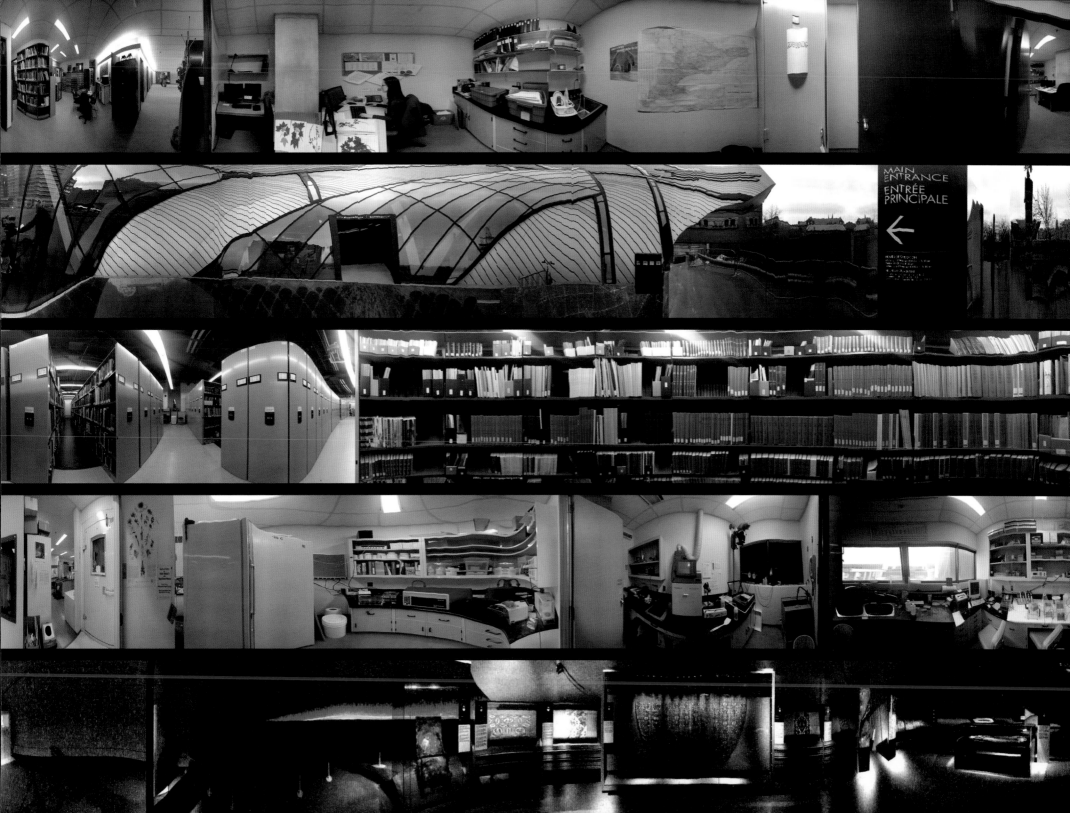

MAIN
ENTRANCE
ENTRÉE
PRINCIPALE

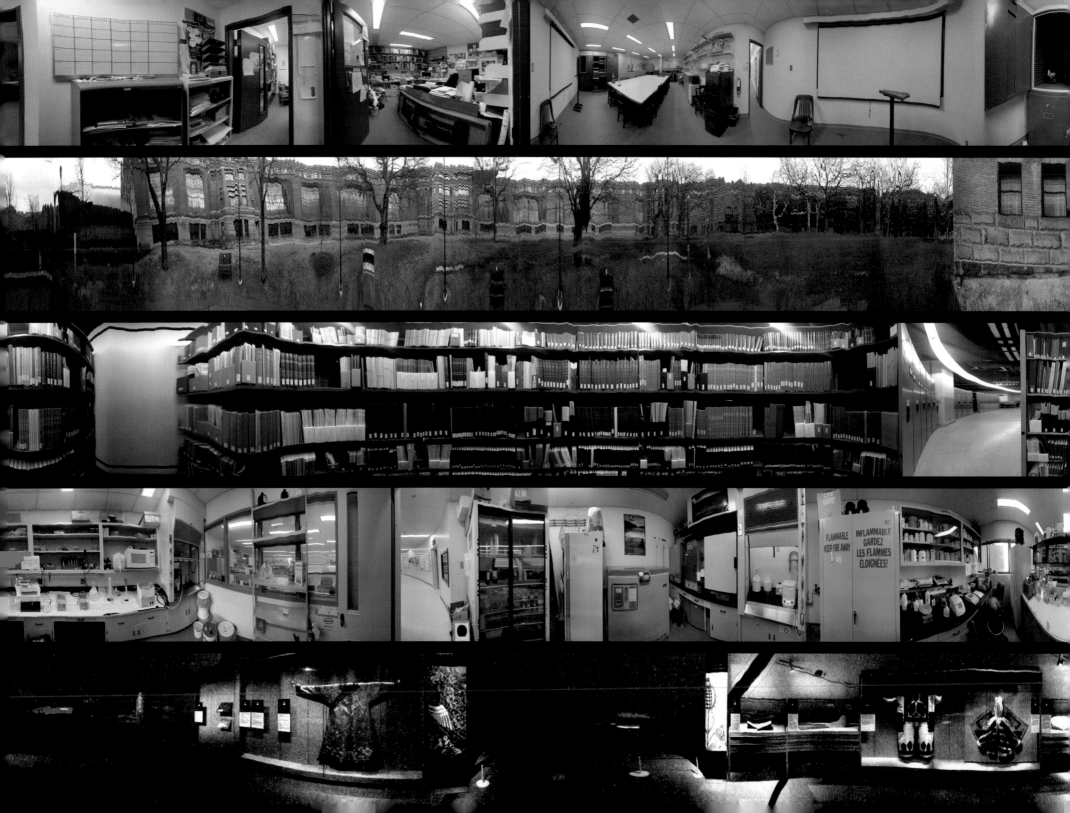

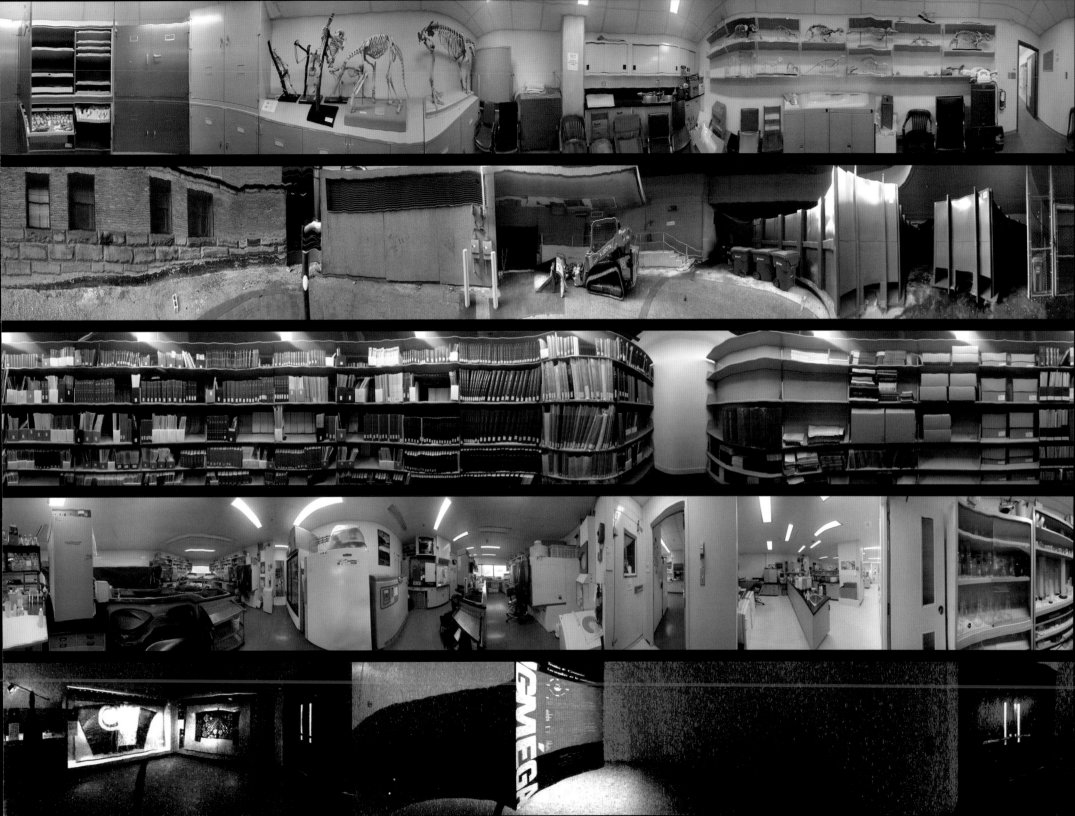

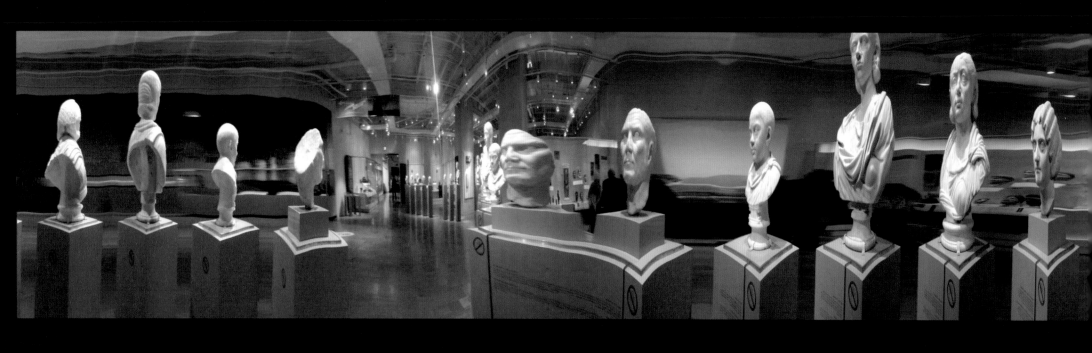

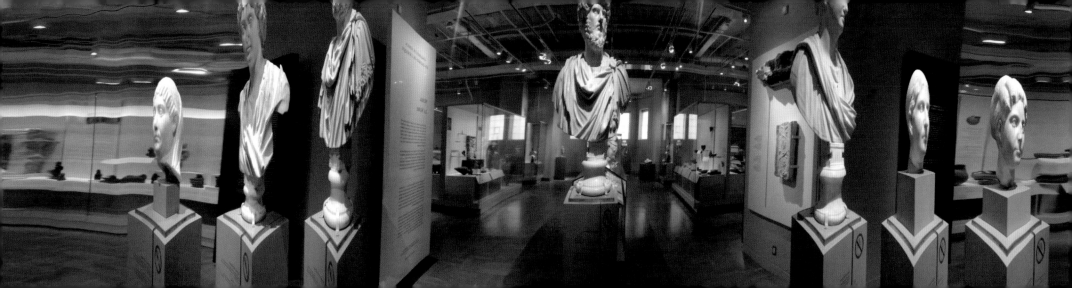

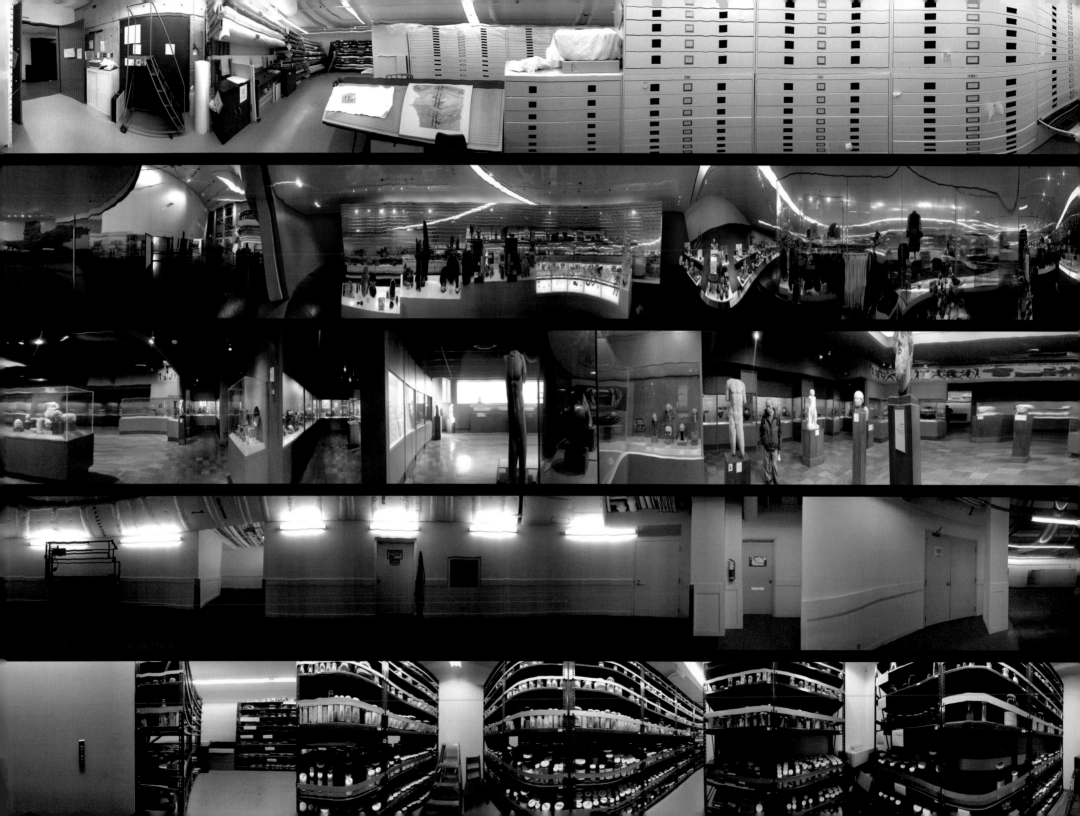

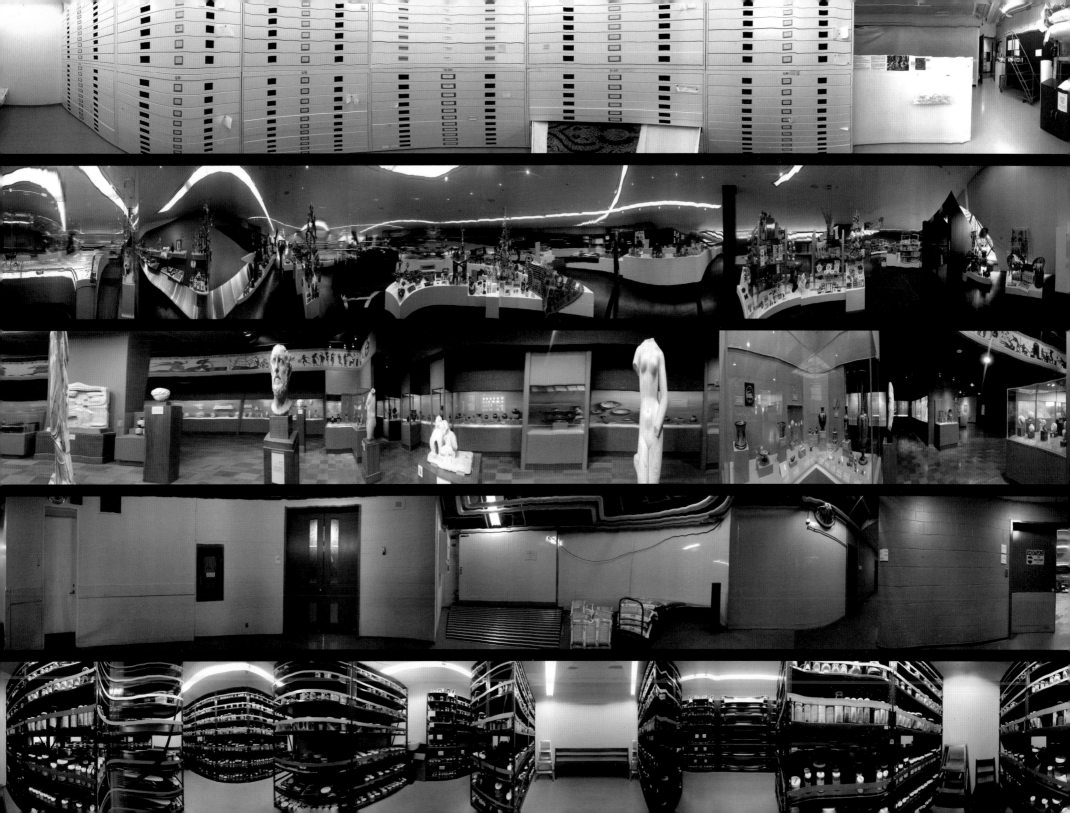

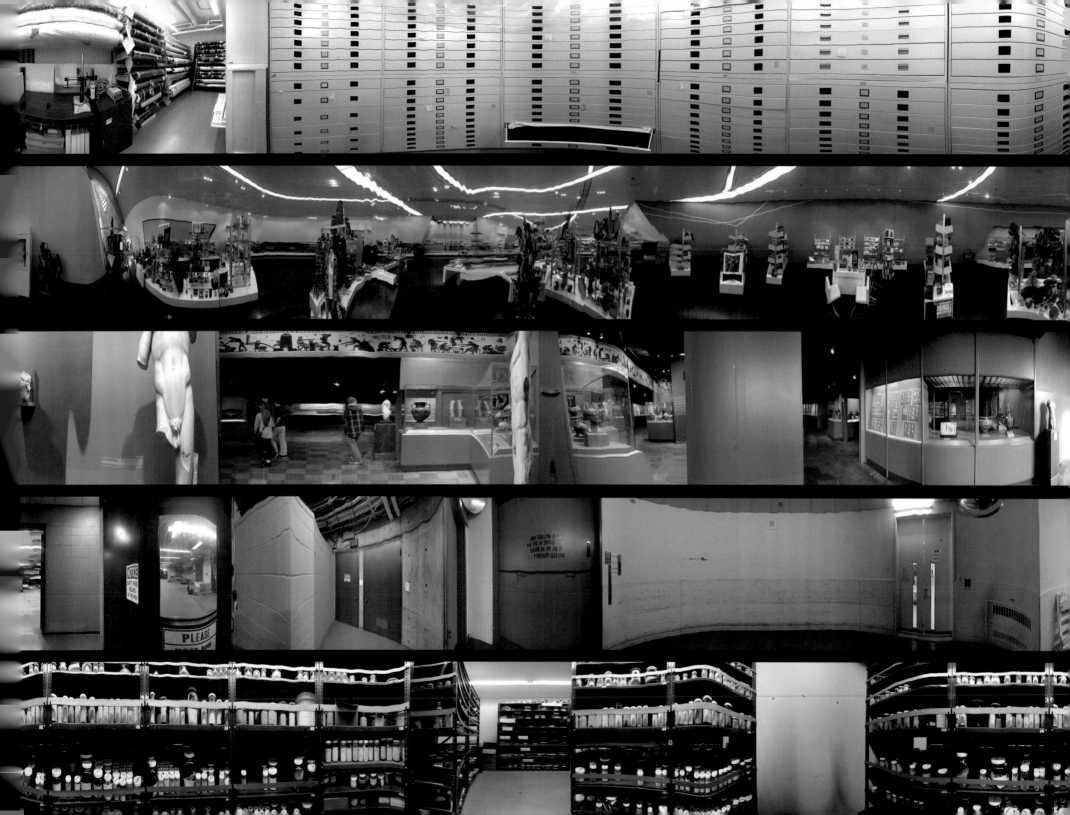

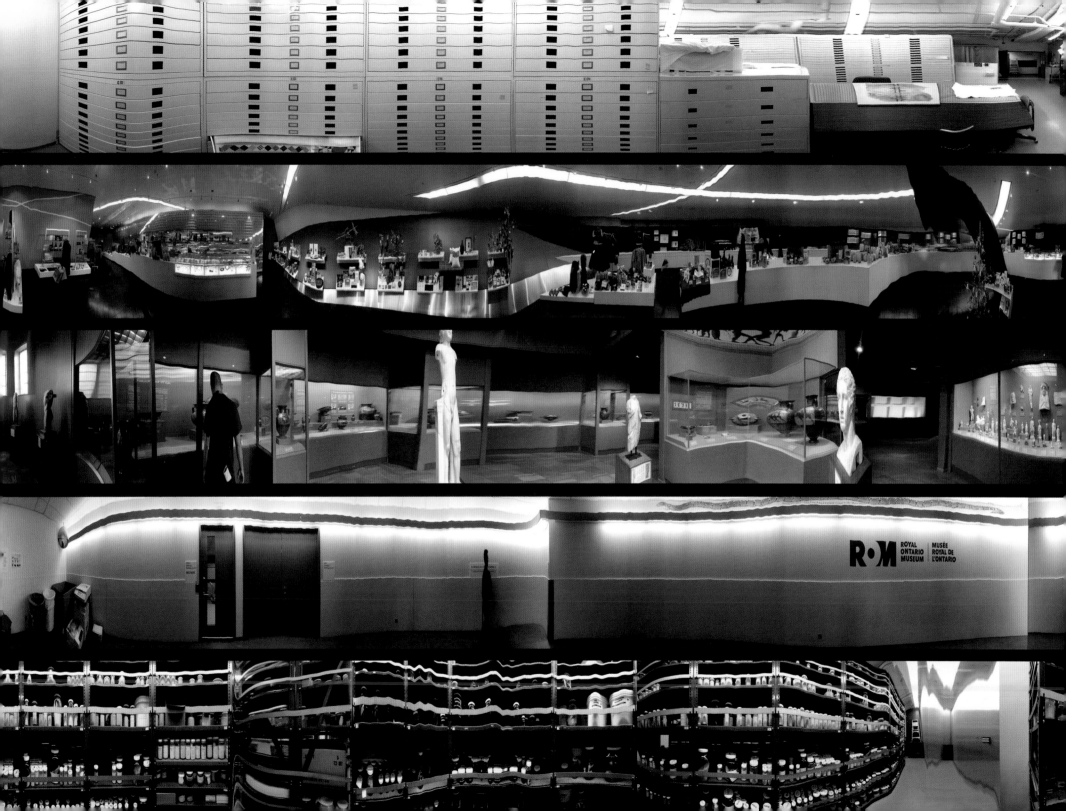

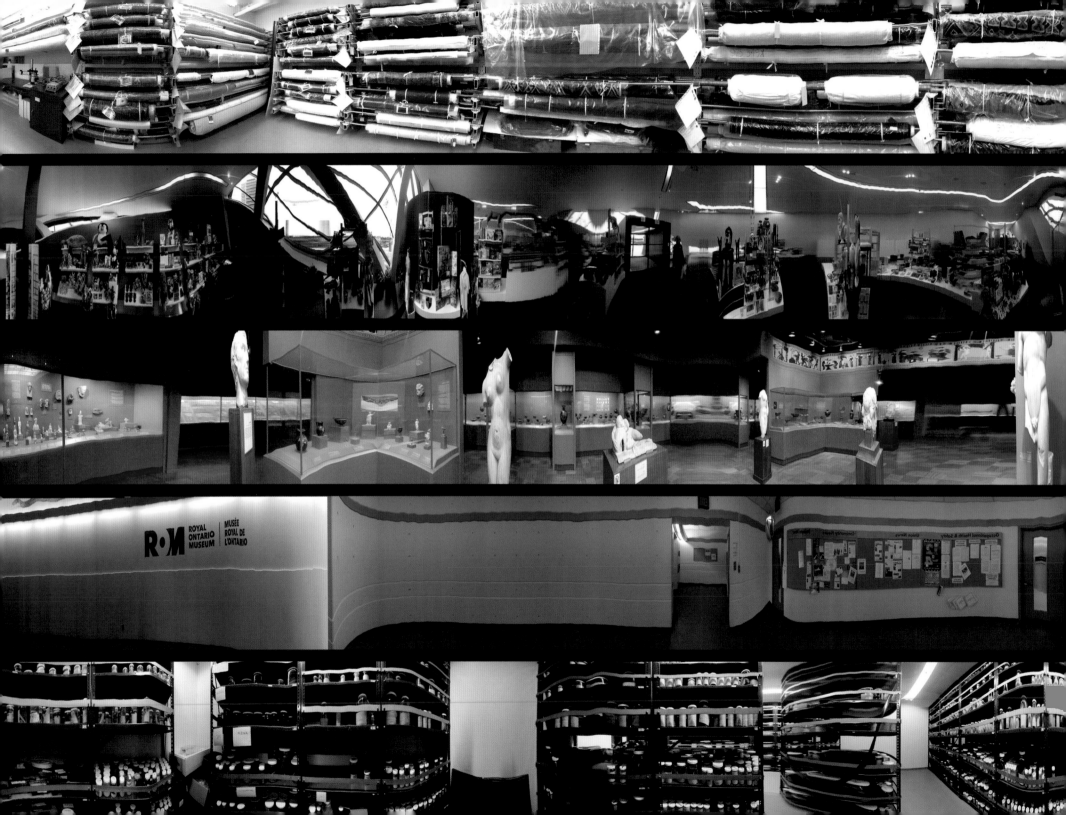

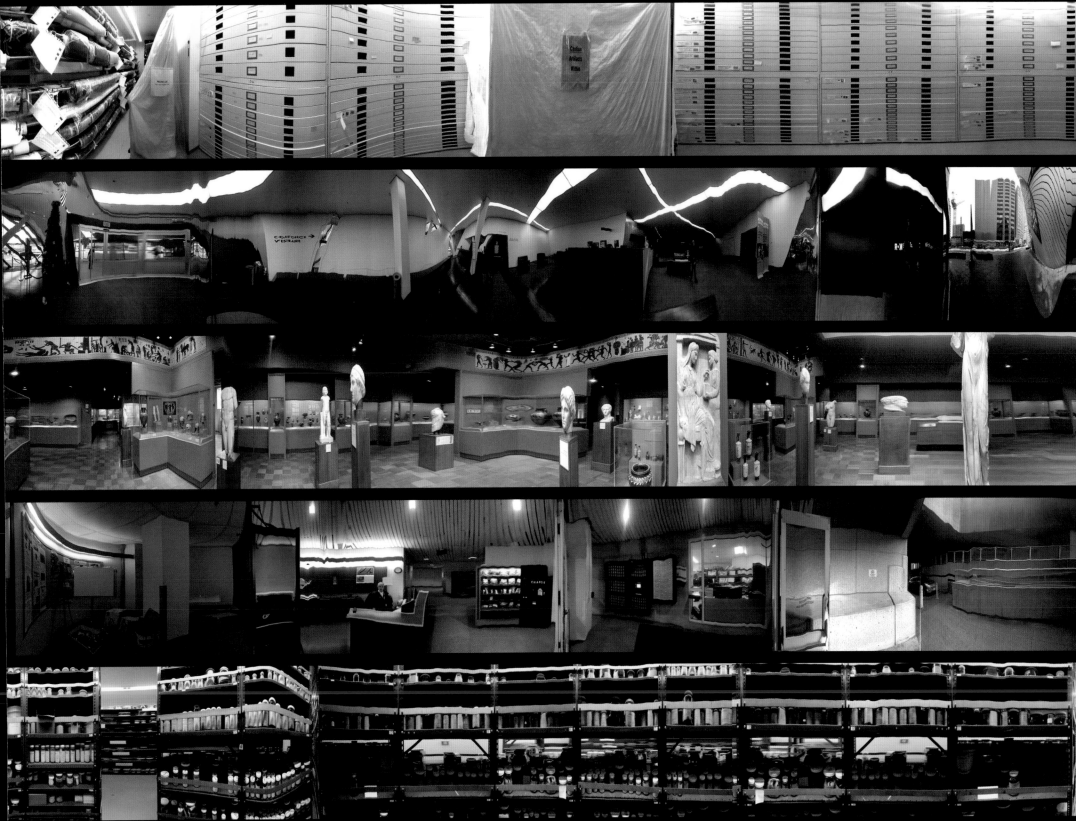

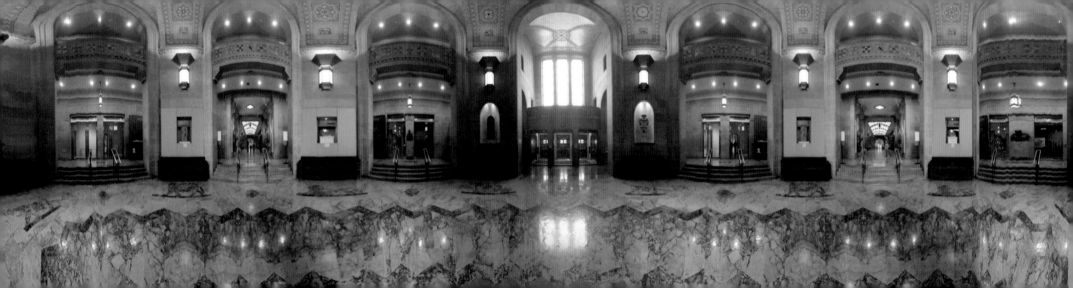

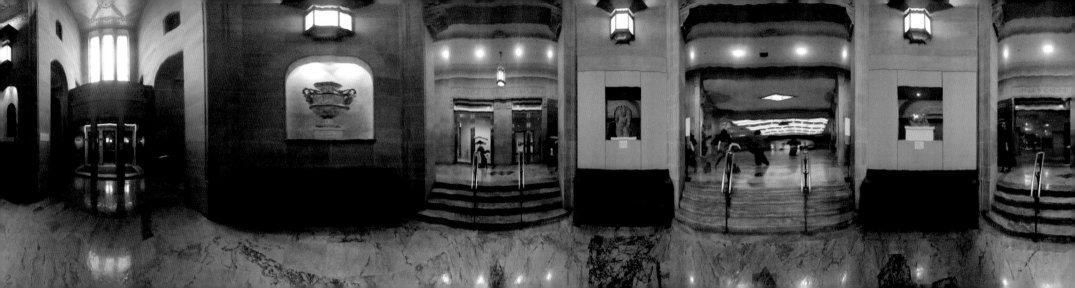

CURRICULUM VITAE

EDUCATION

2002 Masters of Urban Design, Fellowship, Faculty of Architecture, Landscape and Design, University of Toronto

1994 Masters of Architecture, Fellowship, School of Architecture, Syracuse University

1992 Bachelor of Architecture, School of Architecture, University of Toronto

1987 Physics Major, Department of Physics, University of Toronto Computer Science Minor, Department of Computer Science, University of Toronto

STUDIES ABROAD

1994 Florence, Italy

1991 Paris, France / Berlin, Germany

1990 Royal Danish Academy, Copenhagen, Denmark

SOLO EXHIBITIONS

2014 *The Entire City Project*, Nicholas Metivier Gallery
 The Entire City Project, The Royal Ontario Museum

2012 *The Entire City Project*, Nicholas Metivier Gallery

2008 *The Entire City Project,* Nicholas Metivier Gallery

2006 *The Entire City Project*, Nicholas Metivier Gallery

2005 *The Entire City Project,* Art Gallery of Ontario
 CityScapes, Goethe Institute, Toronto
 Urban Transformations, Goethe Institute, Toronto

2004 *Five Cities,* Chicago Cultural Centre

GROUP EXHIBITIONS

2011 *Structure*, Nicholas Metivier Gallery
 Carnival, Nicholas Metivier Gallery

2009 *Beautiful Fiction*, Art Gallery of Ontario, Toronto

2007 *Crack the Sky*, Montreal Biennale

2002 *Next Memory City,* Venice Architectural Biennale

2001 *Substitute City,* Power Plant Contemporary Art Gallery, Toronto

COMMISSIONED PHOTOGRAPHIC WORKS

2014 *The Entire City Project: Royal Ontario Museum*

2013 David Mirvish: *Honest Ed's Warehouse, Toronto*

2012 Davies Ward Phillips and Vineberg LLP: *Toronto Highways*

2010 Telus Building: *25 York Street, Toronto*

2008 130 Bloor Street West: *The Entire City Project: the Village of Yorkville*
 St. Michael's Hospital: *The Entire City Project: St. Michael's Hospital*

2006 St. Joseph Media: *Toronto Ferry Docks*

2005 Art Gallery of Ontario: *The Entire City Project*
 TTC / City of Toronto: *Yonge Street - West Side*
 The Canadian Consulate of Chicago: *Five Cities*
 Toronto Pearson International Airport: *The Airport Series*

2004 Schulich School of Business, York University: *Bay Street Rush Hour*
 The Canadian Consulate of Chicago: *5 Cities Exhibition*
 Art Gallery of Hamilton, Canadian Pavilion: *Sao Paulo Biennale*

2002 Canada Council of the Arts: *Next Memory City* – Canadian pavilion at the Venice Architectural Biennale

BIBLIOGRAPHY

2014 Murray White, *Toronto Star*, "The Long View"

2008 John Bentley Mays, *Globe & Mail*, September 12, "In old Yorkville: A sameness that's beautiful"

2005 Sarah Milroy, *Globe & Mail*, November 18, "Exhibit A: Ride A Photo Through the City"
 Peter Goddard, *Toronto Star*, November 12, "Local Photographer Paves His Own Way"
 Alex Bozikovic, *Globe & Mail*, November 5, "Smile! He Wants to Take Your Picture"

2004 *Canadian Architect*, June, "Aboriginal Urbanism"

2003 *Azure*, Sept / October, "Venetian Sights"
 Toronto Star, September 28, "Innovations In The Laneway"
 Objekt, June / July, "Next Memory City"

2002 *Mark Boutin, Canadian Architect*, November, "What's Next?"
 Border Crossings, No.84, "Next Memory City"
 Toronto Star, September 30, "Canadian Conscienceless in Venice"
 Globe & Mail, September12, "Rebels with an Architectural Cause"
 Azure, September / October, "Canada in Venice"

Alphabet City, "Lost in The Archives"
2001 *Elm Street*, November, "Industrial Arts"
 The National Post, February 10, "Designing Outside Box"
 Globe & Mail, April 4, "The Good, the Bad and the Ugly"
 Toronto Star, March 22, "16 Provocative Variations on Toronto"
 NOW, March 29, "Urban Dreams"

PUBLIC COLLECTIONS

Canada Council for the Arts, Art Bank
The Art Gallery of Ontario
The City of Toronto, Mayor David Miller's office
St. Michael's College, University of Toronto
Schulich School of Business, York University, Toronto

PRIVATE & CORPORATE COLLECTIONS

Royal Bank of Canada, Toronto
The Weston Family Collection, Toronto
The Granite Club, Toronto
Perimeter Financial Corporation, Toronto
St. Joseph's Communications, Toronto
AstraZeneca Pharmaceuticals Canada Inc.
Bennett Jones LLP, Toronto
Davies Ward Phillips & Vineberg LLP, New York, Toronto
Newport Partners, Toronto
McCarthy Tetrault LLP, Toronto
KingSett Capital, Toronto
Bank of Montreal, Toronto
Toronto Pearson International Airport
TD Bank Group, Toronto
Target Canada, Minneapolis
Wellington Financial, Toronto
Joseph Behr & Sons Inc., Rockford, Illinois
Encana Corporation, Calgary